sensing geometry

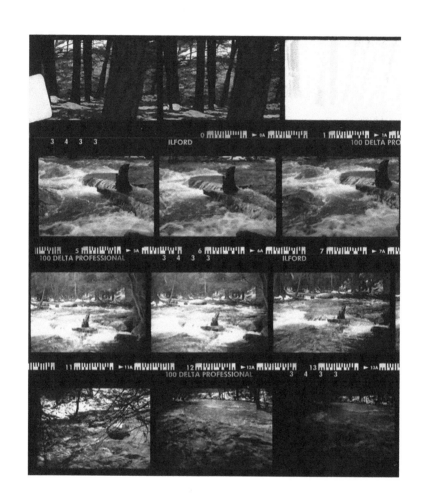

sensing geometry

symbolism and structure in art, science, and mathematics

Steve Deihl

Rock's Mills Press
Oakville, Ontario
2019

Published by
Rock's Mills Press
www.rocksmillspress.com

For information, contact Rock's Mills Press at
customer.service@rocksmillspress.com.

description of the project

For the harmony of the world is made manifest in Form and Number, and the heart and soul and all the poetry of Natural Philosophy are embodied in the concept of mathematical beauty.
— D'Arcy Wentworth Thompson, *On Growth and Form* (1917)

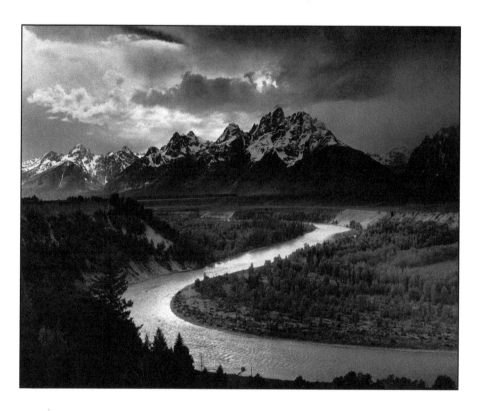

Sensing Geometry is an interpretive work about the connections among mathematics, science, and art. The investigation is driven by ideas and examples, the straightforward presentation of research, and free experimentation in an attempt to relate things that at first glance seem unrelated. The aim of this work is to discover some of these common characteristics. I have illustrated concepts that might initially appear to be subjective or cryptic, but it is my hope that the reader can overcome any prejudgment and instead consider an active mixing that combines both lyrical and analytical method. This project reveals that there are many overlapping relationships that could be regarded as thematically equivalent and comple-

mentary instead of oppositional, in the process perhaps further expanding the network integrating these disciplines.

As a well-known example, the field of architecture clearly bridges many aspects of the liberal arts and sciences, where combining the best of theory and practice creates excellent constructions. Glass, steel, and concrete are engineered with purpose and reason, designed to incorporate not only a specific function but also provide a definite sense of aesthetics, giving the three-dimensionality of space a unique life of its own—a platform aligned with culture and humanity. The abstraction of architecture can also be extended to the universe of mathematics, which is also both very real and conceptual. On a philosophical level, mathematical objects might be said to exist only in our minds because they are progressively built from an idealized framework. But to understand the structure of those objects, mathematicians often begin an investigation by objectively standing apart from them and stating only the obvious such as "Consider this triangle..." or "Here is a line...." In doing so, they are merely calling attention to the phenomenon itself at its most basic level, and it is also from this initially simple viewpoint that a surrounding architecture of ideas like geometry can then be successively built. For example, when a geometer senses the appearance of a shape which is flat and three-sided, simultaneously there is a concept attached to that form and some type of meaning is conveyed about a *triangle*. Symbolically, we might say that the triangle sends its properties to the geometer, who in turn sends content back to the object, and when the information coincides, the shape is then verified and becomes defined.

But when an artist draws a line there might be a different purpose, which is to produce subjective results and feelings, so the interpretation of art will vary from person to person. The line could describe a precise turn, like a Matisse drawing, or be a walk through snow, like a Richard Long sculpture, or a finely executed cut into wood, as a Paul Landacre etching, giving rise to several responses that could all be equally valid—observations of transitory values considered timeless. Thus, some lines are different than others, which is an artistic idea but definitely not a geometric one. Despite these differences, *linearity* has a shared meaning and effect that makes it an essential element for both the geometer and the artist. Bearing this in mind, the book proposes that mathematical structure can be broadly applied to include expressions of human culture by selectively connecting representations that are usually thought to be unconnected: verbal and textual to visual and metaphoric, scientific and mechanical to artistic and expressive.

This approach is developed in two ways: by comparing key mathematical concepts, such as geometric transformations and number theory, to other sources sharing those same intentions, and through the book's design, which is meant to be a mapping of that content according to specific placement of images, quotes, and text, including additional comments in the endnotes of each chapter. It then becomes an arrangement of overlapping impressions that are "guided by commun-

ion with nature and the persuasion of analogies," as Walter Moore writes in *Schrö-dinger: Life and Thought*. For instance, *transformation* can be viewed in many different ways, such as geometrically shifting the position of a triangle or as a model for transferring information about objects. It can also mean something of a spiritual nature, as enlightenment, that might be encountered with a work of art that inspires. Our objective is to develop a network of associations by comparing the relative strengths of their similarities to find intersections where previously there were none. Again, this may be seen through the lens of mathematics, which is a framework that is both rigid and flexible since it is often through subjective insight that discovery is made about objective statements that are assumed to be universal.

Specifically, the project describes identity, similarity, and equivalence as terms that are not only mathematical, but are also common to all experience, occurring in different ways through art forms. As an example, the value of "harmony" might be represented algebraically by a balanced equation, poetically as rhyming couplets, or musically in a symphony. While defining it might be difficult, most of us would agree that harmony's location somewhere along a line from symmetric things to non-symmetric ones would be near the endpoint labeled "symmetry." Here, the analogy is geometric: "Look at this line representing equilibrium, and harmony is closely aligned with symmetry compared with other things." But a full description demands more than dry observations, and leads to the need for symbolic ones. For instance, when reading Wallace Stevens' *Harmonium* (1923), a sensation is felt beyond this linear spectrum that is closer to "an equivalence" with another quality—undefined, but more dynamic—as if it vaulted that pathway and became nonlinear all at once. Clearly, there is something else going here on that transcends mathematical descriptions because perceptions may also be described by a synesthesia, specific to a particular place and time, which is a lyrical or psychic experience and not a scientific one. Art and mathematics do not seek to define or cancel each other; rather, they can remain apart but still be complementary when saying, "Look at the geometry in this Caravaggio painting," or "See the beautiful simplicity in the Leibniz expression of π."

When we compare statements like "2 + 3" and "4 + 1," we can see that one of them is the same as the other, and then use an equation symbol to denote that equality, 5 = 5. But when comparing objects to each other, such as two trees in the woods or even two trees of the same type and size, we might also ask, "Are they equal or unequal?" and "What are the special circumstances allowing equality?" We might conclude that when two things are equal they must actually be the same entity, not just identical twins. Perhaps to resolve this dilemma, we can turn for inspiration to Euclid, who said, "Things which *coincide* with each other are equal to each other." This implies that there may be different types of equalities, depending on how we interpret coincidence.

The geometric term "congruent" is one way to avoid confusing the identities of

things and is used to relate two shapes to each other. Congruence means that there are two objects with the same measurements for corresponding angles and side lengths. Although the words "equal" and "unequal" are most commonly used in comparisons, "equality" and "inequality" are also used as descriptors, but historically "inequal" has been eliminated from use. We could also say "equal" and "non-equal," but non-equal implies it is not an absolute condition, as if something might exist that is just a shade more or less than equal. Related to the notions of symmetry and non-symmetry, equal and unequal are also like two endpoints of a line segment that represents an argument, and, like any dichotomy, it compares two groups or sets of things by either their quantity (amount) or their quality (character). But with a number line there are numbers between numbers and so by analogy there must also be values between values, and a relational decision is made somewhere along this scale based upon experience: are two things weakly alike (similar) or weakly unalike (dissimilar)? Are they strongly alike (equivalent) or strongly unalike (distinct)? Are distinctions stronger than similarities?

While equivalence is well defined in mathematics, it is also seen in literature, music, painting, and poetry. In those cases, equivalence might exceed equality when there is a gestalt of impressions that creates a transcendent feeling; that is, when two or more things coincide to form a larger whole that exceeds all of its components. Based upon this notion, it is suggested that a cognitive map of affinities, organized according to specific geometric dimensions, could be made that might also produce this desired effect. Thus, all associations aligned with zero-dimensional items would be found linked in that particular area of the atlas. Theoretically, the network would represent the work of many contributors, each one having a personal rationale that could be interpreted by others as a shared aspect. Although these elements are part of a system that is always changing, at the same time the overall framework would become more complete after each addition or repositioning. By freely blending media, eventually weaving a fine structure, there are many variations; this book could be considered just one such example.

Several sections interface mathematics with specific philosophies: ontology (states of being), phenomenology (perceptions), semiotics (language structuralism), relational decisions (subjective judgments), and ideas of concurrence (superpositions) and recurrence (embedded imagery)—all of which can be thematically reflected in artistic expressions. With these guidelines in mind, *Sensing Geometry* offers an artistic perspective of familiar topics, showing mathematics to be a likely medium through which interdisciplinary ideas can become linked and multiplied to form an expanding web. At its basis, the project merely presents these sources as possibilities, and asks, "Here are some interesting connections, what should we do next with them?" If interested, I leave it to the reader, who might build upon some of these constructions in the following chapters, to answer that question.

In mathematics, as with art, the deeper truths are often the most compelling

ones because they speak of universal expressions—those conditions that were always present before us and will remain long after. Because there is debate, even among mathematicians, if certain concepts have been invented or discovered, the field itself might also be considered an idealization—an esoteric science perpetuated by self-made rules—and thus it can also present a pure philosophy. And yet, in spite of its inherent abstractions, somehow the model time and again still conforms to our world. If there is the intention of truth-making in *the work*, whether artistic or mathematical, that will be both its origin and validation when tested and held to be true. Perhaps with this idea in mind, Einstein is known to have asked, "How is it possible that mathematics, a product of human thought that is independent of experience, fits so excellently the objects of reality?"

endnotes: *cover, title page, description of the project*

general note for the entire work:
When using quotations from various sources, the original author's intent is left unaltered in terms of using italics, boldface, and any other punctuation or syntax.

cover image:
Photograph by Sam Oppenheim, *Ancient Ice*, Half Moon Island, Antarctic Peninsula, December 2009.
Artist's Note: "This is an example of old dense glacier ice, formed thousands of years ago and pressed under heavy weight before breaking off—it melts and wears in a more crystalline fashion than does common sea ice."

back cover image:
Vair (tincture): A stylized heraldic fur, taken from the alternating pattern of winter coat from the Eurasian red squirrel (Ojejea/Wikimedia Commons).
http://heraldik-wiki.de/index.php?title=Datei:H%C3%A9raldique_fourrure_vair.svg

frontispiece image:
Steve Deihl, *BeaverBrook*, Yulan, 2004–2005

Thompson:
D'Arcy Wentworth Thompson, *On Growth and Form*, Cambridge University Press, Cambridge, 2008, p. 326.

image:
Ansel Adams, *The Tetons and the Snake River* (1942), Grand Teton National Park, Wyoming. National Archives and Records Administration, Records of the National Park Service (79-AAG-1), Archives Identifier Number: 519904

Moore:
Walter Moore, *Schrödinger: Life and Thought*, Cambridge University Press, Cambridge, 1989, p. 171.

Einstein source:
http://www.pbs.org/wgbh/nova/physics/describing-nature-math.html
Einstein answers his own question by asserting that "As far as the propositions of mathematics refer to reality, they are not certain; and as far as they are certain, they do not refer to reality" (quotation from "Geometry and Experience," a lecture given before the Prussian Academy of Sciences, January 27, 1921).
http://pascal.iseg.utl.pt/~ncrato/Math/Einstein.htm

image and text:
Crab Nebula, M1: The Crab Nebula, the result of a supernova noted by Earth-bound chroniclers in 1054 CE, is filled with mysterious filaments that are not only tremendously complex, but which appear to be less massive than the matter expelled in the original supernova explosion and to be moving at a higher speed than would be expected. The Crab Nebula spans about 10 light-years. In the nebula's very center lies a pulsar: a neutron star as massive as the Sun but only the size of a small town. The Crab Pulsar rotates about 30 times each second. Credit: Hubble Space Telescope: NASA, ESA, J. Hester, A. Loll (ASU).
https://www.nasa.gov/multimedia/imagegallery/image_feature_1604.html

further notes:

The Messier Catalogue (the accidental mapping of galaxies):

In 1781, Charles Messier, an avid comet-hunter, published a catalogue of 103 heavenly objects that at first sight appeared to be comets but which, upon further study, showed no perceptible movement from night to night against the background of the other stars, and which therefore could not be comets (or any other type of object in the solar system, for that matter). Messier's purpose was to document the spurious objects to prevent confusion for others who were also observing the sky. Unknown to Messier at the time, these celestial objects were later discovered to be globular star clusters, nebulae, and even galaxies lying far beyond the limits of our own Milky Way Galaxy, some of these containing billions of stars. Several objects were added to the list after Messier's death based on observations and notes he had made during his lifetime. Today the list of Messier objects runs from M1 (the Crab Nebula) to M110 (a dwarf galaxy about 2.6 million light-years away), and includes many familiar astronomical showpieces, such as M31, the Andromeda Galaxy, at a distance of 2.5 million light-years the nearest large galaxy to our own.

Credit: Messier Star Chart, Jim Cornmell, Wikimedia Commons

The Messier objects

contents

mapping and constants
introduction to mathematical ideas

1

Now the problem would be to discover, through recourse to what is essential to history [*Historie*], the historical original meaning which necessarily was able to give and did give to the whole becoming of geometry its persisting truth-meaning.

It is of particular importance now to bring into focus and establish the following insight: Only if the apodictically general content, invariant throughout all conceivable variation, of the spatiotemporal sphere of shapes is taken into account in the idealization can an ideal construction arise which can be understood for all future time and by all coming generations of men and thus be capable of being handed down and reproduced with the identical intersubjective meaning. This condition is valid far beyond geometry for all spiritual structures which are to be unconditionally and generally capable of being handed down.

—Edmund Husserl, *The Origin of Geometry*, 1936

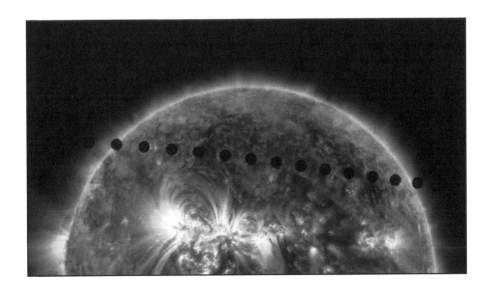

a comparison of art, science, and mathematics

Is there a best way to describe the world? The disciplines of art and science may both see the same thing or the same event at once, but each will tell its story from very different viewpoints, using a specific language that underscores only the most important aspects of their observations. Phenomena are represented differently. Physically, a moving car has speed and direction, but that description does not include the sensation of driving it—there is a trade-off in terms of information that is gained or lost, depending on what is deemed necessary, mechanics or poetry. Adding details, even to the smallest degree, such as memories of streets, acceleration, wind resistance, and shades of upholstery, will result in a better picture, but this task might never end. How do we know when to stop? Perhaps that answer comes from the writer who knows that her novel is finished after everything possible has been eliminated and it still remains complete. This might imply that optimal descriptions are more likely to be holistic ones that can embody both the inherent freedoms of art and the structures of science and mathematics. Like describing the car, intuition becomes the driving force and reason controls it; they act together, steering clear of fallacies in search of the new and unexplored. Initially, the artist uses broad strokes or the scientist approximates a general direction, but then gradually the system is both tightened and expanded. A controlled representation develops, simultaneously spiraling inward to express something in particular, and outward to express something in general. The evolving context amplifies the original observation, which also requires a continual readjustment to any new information.

An analogy to this concept is the path taken by an insect at night as it flies toward a candle. Because of its compound eye structure, it keeps making course corrections according to the angle of its faceted sight-line as it spirals into the light source. The constant change in direction follows the curve of a logarithmic spiral, which is a mathematical model of many natural forms, such as shells, tusks, pine cones, sunflowers, and galaxies. This geometric shape is naturally occurring, and because of that fact, it has also been significant in the historical development of art and architecture in which artists and designers have incorporated that specific mathematical proportion into their work, at least since the Renaissance. Art and science are similar in that they jointly aim to simplify complexity, and in so doing, that new kernel immediately becomes more complex as it now contains additional information and associations resulting from an extension of the previous state. Paradoxically, the description of that complexity is now also more simplified because it is a distillation.

Discoveries across disciplines are often made by recognizing the surprising outcomes that result when seemingly unrelated events coincide. If there is a common foundation of past experiences that are now within a new framework, then they can be tested and tried for consistency. When that theory is held to be true, a new conclusion is drawn from the original hypothesis, and proof replaces conjecture. In this

manner, intuition is certainly integral to learning and progress. With mathematics and physics, the *ansatz* is a provisional approach to describe phenomena—an assumption that is later verified, often empirically. This "onset" is the initial point of inspiration where art meets science, the creative risk that allows potential ideas to blossom by launching a sequence of equations, experiments, and events that produce the new standard.

Mathematician David Hilbert (1862–1943) encapsulated this idea by saying that there are two tendencies present in mathematics:

> On the one hand, the tendency toward *abstraction* seeks to crystallize the *logical* relations inherent in the maze of material that is being studied, and to correlate the material in a systematic and orderly manner. On the other hand, the tendency toward *intuitive understanding* fosters a more immediate grasp of the objects one studies, a live *rapport* with them, so to speak, which stresses the concrete meaning of their relations.

To reduce, simplify, or condense a complexity is to distill it. Thus, both the scientific method and the portfolio of artwork are a set of related processes that have a summative impact intended to be universal. In this sense, it means that the investigation is compelling and true, resulting in knowledge that can be applied in the future—this can also increase the language of critical reasoning. As the focus of investigation contracts, the conclusions become more general and new meaning evolves. For example, in 1890–1891 the Impressionist painter Claude Monet painted a series of haystacks in different seasons and at multiple times of the day; his exploration, with almost scientific detail, applied to a general description of *all* haystacks, fields, light, and time. The effect for viewers, among them the artist Wassily Kandinsky, was that form was almost dematerialized; Monet was showing an inner essence of nature through atmospheric conditions. However, unlike mathematics, art requires no well-defined proof system—its "validation" is exemplified by the consensus of an idea that is well communicated. Art, science, and mathematics are attempts to reduce nature to its essential origins, each asking the same questions: Will our expressions stand the test of time? Is the introduction of a formula eventually succeeded by its elimination?

Like any science, mathematics attempts to rationalize random unconnected observations into coherent behavioral predictions of future events. What makes mathematics most beautiful and compelling is that it consistently describes the underlying structure of many things simultaneously through patterns, similarities, and equalities. It progressively organizes values, dimensions, and parallel constructions; thus it is also an architecture of connections. While art is an external expression of an internal experience among relations such as observations and feelings, mathematics is an investigation that proves relationships among ideas, both as a tool

and a philosophy, using methods and standards that are presumed to be universal.

π and the language of correspondence

If mathematics is a universal connector, then there must also be a type of universal translator that describes how elements are mapped from one set to another, that is, assigning them from **A** to **B**. Three types of mapping are shown below, where the *isomorphism* combines both actions of *onto* and *one-to-one*. *Onto mapping* could be thought of as a room full of chairs with every one of them occupied by someone (even if several people must share the same chair). *One-to-one mapping* would mean that every person gets their own seat (but there might be some empty chairs). A case of *isomorphic mapping* is a room full of chairs with every one of them holding exactly one person (Figure 1).

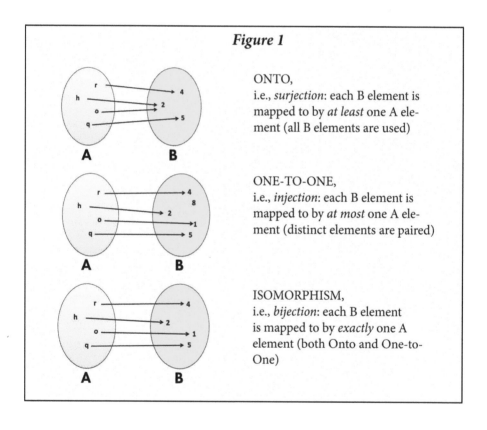

Figure 1

ONTO,
i.e., *surjection*: each B element is mapped to by *at least* one A element (all B elements are used)

ONE-TO-ONE,
i.e., *injection*: each B element is mapped to by *at most* one A element (distinct elements are paired)

ISOMORPHISM,
i.e., *bijection*: each B element is mapped to by *exactly* one A element (both Onto and One-to-One)

More importantly, a mapping that is both onto and one-to-one will be bi-directional; that is, mapping from **B** to **A** will also be an isomorphism: every chair has only one person to fill it and every person has a seat. This means that there is an inverse for the relationship. Since isomorphism means "equal shape" or "equal

form," it is a type of map that preserves the sets and the relations among those elements in both mapping directions. But mapping is just a formal term for a correspondence among parts, like a network of ideas but with a specific set of rules, which means that we can also create a map of affinities related to specific concepts, such as "identity," "similarity," "congruence," and "equivalence."

As an example, using the language of mathematics let's examine the word "ratio" as it specifically applies to a circle. While this symbolic language may be precise, it still needs translating to other forms to uncover its structural elements, which involve the *idea* "ratio." The most elegant statements in mathematics are those like this formula discovered in 1673 by G. W. Leibniz (1646–1716), one which is concise, indisputable, and enduring:

$$4 \sum_{n=0}^{\infty} \frac{(-1)^n}{2n + 1}$$

It means "the ratio of a circle's circumference to its diameter," or π. We could just as easily say: $\pi = \frac{c}{d}$ but this statement only describes the relationship of the circumference and diameter in terms of the operator, division, and says nothing about the numerical value of π. Other mathematicians have discovered *pi* formulas that converge more quickly to that value, but might be considered less aesthetic:

Ramanujan (1913–14):

$$\frac{4}{\pi} = \sum_{n=0}^{\infty} \frac{(-1)^n (1123 + 21460n)(2n - 1)!! \, (4n - 1)!!}{882^{2n+1} 32^n (n!)^3}$$

Chudnovsky brothers (1987):

$$\frac{1}{\pi} = 12 \sum_{n=0}^{\infty} \frac{(-1)^n (6n)! \, (13591409 + 545140134n)}{(n!)^3 (3n)! \, (640320^3)^{n+\frac{1}{2}}}$$

Gosper (1996):

$$\frac{\pi}{5\sqrt{\varphi + 2}} = \frac{1}{2} \sum_{i=0}^{\infty} \frac{(i!)^2}{\varphi^{2i+1}(2i + 1)!}$$

Plouffe (2006):

$$\pi = 72 \sum_{n=1}^{\infty} \frac{1}{n(e^{n\pi} - 1)} - 96 \sum_{n=1}^{\infty} \frac{1}{n(e^{2n\pi} - 1)} + 24 \sum_{n=1}^{\infty} \frac{1}{n(e^{4n\pi} - 1)}$$

The Leibniz formula is a complete message contained within a specific arrangement of esoteric symbols. Its language can be recognized as the unique description of a measurement found on this planet and all others symbolizing the relationship that when you wrap a string around *any* circular object and divide that length by the circle's diameter, the result will always be the same. Leibniz's value of π, derived from calculus, can be written as:

$$\pi = 4 \left(\frac{1}{1} - \frac{1}{3} + \frac{1}{5} - \frac{1}{7} + \frac{1}{9} - \frac{1}{11} + \frac{1}{13} - \frac{1}{15} + \cdots \right)$$

which is equal to:

3.1415926535 8979323846 2643383279 5028841971 6939937510 5820974944 5923078164 0628620899 8628034825 3421170679 ...

Thus, the symbol π represents both the embedded meaning "the ratio of a circle's circumference to diameter," and its value of *a little bit more than three*. The progression of decimals cannot be represented by any fraction, meaning it is an irrational number. It has been memorized to 100,000 places and calculated to more than five trillion in an attempt to find some pattern that would lead to an eternal truth. Here are the 4,999,999,999,951st digits through the 5,000,000,000,000th:

... 6399906735 0873400641 7497120374 4023826421 9484283852 ...

Hidden within the "code" are certain anomalous passages such as the Feynman Point where six nines are found at the 762nd through the 767th decimal place of *pi* ...134 999 999 837... This particular sequence of digits is named after the physicist Richard Feynman who is believed to have said that he would like to memorize the first 767 digits of pi and be able to finish by saying "nine, nine, nine, nine, nine, nine, and so on." While this quip may have taken place in a lecture, it is actually attributed to Douglas Hofstadter and found in his book, *Metamagical Themas*. In either case, the consequence is that after the 767th digit, π would *seem to be* resolved if we stopped at that point and went no further, making it no longer an irrational number.

While the numerical value of *pi* may not really be that interesting, what drives our curiosity is the *subtext*, "why is it this particular number or structure and not a different one?" Likewise, astronomers measuring the density of space might wonder if our universe will eventually collapse or keep expanding—but perhaps a more compelling question might be, "Why is it actually here at all?"

Pythagoras was known to have said "All is Number," and in some sense, counting and measurement can reckon all things numerically. However, hidden among numbers of all types there are some that form an elite cadre known as universal constants. Constants like π, that represent a specific quantity linked to a concept, are believed to hold true for all places and times. Taken together, this small collection of numbers becomes a finely tuned set of parameters that explains the deeper connections in nature. For example, if the gravitational constant *G* was slightly different, life on Earth would not have been possible. Only within a certain amount is the tenuous balance in our sun maintained between collapse and expansion. Similarly, the chemistry required that allows carbon molecules to evolve into humans relies upon a specific state of equilibrium in the electrical forces that bind atomic nuclei.

Isaac Newton found that the force of attraction between any two masses is directly proportional to their product and inversely proportional to the square of the distance between them. The implication is that all things are physically connected to each other, including the most extreme cases such as this dot (.) and the Andromeda galaxy, even if their masses are vastly different and the distances separating them immense. Although very small, their mutual attraction, because the product of their masses is not nothing, will likewise be more than zero. The equation that conveys this concept is:

$$F = G \frac{m_1 m_2}{r^2}$$, where $G = 0.0000000000667408$ (metres3) per (kilogram-second2).

Physicist Lee Smolin examines the belief that the laws of nature are not eternal but may actually be formed as a result of natural selection or self-organization—a belief in direct opposition to the Newtonian idea of viewing an unchanging universe

from an outside vantage point. This concept is also examined by some of the most prominent modern and contemporary thinkers in philosophy and science such as Henri Bergson, Charles Peirce, John Wheeler, Paul Davies, and Andrei Linde. In support of this idea, Smolin details the fact that universal constants must coexist within absurdly small margins:

We live in a universe which has lived so far around ten or twenty billion years, which is about 10^{60} Planck times [the time required for light to travel the smallest possible unit in quantum mechanics = 10^{-43} of a second]. During this time it has neither recollapsed, nor has the expansion run so quickly that the density of matter has become negligible. For this to happen it must be that to an incredible precision the initial expansion speed and matter density were balanced quite close to the line between these two possibilities. How close? If we measure everything in the Planck units, then these two things must have been initially in balance by better than one part in 10^{60}. This means that each quantity must be set to a precision of *at least sixty decimal places*.

In fact, Smolin found that the likelihood of our universe having turned out *just as it is*—given all possible combinations of the numbers associated with physics' *standard model*—is on the order of one chance in 10^{229}. It would seem that two different arguments could be derived from these observations: because that chance is extremely unlikely, either there must be some element of "intelligent design" in nature, like a celestial control panel with dials that were perfectly adjusted by God, or this particular universe, which could be one of many possibilities, just happened to produce intelligent life accidentally by natural selection. Another possibility is that the constants may evolve over time, and the mathematical code for them has not yet been discovered. Regardless of their interpretation, universal constants still remain as they necessarily are: the collection of numbers whose unique combinations light stars, spin electrons, and somehow acted in concert enabling life forms to later comprehend them. They delineate, connote, and connect all aspects of matter and energy. Nature requires these values to be no other than they are; and being such identities, they become irreducible units of the larger whole. Perhaps all we can say is that the universe at this particular "place" in space and time is compatible with carbon-based life forms that are able to make those observations.

The philosopher and scientist Arthur Stanley Eddington (1882–1944) believed that the laws of nature are known *a priori*; that is, primarily residing within our minds as ideas, as opposed to deriving from experience. In *The Philosophy of Science of A.S. Eddington*, John Yolton describes an epistemology highlighting the importance of observation in formulating scientific knowledge, especially given the advances of early 20th century science, which was based upon shifting perspectives. Like mathematics, modern physics and cosmology are built incrementally from theory supported with evidence—an experiment must be verified and capable of being replicated by others. In 1919, Eddington experimentally proved Einstein's theory of

general relativity by observing the bending of starlight around our sun during an eclipse. Teams of astronomers traveled to Brazil and western Africa on May 29th to measure the paths of light rays around the Sun. They found that light rays are actually bent around gravitational fields through space in accordance with the predictions; since the results were consistent, relativity replaced the traditional Newtonian explanation of gravity with a new geometric interpretation of space.

This event essentially supported Eddington's philosophy that theory comes before observation: "The re-introduction of *a priori* physical knowledge is justified by the discovery that the universe which physical science describes is partially subjective." That is, not only are discoveries based upon how data are interpreted, they are also made when imposing a selective use of different methods for measuring that data. It is this aspect of scientific knowledge that led Eddington to call the universe predictable by 'selective subjectivism.'

He also felt that there must be an overall grand Number, related to the fine structure constant, from which all others are derived or depend upon; a presiding scheme which relates all things to each other. By his calculations there are exactly 15,747,724,136,275,002,577,605,653,961,181,555,468,044,717,914,527,116,709,366,2-31,425,076,185,631,031,296 protons in the universe, and the same number of electrons. He called this number *N*, equal to 136 x 2^{256}, his greatest achievement. Today it is not taken seriously as a factual statement about the universe, but it is

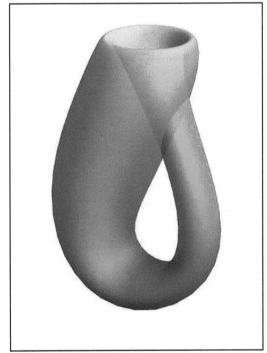

used here to illustrate an extreme point of view.

Certainly, with numerical constants and mathematical equations, the symbols themselves are not universal; rather it is the underlying meaning that is fixed forever and constant:

$$e^{i\pi} + 1 = 0$$

Euler's identity, named after Swiss mathematician Leonhard Euler (1707–1783), succinctly expresses the idea that the logarithmic base, *e*, a constant found prevalent in nature, raised to the power of π times the imaginary unit, $\sqrt{-1}$ = *i, plus one*, will result in zero. As Turnbull writes in *The Great Mathematicians*,

"Was it not Felix Klein who remarked that all analysis was centered here? Every symbol has its history—the principal whole numbers **0** and **1**; the chief mathematical relations + and = ; π the discovery of Hippocrates; *i* the sign for the 'impossible' square root of minus one; and *e* the Naperian logarithm."

Is this arrangement of symbols always true, here and elsewhere? Does Euler's equation also evolve as the universe expands, or is it not subject to physical laws, being a 'pure' concept? With a fundamental formula like Euler's, the symbols may change but not their essence, and mathematicians believe the relationship between 0, 1, *e*, *i*, and π is eternal.

We can incorporate these ideas into a summary of relations, by mapping them as a correspondence between meaning and language, the idea and its image:

symbol	π
representation	a constant for every planar circle, true in all places and times
meaning	the ratio of a circle's circumference to its diameter
equation	$\pi = \dfrac{c}{d}$
expression	$4 \displaystyle\sum_{n=0}^{\infty} \dfrac{(-1)^n}{2n+1}$
translation	$\pi = 4 \left(\dfrac{1}{1} - \dfrac{1}{3} + \dfrac{1}{5} - \dfrac{1}{7} + \dfrac{1}{9} - \dfrac{1}{11} + \dfrac{1}{13} - \dfrac{1}{15} + \cdots \right)$
value	3.1415926535 8979323846 2643383279 5028841971 6939937510 5820974944 5923078164 0628620899 8628034825 3421170679 ...
application	$e^{i\pi} + 1 = 0$

endnotes: *mapping and constants*

Husserl: Edmund Husserl, *The Origin of Geometry*, 1936. Manuscript originally published by Eugen Fink in the *Revue internationale de philosophie*, Vol. 1, No. 2, 1939, under the title, "Die Frage nach dem Ursprung der Geometrie als intentional-historiches Problem." Jacques Derrida, *Edmund Husserl's Origin of Geometry: An Introduction*. Presses Universitaires de France, 1962. Translated, John P. Leavey, Jr., University of Nebraska Press, Lincoln, Nebraska, 1989, page 179.

image: *transit of Venus.* Sequence of images from Solar Dynamic Observatory (SDO) in ultraviolet wavelength of 171 angstroms the Venus transit, merged together to show path of Venus across the Sun. Credit: NASA/SDO. On June 5, 2012 at sunset on the East Coast of North America and earlier in other parts of the United States, the planet Venus made its final trek across the face of the sun as seen from Earth until the year 2117. https://www.nasa.gov/mission_pages/sunearth/multimedia/venus-transit-2012.html#.VkE l0mSrRFQ

Hilbert: D. Hilbert and S. Cohn-Vossen, *Geometry and the Imagination*, translated by P. Nemeny, Chelsea Publishing Company, New York, 1952, Preface.

images: *Isomorphism mappings.* Based on Wolfram MathWorld, http://mathworld.wolfram.com/Isomor phism.html; Regents Prep, http://www.reg entsprep.org/regents/math/algtrig/atp5/OntoFunctions.htm; and Wikicommons, attribution: Lilyu, https://commons.wikimedia.org/wiki/File:Surjection_Injection_Bi jection-fr.svg

Leibniz formula: also attributed to the Scottish mathematician and astronomer, James Gregory, is often denoted:

$$\frac{\pi}{4} = \sum_{k=1}^{\infty} \frac{(-1)^{k+1}}{2k-1}$$

http://mathworld.wolfram.com/GregorySeries.html; https://www.maa.org/sites/default/files/pdf/upload_library/22/Allendoerfer/1991/0025570x.di021167.02p0073q.pdf; https://proofwiki.org/wiki/Leibniz%27s_Formula_for_Pi

pi formulas: http://mathworld.wolfram.com/PiFormulas.html

Feynman Point: Wolfram MathWorld, http://mathworld.wolfram.com/FeynmanPoint.html

pi digits: Akira Haraguchi set the world record for memorizing and repeating 100,000 digits of pi in 16 hours on October 3, 2006. Alexander Yee and Shigeru Kondo calculated 12.1 trillion digits of pi using an algorithm on a computer on December 28, 2013: http://www.numberworld.org/misc_runs/pi-5t/announce_en.html

image: *The Sombrero Galaxy (M104)*, located in the constellation Virgo, 28 million light years distant. NASA/Hubble Heritage. https://www.nasa.gov/multimedia/imagegallery/image_feature_283.html.

10^{229}: "To illustrate how truly ridiculous this number is, we might note that the part of the universe we can see from the earth contains about 10^{22} stars which together contain about 10^{80} protons and neutrons. These numbers are gigantic, but they are infinitesimal compared to 10^{229}. In my opinion, a probability this tiny is not something we can let go unexplained. Luck will certainly not do here; we need some rational explanation of how something this unlikely turned out to be the case." Smolin suggests that "the parameters may actually change in time, according to some unknown physical processes. The values they take may then be the result of real physical processes that happened sometime in our past. This would take us outside the boundaries of the Platonist philosophy, but it seems nevertheless to be our best hope for a completely rational understanding of the universe, one that doesn't rely on faith or mysticism." Lee Smolin, *The Life of the Cosmos*, Oxford University Press, New York, 1997, pages 16, 45, 46, 311–312, and 325.

selected list of constants:

Avogadro constant, N_A:	6.022 140 857 x 10^{23} mol^{-1}
Boltzmann constant, k:	1.380 648 52 x 10^{-23} J K^{-1}
electron mass, m_e:	9.109 383 56 x 10^{-31} kg
elementary charge, e:	1.602 176 6208 x 10^{-19} C
fine-structure constant, α:	7.297 352 5664 x 10^{-3}
Newtonian constant of gravitation, G:	6.674 08 x 10^{-11} m^3 kg^{-1} s^{-2}
Planck constant, h:	6.626 070 040 x 10^{-34} J s
Planck time, t_p:	5.391 16 x 10^{-44} s
proton mass, m_p:	1.672 621 898 x 10^{-27} kg
Rydberg constant, R_∞ :	10 973 731.568 508 m^{-1}
speed of light in vacuum, c:	299 792 458 m s^{-1}

Source: Physical Reference Laboratory, The National Institute of Standards and Technology, U.S. Department of Commerce: http://physics.nist.gov/cuu/index.html.

Eddington:
John W. Yolton, *The Philosophy of Science of A. S. Eddington*, Martinus Nijhoff publisher, The Hague, Netherlands, 1960, page 71.

image:
Klein Bottle, discovered as a four-dimensional mathematical (topological) object by Felix Klein in 1882, the Klein Bottle is like the Möbius Strip (also non-orientable) but with no surface boundary. The "self-intersection" is said to be an immersion. 2010-05-10_klein_bottle.jpg mediawingnuts.blogspot.com. Etymological note: in German, its original name was the Klein *surface*, Kleinsche Fläche, which is very similar to the word for *bottle*, Kleinsche Flasche. However, since the three dimensional representation is reminiscent of a bottle, historically the misnomer has been kept in place.
Kleinsche Flasche: Attribution: Rutebir, https://commons.wikimedia.org/wiki/File:Kleinsche_Flasche.png

Euler's identity:
Herbert Western Turnbull, "The Great Mathematicians," *The World of Mathematics*, James R. Newman, Simon and Schuster, New York, 1956, page 151.

image:
Australite, flanged button, back side. The specimen, a tektite from Australia, likely resulted from a meteorite impact on Earth. It has a diameter of 20 mm and weighs 3.5g. Released under GNU Documentation License. Attribution: H. Raab, https://commons.wikimedia.org/wiki/File:Australite_back _obl.jpg

about dimension

introduction to geometric ideas

2

The object before the mind always has a "Fringe"...

Every definite image in the mind is steeped and dyed in the free water that flows round it. With it goes the sense of its relations, near and remote, the dying echo of whence it came to us, the dawning sense of whither it is to lead. The significance, the value, of the image is all in this halo or penumbra that surrounds and escorts it, — or rather that is fused into one with it and has become bone of its bone and flesh of its flesh; leaving it, it is true, an image of the same *thing* it was before, but making it an image of that thing newly taken and freshly understood.

Let us call the consciousness of this halo of relations around the image by the name of "psychic overtone" or "fringe."

—William James, *The Stream of Consciousness*, 1892

redefining geometry

Taking *geometry* at its original meaning, *the measurement of Earth*, we recall the famous experiment by Eratosthenes nearly 2300 years ago in which he indirectly measured the circumference of our planet. He was able to do this with two conjectures:

(1) he assumed that the Earth was a sphere, and
(2) he also assumed that the sun was sufficiently far away so that its rays of light traveled through space in parallel lines.

Furthermore, he knew that on the summer solstice the sun's rays were directed straight down a deep well in Syene, and thus perpendicular to the planet's surface. At the same time in Alexandria, whose known distance from Syene was about 500 miles, the sun's rays cast a shadow that was 7.2 degrees less than perpendicular; that is, 90 degrees minus 7.2 = 82.8 degrees. Following the paths of the angles to the earth's center, a proportion could be found where 500 miles was 7.2/360 of the whole Earth, giving a distance of approximately 25,000 miles for the circumference.

Eratosthenes' Method of
Measuring the Circumference of the Earth

1/50 of a circle ↔ 5 000 stadia (~800 km)
∴ 1 circle ↔ 50 × 5 000 stadia
= 250 000 stadia (~40 000 km)

1/50 of a circle (~7°)

Parallel sun rays

Pole at Alexandria

Well at Syene (Aswan)

Center of the Earth

Alexandria

5 000 stadia

Syene

However, since Eratosthenes used nonstandard units of "stadia" (the length of an athletic stadium) that varied anywhere from 607 feet in Greece to 517 feet in Egypt, it is unknown how accurate his measurement actually was. Other errors occurred in the difficulty of physically measuring this distance, either by walking or by camel, while counting stadia and marking a straight path. Despite these facts, his calculations were still remarkably accurate, within a possible range of 2% to 16% of the actual polar circumference of 24,860 miles.

Today geometry is mainly known as the investigation of the physical properties of shapes using logical reasoning; thus it is a science that examines spatial relations. But if those relationships are based upon an idealized version of reality, such as assuming that the Earth is a perfect sphere instead of the slightly flattened one that it is, what type of geometry explains our interactions among the real objects and moments we encounter every day? And what kind of system could incorporate non-spatial phenomena such as internal sensations and feelings to make decisions about those objects? Conceptually, this might describe geometry as a type of architecture, if we consider that they are both structural arrangements of space, time, and impression.

In the 1920s, Carl Jung described his notion of *synchronicity* as an "acausal connecting principle." He said that causality is a "merely statistical truth and not absolute, it is a sort of working hypothesis of how events evolve out of another." Furthermore, there is "a peculiar interdependence of objective events among themselves as well as with the subjective (psychic) states of the observers." This, of course, is directly opposed to both the scientific method of cause and effect, and also to the geometric method that builds proofs from theorems, but here it should be noted that those very same theorems are originally derived from common observations that are assumed to be universal truths, called axioms. Additionally, there are examples in quantum mechanics, also discovered in the 1920s, where particles can exhibit an unexplainable violation of causality. Thus, it would seem that subjective perceptions and interpretations are critical to the process of forming conclusions not only in art, but science and mathematics as well, remaining valid as long as the model fits reality.

As an example of his concept, Jung presents two versions of an event, one of which is causally connected and the other which involves coinciding impressions. The first describes *D*, which causally came into existence from *C*, having existed before *D*. And in turn, *B*, which originated from *A*, produced *C*. But the synchronistic view produces an equally meaningful picture by linking events *A'*, *B'*, *C'*, *D'* that all happen to appear at the same moment and place. His explanation is that the physical events *A'* and *B'* are of the same *quality* as the psychic events *C'* and *D'*, and further they "are the exponents of one and the same momentary situation. The situation is assumed to represent a legible or understandable picture."

Since there are always interactions of physical and psychic events in the world,

we might take a philosophical approach and say that geometry, like architecture, is an arrangement of objects, ideas about objects, and our impressions of them. In other words, the idealized construction of geometric shapes and properties simultaneously creates a theory about them, immediately joining form and content. Using this interpretation, deeper concepts from mathematics might lead us to connect less traditional types of observations through a formal organization, like a network. That is, "things which coincide with each other" would be sorted by some taxonomy, but then within that system freely grouped according to their attributes, with the result being something that continuously evolves from subjective inputs.

Although such a map could be made from any source, in this work we will mainly focus on aligning concepts in art, literature, and philosophy with those in mathematics: geometric dimensions and transformations, infinity, similarity, identity, and equivalence. The correspondence of these mathematical structures with non-mathematical ones could then create a network of impressions with affinities as vertex points, each connected by a new context that was formerly unknown. In this manner, distant relationships would be magnified to produce an overall theme which could then be seen in multiple ways.

transformations

In geometry there is a specific action, called a *transformation*, that takes an original entity, the *pre-image*, which maps onto an *image*. Geometric transformations result when some form, like a triangle, is altered in terms of its location and/or shape – it usually occurs in two or three dimensions as planar figures or volumes, but this limitation is only a result of our three-dimensional world. When using matrices, transformations can be represented by variables, x, y, z, etc., one for each given dimension, and thus adding another variable, like w, would simply provide a method for attaining transformations within a fourth dimension. In this case, mathematics exceeds reality because there is no physical method for testing it.

With geometry now broadly defined to include the possibility of both objects and experiences, we could similarly expand the notion of a transformation to be a conversion through space and time, either physical or metaphysical, that can effect a change in representation, but not identity. Comprehensively, this definition might include not only geometric representations of rigid and non-rigid shifts, flips, turns, and distortions, but also transformations that are related to physical and chemical transitions, electromagnetic phase shifting, as well as cultural, spiritual, and psychological adaptations, biological metamorphoses, genetic alterations and mutations, emergent intelligence, and transcendent states.

There are several basic types of geometric transformations:
- translation = a shift, or slide, to a different location like a chess piece
- reflection = a symmetric flip over a boundary, reversing the orientation
- rotation = a turn through space around a single point, like a wheel

- dilation = scaling, a proportional increase or decrease in size
- shear = a push in the direction of an axis or plane, stretching the form

For example, to translate any shape, which itself is comprised of infinite points, is to slide it to a different position from where it started by moving each of its points the same distance and direction. Its location is now different, but the form remains unchanged in terms of its size since the distance between all of its points has remained constant throughout the process; however, dilation and shear are not *isometries* because they undergo a comparative change in size. With translation, reflection, and rotation, the forms before and after the transformation remain congruent, meaning their corresponding sides and angles are equal.

Any combination of transformations is possible, with one transformation following another from a set of directions – this is called a *composition*. Prime notation is used to mark the sequential order; that is, pre-image point *A* becomes image point *A'*; a second transformation will produce *A"*, and a third becomes *A'"* thus indicating the generational pathway back to the beginning. The sequence transfers all of the vertices from their original state to a new one. It has been proven that every isometry can be expressed as the composition of at most three line reflections. For example, a translation is the composition of two reflections across parallel lines and a rotation is the composition of two reflections across intersecting lines.

The following figures illustrate several types of geometric transformations:

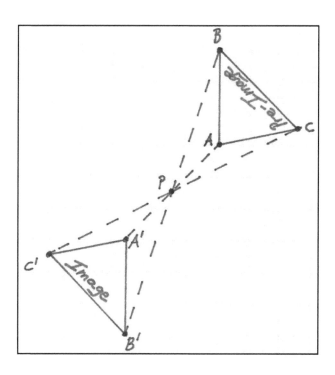

A **point reflection** maps any object through a single point. In effect, the object is squeezed into a singularity and turned as it exits the other side, like a vortex effect. This type of reflection is equivalent to a rotation of 180 degrees and the distance among all corresponding points is preserved: i.e., **A** to **B** to **P** is the same distance as its reflection, **A'** to **B'** to **P**.

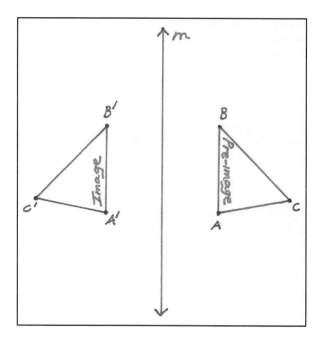

A **line reflection** *maps any object across a line.* The object is flipped and the image is symmetric to the pre-image, essentially reversing its orientation. The distance from **A** to **B** to **C** is the same as from **A'** to **B'** to **C'**, and **A** to **line** *m* is the same distance as its reflection, **line** *m* to **A'**.

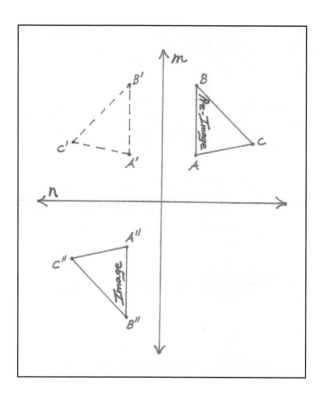

A **rotation** *maps any object by turning it around a point.* This transformation is a spin. A rotation can be accomplished by reflecting an object across any 2 intersecting lines as a composition. The distance from **A** to the rotation point – the intersection of the two lines – is equal to that of both **A'** and **A**." Here, with lines *m* and *n* at 90 degrees, the pre-image points, *A, B, C,* will pass through the intersection to their counterparts, *A", B",* and *C".*

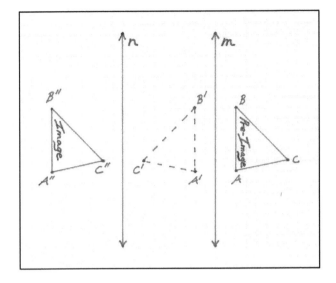

A *translation* maps any object by adding or subtracting units to the coordinates. This transformation is a slide. A translation can be accomplished by reflecting an object across 2 parallel lines as a composition. The distance from **A** to line *m* = line *m* to **A'** and **A'** to line *n* = line *n* to **A"**.

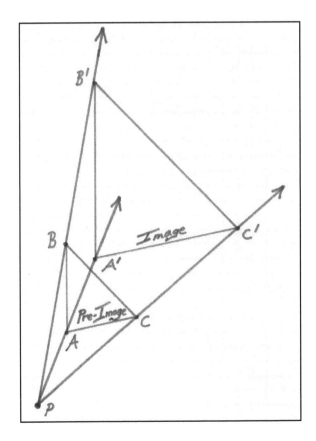

A *dilation* maps a pre-image to an image by a scale-factor, changing its size. This is a type of geometric transformation whose pre-image and image are similar; that is, all angles are congruent to each other and the corresponding sides are in proportion, but not congruent. A scale-factor of $k > 1$ will increase the distances between points, and if $0 < k < 1$, then the image will decrease.

geometric hierarchy and the monad

There is a structure among the geometric dimensions similar to atomic theory, whereby geometric vertices, acting as unit components, are like quarks that build chains of composites of increasing size, such as protons to atoms, atoms to molecules, and molecules to compounds. The geometric analogy is point to line to plane to volume. Organizing a dimensional hierarchy creates increasing levels of complexity, and we can use this notion to build a network of impressions by mapping perceptions and concepts aligned with each specific dimension. This taxonomy summarizes the geometric dimensions:

(0) dimension is a point with no spatial qualities, existing only as a location or idea
(1) dimension is a line, consisting of all linear things with no width or thickness
(2) dimension is an area, consisting of all planar things with no thickness
(3) dimension is a volume, consisting of all solid things that are tangible
(4) dimension is spacetime, consisting of all objects, ideas, and experiences
(v+) more dimensions are mathematically possible

Around 300 BCE, Euclid wrote thirteen books about geometry, the *Elements*, which laid the foundation for mathematics as a science that proceeds from the unknown to the known to reach further unknowns. Thus, both historically and currently geometry is built upon a series of evolving truths. And like the dimensions themselves, there is a hierarchy of order; in geometry, logic is the device that successively drives an argument from a collection of postulates (also called axioms) and propositions to eventually reach an incontestable conclusion. Axioms are intuitive statements that are *assumed to be true but cannot be proven*, such as "through any two points there is exactly one line." Because they are subjective observations that nevertheless produce true results about the physical world, they are believed to be timeless discoveries that were not invented or artificially created but have always existed:

1. A straight line segment can be drawn joining any two points.
2. Any straight line segment can be extended indefinitely in a straight line.
3. Given any straight line segment, a circle can be drawn having the segment as

radius and one endpoint as center.

4. All right angles are congruent.

5. Given any straight line and a point not on it, there "exists one and only one straight line which passes" through that point and never intersects the first line, no matter how far they are extended (later proved to be false for non-Euclidean spaces).

Euclidean geometry has been the model of order in our world for more than 2,000 years, but at the same time it is also recognized as an idealized construction, limited in practical usage. Yet, given only a unit vertex and five postulates it is still possible to reconstruct a version of nature's design in terms of dimensional states and pure geometric organization. Each new theorem becomes the stepping-stone for further investigations and their sum total aspires to give an accurate picture of the world. As elements form matter, and structure follows design, the nuts and bolts assembly of proof-building is similar and can be reapplied continuously:

concept ⇒ design ⇒ structure = axiom ⇒ proof ⇒ theorem

The process of constructing successive layers of knowledge can be compared to geometric dimensions and postulates: increasing levels are attained by creating additional vertices outside original boundaries.

But what is a vertex? Really, it is just an *idea* – a description for the baseline of geometric structure. In 1714, G.W. Leibniz published *La Monadologie*, a metaphysical system in which he argues for the existence of a unit substance, the Monad, that gives individual substances "causal powers, and hence, be centers of genuine activity." He outlines in 90 paragraphs a step-by-step case for accepting his reasoning:

1. The Monad, which we shall discuss here, is nothing but a simple substance that enters into composites – simple, i.e., without parts.

2. And there must be simple substances, since there are composites; for the composite is nothing more than a collection or aggregate, of simples...

8. Monads, although they have no *parts*, must have some *qualities*. There are two reasons why this must be so. (1) If they didn't have qualities they wouldn't be real things at all. (2) If they didn't differ from one another in their qualities, there would be no detectable changes in the world of composite things...

10. I take it for granted that every created thing can change, and thus that created monads can change. I hold in fact that every monad changes continually.

18. We could give the name 'entelechy' [source of power, energy, guiding principle, soul] to all simple substances or created monads, because they

have within them sources of their own internal actions — makes them immaterial automata, as it were …

"It must be said," he writes in a letter to Burcher de Volder, "that there is nothing in things except simple substances, and, in them, nothing but perception and appetite. Moreover, matter and motion are not so much substances or things as they are the phenomena of percipient beings, the reality of which is located in the harmony of each percipient with itself and with other percipients."

As presently understood, thoughts in our minds are created by electro-chemical reactions between nerve cells and synapses. But if we want to examine just one of those components, as a bit of information, its geometric equivalent would be a zero-dimensional point, a vertex representing a single unit of consciousness. This does not imply that the geometric vertex is animated; rather, it is merely symbolic of a potential state of being — the impulse and location from which thought and space are launched. A further analogy is that Leibniz's monad is a vertex, or to rephrase it, *vertex is the geometer's impulse*. Since geometry is an idealized version of reality, a single biological "thought" is also possible within this framework, given the atomistic viewpoint that all composites are formed from singular states. If we accept this

conjecture, then a continuous stream of thought could theoretically be broken down into discrete particles, each represented by a vertex, and "graphed" as a broad spectrum of impressions.

the zero dimension:

Given these conditions, that a vertex is both a location and an idea, it then naturally follows that it could also be a building block for further constructions. And since a vertex is really just a concept, then everything built from it is also abstract, despite the fact that there are solid shapes in the world. But even an idealized geometry is still usable as a system for understanding larger relationships. Recall that a point reflection maps any object through a vertex, which in this case is like a black hole singularity, to reemerge in a different place with its size unchanged, but the figure now turned 180 degrees. Although this action takes place in the coordinate plane, it is also like a conversion of states because that mapping has changed the conditions for the original pre-image, in this case by moving it from one location to another, giving it a different perspective.

If the vertex is taken to be an initial condition for geometry, then we could consider that further constructions and mappings can therefore arise from it. Thus, in creating our hypothetical concept map, the zero-dimensional network would contain affinities related to identity, singularity, origin, and timeless locations. As a monad, the vertex has an identity, yet because of its isolated nature, an unconnected vertex has only a self-aware state. Again, this notion is disconnected with real experiences in life which dictate that nothing can exist without some attached context. But the vertex has only "I am" to define it. Mathematically, this is like the reflexive property of equality, where for every x that is a real number, $x = x$.

In a fictional treatment of this idea, *Flatland: A Romance in Many Dimensions*, Abbott writes about geometry from the viewpoint of two-dimensional beings. The narrator, a square, named A Square, describes a zero-dimensional aspect where:

> That point is a Being like ourselves, but confined to the non-dimensional Gulf. He is himself his own World, his own Universe; of any other than himself he can form no conception; he knows not Length, nor Breadth, nor Height, for he has had no experience of them; he has no cognizance even of the number Two; nor has he a thought of Plurality; for he is himself his One and All, being really Nothing.

the first dimension:

Using this taxonomy as a general structure, the next dimension results when two vertices are connected in space forming a geometric line, which is continuous, or a segment, which has two endpoints. Even though there are an infinite number of points on a line, graphically only two are needed to represent it, and both of those

vertices could now be said to be in relation to each other. Furthermore, a geometric reflection maps an object across a line, as if flipping it over a fence, but with a changed orientation. Since the image is congruent to the pre-image, but reversed, then mathematically this is like the symmetric property of equality, where for every x and y that are real numbers, if $x = y$, then $y = x$.

Symmetrical objects are prevalent in nature: most animals display bilateral symmetry where a line of reflection can be drawn through their bodies, producing two matching halves. A line represents not only a "bridge," serving as the connecting edge between two or more vertices, but also "polarity" since the vertices may be conceptually opposed. Yet even then, a stronger bond is established between the formerly isolated points as a dichotomy, such as the paradox that good is defined by evil and evil defined by good. As more network connections are made along this axis, the structure grows in complexity and nuance.

the second dimension:

Two-dimensional structures are flat areas with no thickness. As the geometric system has increased by adding vertices and connecting edges, this form is now essentially an infinite sheet of surface, extending in all planar directions. Once a third vertex was added and connected outside the line's boundary, a triangle was formed – it has the minimum number of vertices and edges to make a planar figure. Simultaneously there was also created a closed pathway or circuit that is directional, where the first and last vertices are the same, like connecting dots. This concept is mathematically similar to the transitive property of equality, where for every x, y, and z that are real numbers, if $x = y$ and $y = z$, then $x = z$.

The circuit of vertices is also like the logical syllogism – a directed process that forms a conclusion, given two or more premises. Physically, this would be like a shortcut from point A to reach D without needing to first visit B and C. Thus, within the planar figure, there is a continuous relay among the nodal elements. This is now an arrangement for process and action to take place: $A \rightarrow B \rightarrow C \rightarrow A$. Together, the assembly of vertices functions as a whole unit and as more vertices and intersections are created, the figure becomes more complex – a two-dimensional network structure.

the third dimension:

While identity is aligned with the zero-dimensional vertex, volume is the three-dimensional space that it occupies. Area (two dimensions) is its surface, and perimeter (one dimension) is its linear enclosure. Two planes form a line when they intersect, and multiple intersecting planes can connect to form another 3-D shape. Intersecting edges within planes in turn create new vertices and the collection of formerly separate relations and circuits becomes incorporated into a composite mass. Thus, volume is the right combination of all former dimensions, containing

elements of each – the sum total is a wholly formed entity that we recognize every-day as a solid thing.

Like all other transformations, dilations can occur in the third dimension. But unlike other transformations, it is not an isometry because the pre-image enlarges or diminishes the image according to a scale factor. The scale factor, k, essentially mul-tiplies all of the points in the pre-image by a desired amount, resulting in expansion or deflation of the entire image. Obviously, if the scale factor = 1, then no action takes place. If $k = -1$, then the image will vanish through the origin, turning 180 degrees as it does so, and reemerge unchanged in size and in another location, equivalent to a point reflection:

$$D_{-1}(x, y, z) \rightarrow (-x, -y, -z)$$

the fourth dimension:
Our known universe integrates all previous dimensions, zero through three, plus the additional "vertex" of time, without which recollection, progress, movement, and growth would not be possible. Time allows for moment and eternity, presence and absence – it measures stillness and action. The motion of objects can only be meas-ured relative to each other and other stationary sources, such as a fixed point, or the apparently rigid background of stars. A representation of the four-dimensional spacetime continuum is the *worldline*, showing past, now, and future, integrated into space:

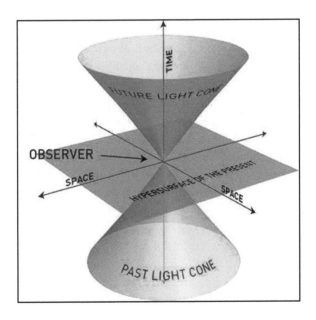

Because the speed of light is constant, Einstein predicted that in a moving frame of reference, objects approaching near-light speeds would undergo significant transformations in the form of time dilation, length contraction, and a relativistic increase in mass. These equations show the relationship of v, the velocity of moving object, with the speed of light, given by c (*celeritas*):

Time Dilation:	$$T = \frac{t_0}{\sqrt{1 - \frac{v^2}{c^2}}}$$	where t_0 = time interval
Length Contraction:	$$L = l_0\sqrt{1 - \frac{v^2}{c^2}}$$	where l_0 = initial length
Relativistic Mass:	$$M = \frac{m_0}{\sqrt{1 - \frac{v^2}{c^2}}}$$	where m_0 = initial mass

Since all forms of electromagnetic radiation (radio waves, microwaves, light waves, etc.) travel at this velocity, the Lorentz transformations demonstrate the impossibility of spaceships attaining the speed of light, but they do not apply to objects that always travel faster than light, such as the postulated tachyon particle, whose lower speed limit is that of light. Undoubtedly, there would be a disconnection with time and such possible encounters would result in a rethinking of the laws of cause and effect.

Since present cosmology posits that the universe began as a singularity, then this Point would have no time-value, existing indefinitely as the location of potential space. It might also seem reasonable to suggest that coincident to the post-inception inflationary period of space, geometric vertices as dimensions, including time, were sequentially created in conjunction with subatomic particles. For example, the advent of one-dimensional structures necessitates the introduction of a temporal unit because the vertex identities now have a relation to each other in the form of a bond, the connecting segment. In a network, this connection is a context, or edge. Time now exists along the infinitely narrow band of one dimension – it just goes back and forth between the two nodes to signify their relation to each other. However, there is still no surface to the phenomenon; this happens later in geometric evolution when another vertex is added noncollinearly, creating the simplest polygon, a triangle. It is easy to see this possibility only from a viewpoint standing outside the given dimension, a meta-position – this perspective is only found from another dimensional level. If the progression of dimensions is like that of the early universe's construction, then it would also grant the possibility that any

additional whole or fractional dimensions were simultaneous to this event as well.

further dimensions:

Since the zero dimension is comprised of one vertex, the first dimension requires a minimum of two vertices, and the second dimension needs only three vertices, a pattern can be seen to develop where each dimensional state is equal to the required minimum number of vertices minus one. There is also a specific symmetry aligned with the numbers in a section of Pascal's triangle, as detailed by mathematician George Pólya:

> The analogy between segment, triangle, tetrahedron has many aspects. A segment is contained in a straight line, a triangle in a plane, a tetrahedron in space. Straight line-segments are the simplest one-dimensional bounded figures, triangles the simplest polygons, tetrahedrons the simplest polyhedrons. The segment has 2 zero-dimensional bounding elements and its interior is one-dimensional. The triangle has 3 zero-dimensional and 3 one-dimensional bounding elements and its interior is two-dimensional. The tetrahedron has 4 zero-dimensional, 6 one-dimensional, and 4 two-dimensional bounding elements, and its interior is three-dimensional.

segment:	2	1		
triangle:	3	3	1	
tetrahedron:	4	6	4	1

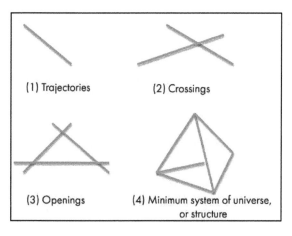

(1) Trajectories (2) Crossings

(3) Openings (4) Minimum system of universe, or structure

The twentieth century philosopher and mathematician Buckminster Fuller (1895-1983) reveals his own spatial design concept in *Critical Path*, linking it to that of Euler's:

As the great mathematician Leonard Euler discovered with his topology, all visual experiences consist of three

inherently different and unique phenomena: (1) lines; (2) when lines cross, we get vertexes (corners, fixes, points); (3) when several lines intercross, we get an area (window or face), or as we call them in synergetics: (1) trajectories, (2) crossings, (3) openings. A system divides all of the Universe into (a) all of the Universe outside the system, (b) all of the Universe inside the system, and (c) the little bit of remaining Universe which comprises the system that separates the macrocosm from the microcosm. The minimum system of Universe (4) is complex – four corners, four windows, and six edges.

Once again there is in mathematics this recurring theme (which can also be seen elsewhere) of finding intersections, overlapping values, and the places where things coincide.

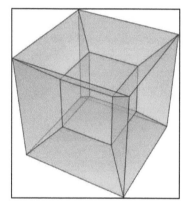

A popular depiction of an object found in the fourth spatial dimension is the *hypercube*, described by astronomer Carl Sagan and others as a cube-within-a-cube, where all edges are of equal length and all angles between the edges are 90 degrees (left).

Leonard Euler not only discovered the identity $e^{i\pi} + 1 = 0$, he also formalized graph theory, which describes networks, and topology, which is the study of mathematical surfaces. He found that solid figures having planar faces like pyramids and cubes, called *polyhedra* (*below left*), all share a common relationship between the numbers of their vertices, edges, and faces. In fact, Euler's idea was later generalized to also include two-dimensional connected planar graphs (*below center*) and convex polygons (*below right*).

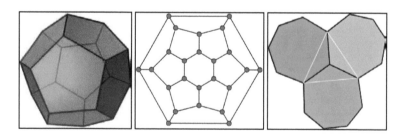

In the previous century, Descartes had written the *Elementary Treatise on Polyhedra*, in which he found relationships among these three-dimensional objects, but his version was framed in terms of their interior angles and remained unpublished and unknown for over 200 years. Euler's later discovery was also a remarkable

observation, but arguably more aesthetic as a concise statement:

$$V - E + F = 2$$

Simply stated, the number of vertices minus the number of edges, plus the number of faces for these objects, will always equal two. In other words, the total number of zero-dimensional units, minus one-dimensional units, plus two-dimensional units, equals two. For two-dimensional networks, graphs, and polygons, the outside region is also counted as a face because mathematically those shapes are analogous to the flattened projection of a three-dimensional object, and that exterior face, appearing outside the network like a surrounding infinite plane, must be included.

By comparison, a similar formula exists for the six regular hyperpolyhedra in four-dimensional Euclidean space, one of which is the hypercube, or *tesseract*, which has 16 vertices, 32 edges, 24 square faces, and 8 cubic cells:

$V - E + F - C = 0$, where C is a three-dimensional cell.

Just as a "normal" three-dimensional cube has a projected shadow in two dimensions, a three-dimensional tesseract model is the projected representation of something that is impossible to make in our world. Its solid structure is a shadow from another realm – a tantalizing image revealing only the outline of the authentic structure that lies beyond our capability to fully perceive it. This idea brings to mind Plato's allegory of the cave from the *Republic* (ca. 380 BCE), in which he describes a group of prisoners bound inside a cave who witness only the representations of forms as shadows projected against the back wall. The true objects pass unseen behind the prisoners, who mistakenly ascribe reality to the shadows, knowing no other. If these other dimensions exist, then they likely contain impressions that three-dimensional observers can only partially apprehend, and those archetypes would then be considered original, irreducible, and authentic phenomena.

Attempts to explain eccentric or supernatural events can be found by returning to the early days of natural philosophy, as well as in cultural studies of mythology carried out by Joseph Campbell, James Frazer, and others. Examples of non-ordinary reality are momentary altered states such as trances and lucid dreams, perceived apparitions and phantasms, delusions, mirages, hallucinations, premonitions, precognition and feelings of déjà vu, ecstatic visions and exultations, revelations, epiphanies, miracles, and states of grace. Because these experiences are more generally "felt" than understood, traditionally it has been easy to ascribe them to the realm of another dimension, when in fact they could actually be chemically induced or neurologically based. Culturally, those experiences took the forms of spiritualism, animism, shamanism, and magic; today they are still ubiquitous and resonate worldwide in religion, art, and philosophy.

Of course, these higher dimensions can only be speculated upon, and historically society has often granted them a spiritual quality simply because they do not originate from physical spaces, but rather from psychic ones. For example, it is a commonly held religious belief that higher dimensions might contain the souls of past lives. Since it is defined as beyond our experiences (*a priori*), we could call this potential field a transcendental state and make it geometrically analogous to the unknown dimensions in *Flatland*. From the viewpoint of Platonism, this dimension could symbolically represent the realm of universal abstractions where ideal objects and their attached meanings are somehow translated to our three-dimensional world. To further speculate, this transcendental state would then hold a density of impressions that could be drawn upon, like a source for Jung's collective unconscious, projecting archetypes of behavior, self, and intellect.

As a summary of these various concepts, consider James Joyce's modernist novel *Ulysses*, published in 1922, which portrays the main character Leopold Bloom during the course of a single day, June 16, in Dublin. The following passage reveals Bloom's stream of consciousness as it relates to Joyce's motif of metempsychosis. This is achieved both literally, as the idea of transmigration taken from the Greek tradition of natural philosophy, and figuratively, as the "translation" of text from one form to another.

Both of these effects could be considered transformations in the larger sense, producing a change in representation but not identity, since with the primary meaning, *reincarnation*, the soul apparently remains intact during the process of moving from one body to another after death. Secondly, when an author creates a work of literature, that artifact is like a geometric transformation in which a pre-image (or proto-text) and its subsequent copies become multiple images (text) when disseminated. By analogy, it could also be said that the author's intention (pre-image) is projected onto the work (image), with each transformation still holding

the original embedded meaning.

But in this instance, Joyce has given Bloom's wife, Molly, the role of *mis*translating his motif, leading to confusion which must be corrected through further (internal) dialogue:

> The sluggish cream wound curdling spirals through her tea. Better remind her of the word: metempsychosis. An example would be better. An example?
>
> The *Bath of the Nymph* over the bed. Given away with the Easter number of *Photo Bits*: Splendid masterpiece in art colours. Tea before you put milk in. Not unlike her with her hair down: slimmer. Three and six I gave for the frame. She said it would look nice over the bed. Naked nymphs: Greece: and for instance all the people that lived then.
>
> He turned the pages back.
>
> —Metempsychosis, he said, is what the ancient Greeks called it. They used to believe you could be changed into an animal or a tree, for instance. What they called nymphs, for example...
>
> ...There's a priest. Could ask him. Par it's Greek: parallel, parallax. Met him pike hoses she called it till I told her about the transmigration. O rocks!

endnotes: *about dimensions*

James: William James, "The Stream of Consciousness," an essay in the anthology *The Nature of Consciousness: Philosophical Debates*, edited by Ned Block et al., The MIT Press, Cambridge, 1997, pp. 77 and 78.

image: Katherine O'Brien, *Snowstorm, Martha's Vineyard*, black and white photograph, 11" x 14", 1994.

image: Eratosthenes' method of calculating the circumference of the Earth: Image created by cmglee, and is found at https://en.wikipedia.org/wiki/File:Eratosthenes_measure_of_Earth_circumference.svg.

Jung: C. G. Jung, *The I Ching or Book of Changes*, Foreword, Richard Wilhem translation, Princeton University Press, Princeton NJ, 1977, pp. xxiv-xxv.

Note from the text: While causality is represented by $\rightarrow B \rightarrow C \rightarrow D$, Jung's synchronicity is represented by $X^{A'B'C'D'}$.

image: Euclid of Alexandria, Published in *Portraits and Lives of Illustrious Men*, by Andre Thevet, Paris, 1584, engraved by Thomas Campanella De Laumessin.

image: Steve Deihl, *Starfield*, detail (31.5" x 37"), oil on galvanized steel, 2009.

Euclid: Euclid's *Elements* can be found at an interactive website: http://aleph0.clarku.edu/~djoyce/java-/elements/elements.html) and the *Postulates* at http://mathworld.wolfram.com/EuclidsPostulates.html.

Leibniz: Ted Honderich, *The Philosophers*, Oxford University Press, 1999, p. 88.

G. W. Leibniz, *The Principles of Philosophy Known as Monadology* (*La Monadologie*, 1714), Jonathan Bennett translation, 2010–2015; retrieved from http://www.earlymoderntexts.com/assets/pdfs/leibniz17-14b.pdf.

image: *worldline*, created by Stib at en.wikipedia; retrieved from https://commons.wikimedia.org/wiki/-File:World_line.png

Polya: George Polya, *How to Solve It: A New Aspect of Mathematical Method*, Princeton University Press, 1945, p. 44.

Fuller image and text: R. Buckminster Fuller, *Critical Path*, St. Martin's Press, New York, NY, pp. 7–8, including internal reference to *Synergetics*.

images:
hypercube: 190px-Hypercube.svg.png en.wikipedia.org; see Carl Sagan, *Cosmos: The Edge of Forever: The Fourth Dimension*, 1980, at https://www.youtube.com/watch?v=lwL_zi9JNkE.
24-fullerene: https://commons.wikimedia.org/wiki/Fullerene_graphs#/media/File:Graph_of_24-fullerene_w-nodes.svg.
heptagonal tiling: https://commons.wikimedia.org/wiki/Category:Regular_heptagons#/media/File:Heptagonal_tiling_vertex_figure.svg.
dodecahedron: https://commons.wikimedia.org/wiki/File:Dodecahedron.svg.

tesseract:
In fiction, the *tesseract* has been written about by Robert A. Heinlein in his 1941 short story, "—And He Built a Crooked House—", and Madeleine L'Engle's classic 1962 novel, *A Wrinkle in Time.*

additional references:
http://www.ams.org/samplings/feature-column/fcarc-eulers-formula;
http://mathworld.wolfram.com/Tesseract.html;
https://people.math.osu.edu/fiedorowicz.1/math655/HyperEuler.html.

There are exactly 6 Regular Convex 4-polytopes: http://www.math.harvard.edu/~knill/seminars/polytopes/polytopes.pdf.

hypercube formula: https://people.math.osu.edu/fiedorowicz.1/math655/HyperEuler.html.

image: Gian Lorenzo Bernini, "L'Estasi di Santa Teresa" ["The Ecstasy of Saint Teresa"], 1647–1652, Cornaro Chapel, Santa Maria della Vittoria, Rome. In this masterpiece of High Baroque sculpture, Bernini depicted the moment of religious ecstasy by the Spanish mystic and Carmelite nun, Teresa of Ávila (1515–1582), when an angel with a spear appeared before her. From her autobiography, *The Life of St. Teresa of Jesus, of The Order of Our Lady of Carmel:*

> 16. … I saw an angel close by me, on my left side, in bodily form. This I am not accustomed to see, unless very rarely. Though I have visions of angels frequently, yet I see them only by an intellectual vision, such as I have spoken before. It was our Lord's will that in this vision I should see the angel in this wise. He was not large, but small of stature, and most beautiful – his face burning, as if he were one of the highest angels, who seem to be all of fire: they must be those whom we call cherubim.
> 17. I saw in his hand a long spear of gold, and at the iron's point there seemed to be a little fire. He appeared to me to be thrusting it at times into my heart, and to pierce my very entrails; when he drew it out, he seemed to draw them out also, and to leave me all on fire with a great love of God. The pain was so great, that it made me moan; and yet so surpassing was the sweetness of this excessive pain, that I could not wish to be rid of it. The soul is satisfied now with nothing less than God. The pain is not bodily, but spiritual; though the body has its share in it, even a large one. (*The Life of St. Teresa of Jesus, of the Order of Our Lady of Carmel* [autobiography], David Lewis, translator, Thomas Baker, London, 1904, p. 165; see http://www.catholicspiritualdirection.org/lifeofteresa.pdf and https://en.wikipedia.org/wiki/Ecstasy_of_Saint_Teresa.)

James Joyce: James Joyce, *Ulysses*, Vintage Books, New York, 1990, p. 65 and 154; and Tom Simone, *"Met him pike hoses": Ulysses and the Neurology of Reading*, https://muse.jhu.edu/login?auth=0&type=summary&url=/journals/joyce_studies_annual/v2013/2013.simone.pdf

image: Photograph by Sam Oppenheim, *English Countryside*, near Salisbury Plain, United Kingdom, June 2002.

historic framework

connecting art and mathematics

<div style="text-align: right;">

3

</div>

Geometry has two great treasures: one is the theorem of Pythagoras, the other the division of a line into mean and extreme ratios, that is, *phi*, the Golden Mean. The first way may be compared to a measure of gold, the second to a precious jewel.

<div style="text-align: right;">

— Johannes Kepler

</div>

There is archaeological evidence that numbers in the written form of primitive hatches or notches date back to at least 12,000 BCE; prior to this time, symbolic forms of language or "signs" have been found in caves, often associated with painted, drawn, or incised animal forms. It is widely believed that this could be the common origin of both language and mathematics as visual or geometric expressions. In the Paleolithic era (*supérior*), from about 40,000 BCE to around 12,000 BCE, cave art flourished in the Dordogne region of France, most likely as a result of several contributing factors, among them climatic changes that had concentrated fauna as diverse as reindeer, lions, and rhinoceros in the area. Most recently, anthropologists such as David Lewis-Williams have hypothesized that in a shamanistic society, individuals experiencing altered states of consciousness were replicating natural brain activity as art. Within this context, the *Aurignacien* period (c. 35,000 to 28,000 BP) has traditionally been associated with archaic art forms of expression, and the *Magdalenien* period (c. 18,000 to 12,000 BP) could be thought of as a golden age with classically developed artwork in the form of painting, drawing, bas-relief sculpture, and three-dimensional carving. However, with the discovery of the French cave, Chauvet, these descriptions need to be revised, as dating techniques have revealed its artwork to be at least 30,000 years old, rivaling that of the Magdalenien cave Lascaux in its highly developed technique and style.

During the Paleolithic era, Cro-Magnon (*Homo sapiens sapiens*) was the new species that firmly established a culture that excelled in both tool-making capabilities and fine art. These are characteristics that its predecessor, *H.s. Neanderthalensis*, did not share and are considered to be the hallmarks of modern man. It was inside

these caves, often in the most remote and inaccessible locations, that thousands of artistic impressions were created, mostly of local animals; rarely are any human forms in evidence.

However, as detailed by paleontologist André Leroi-Gueron, there are many other markings as well which are abstract in nature. He surveyed dozens of caves, categorized the types of abstract demarcations, and statistically tabulated their locations in terms of the context. He found four specific symbolic types: purely geometric forms, figuratively geometric, synthetically geometric, and figuratively analytic. He also grouped them into four locations: signs placed at the beginning of a "sanctuary," which is a large open area deep within the caves and typically filled with superimposed animal forms; signs situated with grand animal compositions; signs within these compositions; and signs which marked the end of the sanctuary.

Based upon their physical proximity within the compositions and those specific locations inside the caves, it is apparent that "signs" were deliberately created and thoughtfully placed to signify something meaningful. The result may be an early attempt to represent nature and communicate an associated concept by synthesizing art, essence, and symbol. A likely conclusion is that at this time in prehistory, there was a conscious decision to represent the world as these distinct entities: animal forms and non-animal forms (the real and the abstract). Dirk Struik, a mathematics historian, has asserted that these examples of Paleolithic art are the first representations of number and form.

Formal attempts to unify art and mathematics can be seen in the teaching and philosophy of the Pythagoreans (around the 5th century BCE), who avidly sought to

harmonize art, music, and mathematics. By the time of the Middle Ages, Euclid's *Elements* became a core of the curriculum known as the *quadrivium*, which connected arithmetic, music, geometry, and astronomy. Mathematics was seen as the study of the "unchangeable," subdivided into Quantity (the discrete) and Magnitude (the continued). Quantity was further divided into the Alone (the absolute), which was the discipline of Arithmetic, and Relation (the relative), which was Music. Magnitude was further divided into states of At Rest (the stable), which was the discipline of Geometry, and In Motion (the moving) which was Astronomy.

When considering a network of affinities aligned with geometric dimensions, it would be easy to draw parallels to the Pythagoreans' scheme: the Alone is a zero-dimensional property because it is a single vertex; Relation is obtained with two vertices in a one-dimensional space; At Rest is a three-dimensional property of stability found in solid geometry; In Motion could be both two-dimensional, when considering the smaller viewpoint of the process between three or more vertices in a connected planar cycle, or four-dimensional, when considering the larger viewpoint of objects moving through spacetime.

the golden ratio

One specific thread linking mathematics to visual art and architecture is the Golden Ratio, denoted *phi,* or φ, which was formally conceived in ancient Greece as the solution to the problem of perfectly dividing a line into "means and extremes." The great astronomer Johannes Kepler, who simplified all planetary motion into three basic laws, was particularly struck by the aesthetic beauty of this number, comparing it to a precious jewel. Furthermore, a Kepler Triangle is special type of right triangle having the ratio of:

$$1:\sqrt{\varphi}:\varphi$$

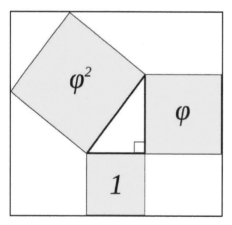

As found through recent satellite observations, the fabric of the universe just after inception was a non-uniformly smooth structure, featuring 'broken symmetry.' This was a necessary requirement to create matter, just as small changes within an organism's genetic code produce the mutations necessary for evolution. From the outset, spacetime needed to be lumpy to gather material gravitationally. It could be said that the requirement of differentiation in nature stems from inherent structural inequalities. The mathematical analog to this fundamental concept of inequality is the propor-

tion of the Golden Ratio, philosophically equivalent to creating a heterogeneous structure from a homogeneous one, complexity from simplicity, and harmony from division.

According to classical Greek belief, the "perfect proportion" is found by dividing a line unevenly so that the ratio of the larger part to the smaller part is equal to the whole line divided by the larger part. This happens to be the same proportion found in humans: a person's height, no matter how tall or short they are, divided by the distance from the ground to the navel, is always the same, approximately 1.6. Thus, the perfect division of a line is associated with an ideal harmony, and this significant geometry can therefore be reproduced in art and architecture. Using the above diagram, *the ratio of the longer section, a, to the smaller, b, is equal to the ratio of the entire length, a + b, to the longer section, a.*

In algebraic terms, $\frac{a}{b} = \frac{a+b}{a}$ and this proportion is symbolized by φ (*phi*), the Golden Ratio.

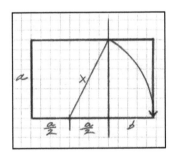

Since we defined the Golden Ratio as $\frac{a}{b} = \varphi$, then a = φ, and b = 1.

Substitute and cross multiply: $\frac{\varphi}{1} = \frac{\varphi+1}{\varphi}$.

This is the *phi* identity: $\varphi^2 = \varphi + 1$.

It can also be rewritten as: $\varphi = 1 + \frac{1}{\varphi}$.

$\varphi^2 = \varphi + 1$ is a quadratic equation that can be solved as $\varphi^2 - \varphi - 1 = 0$ using the quadratic formula: $x = \frac{-b \pm \sqrt{b^2 - 4ac}}{2a}$.

For our equation, $= \frac{-(-1) \pm \sqrt{(-1)^2 - 4(1)(-1)}}{2(1)} = \frac{1 \pm \sqrt{5}}{2}$.

Obviously, we want to choose the positive root as a distance for **a**, $\varphi = \frac{1+\sqrt{5}}{2}$.

To geometrically construct the Golden Ratio, start with a square, each side = **a,** then find the midpoint of the base, creating two equal sections of **a/2** each. From that midpoint, draw a line, **x**, connected to the top right vertex. By pivoting **x** onto the baseline, it creates an additional section – this is the Golden Section, **b**, and a rectangle can be formed with sides of "a" and "a + b." Here, the Golden Ratio, φ, is both **a/b** and **(a+b)/a.**

If **a** = 1, then by the Pythagorean Theorem, $x = \frac{\sqrt{5}}{2}$, and the value for the entire

length, **a** + **b** = the Golden Ratio, $= \frac{1+\sqrt{5}}{2} = \varphi$, and the Golden Section, **b** $= \frac{\sqrt{5}-1}{2} = \frac{1}{\varphi}$.

The first 100 digits of *phi* are: 1.6180339887 4989484820 4586834365
6381177203 0917980576 2862135448 6227052604 6281890244 9707207204
1893911374…

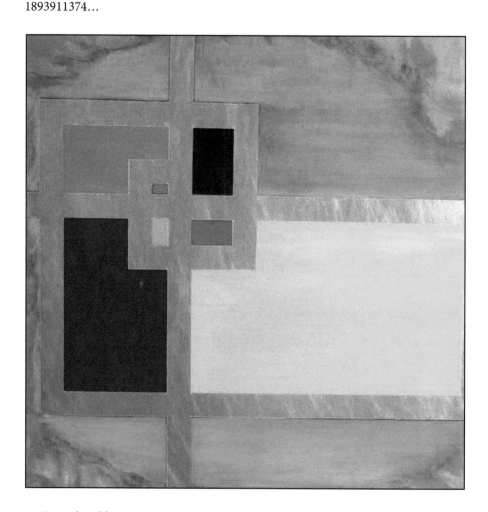

Several Golden sections and the rectangular elements they form can evolve into
a logarithmic spiral—a shape that grows by continued similarity, remaining the
same except for an increase in magnitude. This curve exactly describes growth
patterns of many natural forms including horns and tusks, shells, and galaxies;
furthermore, evidence of this same spiral growth pattern is seen in certain plants
such as sunflowers, pine cones, and pineapples. In fact, there is a connection
between most plants and *phi* and therefore to the mathematical Fibonacci Sequence,
because of nature's predisposition that the optimal angle for most efficiently packing
seeds and petals together to obtain maximum pollination, sunlight, and growth

potential is 137.5 degrees. It turns out that 360 degrees divided by 222.5 degrees (222.5 = 360 - 137.5) ≈ *phi*, the Golden Ratio. In other words, as a plant grows, there is a necessary trade-off between the number of petals it can produce without crowding those below it. This divergence angle has been measured microscopically to confirm that there is a tendency, but not a law of nature, that as one turns through the helix of the stem, the angle is around 137 degrees.

Numerous examples of this phyllotaxis abound among plant species: lilies and iris have sets of three petals for every turn, buttercups and columbine have five, ragwort and marigold have 13 petals, asters have 21, and daisies have sets of 34.

the Fibonacci sequence

The numbers 3, 5, 13, 21, 34 are not random, but are actually special numbers related to the Golden Ratio. Their discovery is found in the *Liber Abaci*, written in 1202 by Leonardo di Pisa, more popularly known as Fibonacci (1180–1250). It was the first European publication using Hindu-Arabic numerals and also contained a problem related to the reproduction of rabbits that produces a set of numbers, now called the Fibonacci Sequence:

> *How many pairs of rabbits will be produced in a year, beginning with a single pair, if in every month each pair bears a new pair, which becomes productive from the second month on?*

Start of Month 1:	0 Adult pair	1 Baby pair	Total = 1
Start of Month 2:	1 Adult pair	0 Baby pair	1
Start of Month 3:	1 Adult pair	1 Baby pair	2
Start of Month 4:	2 Adult pair	1 Baby pair	3
Start of Month 5:	3 Adult pair	2 Baby pair	5
Start of Month 6:	5 Adult pair	3 Baby pair	8
etc....			

This is an example of a recurrence relationship, also found in dynamical systems such as the Mandelbrot Set, which describes fractal patterns in nature. The Fibonacci Sequence is derived from an equation that defines the system recursively, meaning *each term of the sequence is defined as a function of the preceding terms*: $F_n = F_{n-1} + F_{n-2}$.

The first 15 Fibonacci numbers are: 1, 1, 2, 3, 5, 8, 13, 21, 34, 55, 89, 144, 233, 377, 610, where $F_0 = 0$, $F_1 = 1$, $F_2 = 1$, etc. The remarkable connection between this

sequence of numbers and the Golden Ratio is that the very last Fibonacci number divided by the next to last one is equal to *phi*, as the numbers approach infinity: $lim_{n\to\infty}\frac{F_n}{F_{n-1}} = \varphi.$

Phi is incorporated into the Binet Formula (1843), which is an explicit formula to find *any* Fibonacci number directly:

$$F_n = \frac{\varphi^n - (-\varphi)^{-n}}{\sqrt{5}} = \frac{(1+\sqrt{5})^n - (1-\sqrt{5})^n}{2^n\sqrt{5}}$$

A more simplified version rounds the number to:

$$F_n = \frac{\varphi^n}{\sqrt{5}} = \frac{1}{\sqrt{5}}(\frac{1+\sqrt{5}}{2})^n \quad \text{for n} \geq 0.$$

For example, the 137th Fibonacci number equals the nearest integer of: $\frac{\varphi^{137}}{\sqrt{5}}$ = 19,134,702,400,093,278,081,449,423,917. This number also happens to be prime, meaning it has no other factors besides one and itself.

There are many astonishing mathematical identities with Fibonacci numbers. For instance, any Fibonacci number squared, minus the product of the Fibonacci numbers immediately before and after it, is always either positive or negative one…!

Example: $(F_n)^2 - (F_{n+1})(F_{n-1}) = \pm 1$: $13^2 - (21)(8) = 1$; $21^2 - (34)(13) = -1$.

Furthermore, every counting number is either a Fibonacci number or can be expressed as a sum of non-consecutive Fibonacci numbers…!

Example: 51 = 34 + 17, 17 = 13 + 4, and 4 = 3 + 1, therefore, 51 = 34 + 13 + 3 + 1.

Another Fibonacci identity is that the sum of the squares of Fibonacci numbers up to any number, *n*, is equal to the product of the last Fibonacci number and the next one.

$F_1{}^2 + F_2{}^2 + F_3{}^2 + … + F_n{}^2 = F_nF_{n+1}$, can be visualized by looking at the areas of a rectangle made of Fibonacci squares:

The equation says that the sum of the squares, $1 + 1 + 4 + 9 + 25 + 64$, should be equal to the product of the last Fibonacci number, 8, and the next one, 13. We can see that if the individual areas are added together it is also equal to the area of the larger rectangle, both of which are 104 square units. This identity, along with the others here, can be proven to be true for any Fibonacci number using the method of mathematical induction.

While the mathematical connection between *phi* and the Fibonacci Numbers is integral to the Binet Formula, it can also be clearly seen here in a progression of *phi* identities showing Fibonacci numbers 1, 1, 2, 3, 5, 8, 13, 21, 34, 55, etc.:

$$\varphi = 1 + {1}/{\varphi}$$
$$\varphi^2 = \varphi(\varphi) = \varphi(1 + {1}/{\varphi}) = 1\varphi + 1$$
$$\varphi^3 = \varphi(\varphi^2) = \varphi(\varphi + 1) = \varphi^2 + \varphi = \varphi + 1 + \varphi = 2\varphi + 1$$
$$= \varphi^2 + \varphi$$
$$\varphi^4 = \varphi^2(\varphi^2) = (\varphi + 1)(\varphi + 1) = \varphi^2 + 2\varphi + 1 = \varphi + 1 + 2\varphi + 1 = 3\varphi + 2$$
$$= \varphi^3 + \varphi^2$$
$$\varphi^5 = \varphi^2(\varphi^3) = (\varphi + 1)(2\varphi + 1) = 2\varphi^2 + 3\varphi + 1 = 2(\varphi + 1) + 3\varphi + 1$$
$$= 2\varphi + 2 + 3\varphi + 1 = 5\varphi + 3$$
$$= \varphi^4 + \varphi^3$$
$$\varphi^6 = \varphi^3(\varphi^3) = (2\varphi + 1)(2\varphi + 1) = 4\varphi^2 + 4\varphi + 1 = 4(\varphi + 1) + 4\varphi + 1$$
$$= 4\varphi + 4 + 4\varphi + 1 = 8\varphi + 5$$
$$= \varphi^5 + \varphi^4$$
$$\varphi^7 = \varphi^3(\varphi^4) = (2\varphi + 1)(3\varphi + 1) = 6\varphi^2 + 7\varphi + 1 = 6(\varphi + 1) + 7\varphi + 2$$
$$= 6\varphi + 6 + 7\varphi + 2 = 13\varphi + 8$$
$$= \varphi^6 + \varphi^5$$
$$\varphi^8 = \varphi^4(\varphi^4) = (3\varphi + 2)(3\varphi + 2) = 9\varphi^2 + 12\varphi + 4 = 9(\varphi + 1) + 12\varphi + 4$$
$$= 9\varphi + 9 + 12\varphi + 4 = 21\varphi + 13$$
$$= \varphi^7 + \varphi^6$$
$$\varphi^9 = \varphi^4(\varphi^5) = (3\varphi + 2)(5\varphi + 3) = 15\varphi^2 + 19\varphi + 6 = 15(\varphi + 1) + 19\varphi + 6$$
$$= 15\varphi + 15 + 19\varphi + 6 = 34\varphi + 21$$
$$= \varphi^8 + \varphi^7$$
$$\varphi^{10} = \varphi^5(\varphi^5) = (5\varphi + 3)(5\varphi + 3) = 25\varphi^2 + 30\varphi + 9 = 25(\varphi + 1) + 30\varphi + 9$$
$$= 25\varphi + 25 + 30\varphi + 9 = 55\varphi + 34$$
$$= \varphi^9 + \varphi^8$$

art and the golden ratio

Because there exists an independent mathematical concept that is inherent and observable in the universe, artists throughout history have incorporated the Golden Ratio and Fibonacci numbers into their work, believing them to be significant and immutable elements in natural design. Renaissance artists, Leonardo da Vinci among them, in discovering perspective drawing techniques, harkened back to both the Pythagoreans and medieval universities when they utilized the Golden Ratio in their paintings, consciously integrating a mathematical concept into their art to achieve a more profound effect. Since this innate proportion is basic to human anatomy, it was seen as an example of the unity of Man and Nature. This concept was perhaps best exemplified by the drawings of Albrecht Durer and Leonardo's *Vitruvian Man* (1492): height is equal to breadth, sex organs are located at half of the height, and height divided by distance of navel to the ground equals *phi*.

Architects have also designed buildings with specific elements that make use of the aesthetics of this shape, perhaps incorporating it in the Great Pyramid of Giza (ca. 2530 BCE) and the Parthenon (432 BCE), in both of which historians have attempted to reconcile the proportions of the buildings with Golden Ratios and Sections. Modern architects also incorporate this proportion with the specific intention of providing some type of harmonious relationship between the person and the structure.

The Swiss-born architect Le Corbusier (1887–1965), who called his houses *machines à habiter* ("machines for living in"), created clean, precise buildings as characterized by the modernist International Style of architecture; at the same time, these structures still retained an element of human scale by containing the unit within us all, *phi*. His anthropometric scale, the *Modulor*, was an idealized

proportion based upon a man with a raised arm. According to his scheme, Le Corbusier wanted to harmonize human scale with architecture by using the Golden Ratio, Fibonacci numbers, and the metric and standard measurement systems.

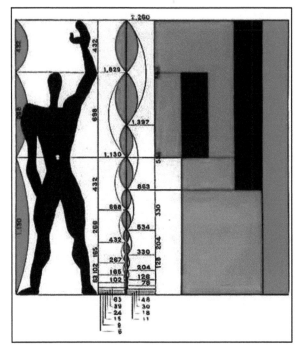

One of the best known modern artists using ideas about the Golden Ratio and Fibonacci numbers was Mario Merz (1925–2003). His mixed media art was wildly imaginative and pluralistic, but always reflected his obsession with those numbers in some way—often obscurely. For example, as part of his opening exhibition at the Guggenheim Museum in 1989 (from September 28 to November 26), there was a performance in which a string quartet played on the main floor's rotunda. Viewers watched along the winding circular ramp as the musicians began with Merz "conducting": they played one long note, all instruments together; then paused before playing the same note again, followed by two more of the same note, then three more, five, eight, thirteen, etc., eventually lasting longer than anyone in the audience could count (but certainly

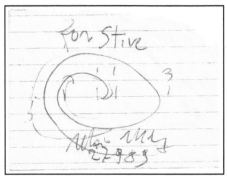

the musicians were keeping track of the number of notes being played). A pattern of musical notes evolved that replicated the Fibonacci Sequence. In fact, Fibonacci numbers became Merz's "signature," appearing in numerous examples of his artwork as neon-lit numbers within his sculptures, and less explicitly represented in the form of an enormous lizard scaling the outside wall of the museum during this exhibition.

Merz effectively incorporated a mathematical system into his artwork, without really needing to explain its purpose because those numerical constants and relationships already existed as universal truths and were in place before humans

became aware of them. His system for expression was along a creative path—a lyrical approach to synthesizing art, geometry, and nature.

simplicity and complexity

With the advent of René Descartes' rectilinear system (the 1620s Cartesian coordinate system that established x-y axes forming four quadrants with an origin at the intersection), geometric analysis could be linked to both mapping functions and algebraic solutions by the establishment of a usable framework that synthesized both representations at once. Geometric truths, formerly established by perception and reason alone, could now be demonstrated with algebraic consistency and applied to nature. Other coordinate systems are also possible, as Jean-Robert Argand demonstrated in 1806 when he integrated the complex number system into two axes, real numbers and imaginary numbers. Vectors, which symbolize directed magnitude, can also be graphed in this coordinate system and combined graphically or algebraically—added, subtracted, or multiplied. Furthermore, the visual representation of those sums, differences, and products are examples of the unity of mathematics expressed in different ways; for example, the vector representing the sum of two forces is geometrically equivalent to the diagonal of a parallelogram. Physically, this sum is the resultant of an action.

David Hilbert (1862–1943) believed that because geometry is among the most diverse branches of mathematics, it could bring about a "summarizing survey of mathematics as a whole." He also said "a presentation of geometry in large brushstrokes, and based on the approach through visual intuition, should contribute to a more just appreciation of mathematics by a wider range of people than the specialists … instead of formulas, figures that may be looked at and that may easily be supplemented by models which the reader can construct." The implication is that the combined effect from multiple representations of the same concept will result in a system that is at once more narrowly focused but also more complex.

In 1900, at the Paris International Congress of Mathematicians, Hilbert famously presented a group of mathematical problems that were meant to be solved in the coming century because he deemed them critical issues—he later published a complete list of 23. Currently, there remain several that are unresolved, among them the *Riemann hypothesis* (number 8 on the list), and the *Kronecker-Weber theorem* (number 12). A more philosophical conundrum was number 24, which stated:

> The 24th problem in my Paris lecture was to be: Criteria of simplicity, or proof of the greatest simplicity of certain proofs. Develop a theory of the method of proof in mathematics in general. Under a given set of conditions there can be but one simplest proof. Quite generally, if there are two proofs for a theorem, you must keep going until you have derived each from the other, or until it becomes quite evident what variant conditions (and aids)

have been used in the two proofs. Given two routes, it is not right to take either of these two or to look for a third; it is necessary to investigate the area lying between the two routes.

More recently, at a 2013 conference in New York, the CUNY Graduate Center hosted a symposium on Hilbert's 24th problem entitled *Simplicity*. Among the participants were mathematicians, philosophers, and artists who were presenting issues related to the dichotomy of simplicity and complexity. Over the course of three days, there were presentations that attempted to resolve the central question: Are there criteria for simplicity? or alternatively, By what standards do we judge complexity? Essentially, while these questions remain unsolved, the exploration itself can still be illuminating and produce a more generalized viewpoint than without an investigation. It should especially be noted that this forum required interdisciplinary participants, without whom the context might have remained a one-dimensional discussion.

It is commonly understood that as a system becomes more complex, it is less simple; but isn't that complexity often a reduced form of multiple elements, that is, a distillation? As an extreme example, the most complex system (universe) theoretically began as the most simple system (singularity) which somehow must have originally contained all of the necessary material to create complexity, or at least the nascent capacity for it to evolve into complexity. The paradox relies upon the scale that is used. In his lecture, *The Complexity of Simplicity*, philosopher Curtis Franks suggests that:

> Mathematical discovery rarely respects our preconceived notions of a problem's topic. What we deem simple thus changes in the course of our efforts to cope with innovation and does not reflect any criterion isolable independent of those very efforts. Reflecting on this, we can begin to appreciate that our judgments of simplicity are often underwritten by highly complex practices and prior understanding. We can trace this reversal of the foundational attitude familiar more generally in contemporary social science and aesthetics to some early remarks of David Hilbert himself. Hilbert asked that we shift our attention from the "objective" fetish of topical purity and towards its "subjective" counterpart.

That counterpart might be interpreted as the insight leading to discovery: freedom from preconception, innovation in technique, and recognition of unexpected conclusions as significant. An example of this notion can be seen in chaos theory, discovered by collecting unanswered questions from diverse sources (complexity), which were then integrated with wide-ranging implications (simplicity). This is a mathematical model that correlates natural geometric surfaces

and boundaries like clouds and mountains, the complex number system using $\sqrt{-1} = i$, and physics into an explanation for certain large dynamical systems, such as weather, that are highly sensitive to subtle initial conditions. That initial sensitivity later influences the system's greater development and outcome, sometimes catastrophically, as it quickly spirals out of control.

Two notable contributors to the development of chaos theory were Edward Lorenz, who in 1972 coined the term "butterfly effect" in a scientific paper entitled "Predictability: Does the Flap of a Butterfly's Wings in Brazil Set Off a Tornado in Texas?" and the IBM research scientist Benoit Mandelbrot who published *The Fractal Geometry of Nature* in 1982. Ironically, when he initially began his work in 1961, Mandelbrot was looking for an explanation to a "white noise" that interfered with the flow of data across telephone lines, breaking up the signal. But "Mandelbrot had always thought visually, so instead of using the established analytical techniques, he instinctually looked at the white noise in terms of the shapes it generated … A graph of the turbulence quickly revealed a peculiar characteristic. Regardless of the scale of the graph, whether it represented data over the course of one day or one hour or one second, the pattern of disturbance was surprisingly similar. There was a larger structure at work." This discovery is almost exactly parallel to that of Arno Penzias and Robert Wilson at Bell Laboratories in 1964 who serendipitously discovered primordial radiation from deep space. They too had been investigating an unexplained interference in the transmission of radio waves, but the bigger picture was not made clear until theoretical physicists at Princeton were alerted to this measurement, which exactly fit their model of the Big Bang.

Initially the direct result of an engineering quandary but simultaneously aesthetic, the fractal models that Mandelbrot created represent a new vision of geometry and nature. In his 1982 masterpiece, he wrote:

> Clouds are not spheres, mountains are not cones, coastlines are not circles, and bark is not smooth, nor does lightning travel in a straight line.
>
> More generally, I claim that many patterns of Nature are so irregular and fragmented, that, compared with Euclid … Nature exhibits not simply a higher degree but an altogether different level of complexity. The number of distinct scales of length of natural patterns is for all practical purposes infinite.

endnotes: *historic framework*

Kepler:
Mario Livio, *The Golden Ratio: The Story of Phi, the World's Most Astonishing Number*, 2003, page 62.

image:
romanesco broccoli showing phi structure and self-similar geometry: "Romanesco broccoli," Jacopo Werther, 2011, http://commons.wikimedia.org/wiki/File:Romanesco_Broccoli_detail_-_%281%29.jpg.

Lewis-Williams:
David Lewis-Williams, *The Mind in the Cave: Consciousness and the Origins of Art*, Thames and Hudson, 2002.

Leroi-Gourhan:
André Leroi-Gourhan, *L'art pariétal: Langage de la préhistoire*, Editions Jérôme Millon, Grenoble, 1992.

image:
Frieze of Cave Lions, Chauvet Cave, Ardèche region, France. Chauvet was discovered in 1994, having been sealed intact containing artwork that dates to at least 32,000 years BP. For more on Chauvet, see Werner Herzog's documentary, *Cave of Forgotten Dreams*. Courtesy Heritage Image Partnership/Alamy.

image:
Hands in Pettakare. Description: Handprints in Pettakare Cave at the Leang-Leang Prehistoric Site, Maros, Indonesia. Credit: Cahyo Ramadhani, Wikimedia Commons.

text:
Bickley-Green, C. (1995). "Math and Art Curriculum Integration: A Post-Modern Foundation," *Studies in Art Education*, 37(1), 6–18.

Struik:
"There are some rods, wood or bone, found in Africa [dating from 8,000 to 20,000 BCE], with carvings of parallel lines, perhaps the tally of hunting results. Then there are the famed cave paintings in Spain and France, also very ancient, which show mathematical traces, if only by the fact that they are two-dimensional projections of solid bodies, hence exercises in mapping."

Paulus Gerdes, *Awakening of Geometrical Thought in Early Culture*, MEP Publications, 2003, foreword by Dirk J. Struik, page ix. Additional source, Dirk J. Struik, *A Concise History of Mathematics*, G. Bell and Sons, London, 1954.

image:
Kepler Triangle: Using the Pythagorean theorem, a right triangle with sides of 1, $\sqrt{\varphi}$, and φ, creates the equation: $(1)^2 + (\sqrt{\varphi})^2 = (\varphi)^2$ or $\varphi^2 = \varphi + 1$. Original uploader was Vancho at en.wikipedia. https://commons.wikimedia.org/wiki/File:Kepler_triangle.svg#/media/File:Kepler_triangle.svg.

image:
Steve Deihl, *Left Twist*, 22" x 20", oil on galvanized steel, 2006.

phyllotaxis of 137.5 degrees:
K.K. Tung, *Topics in Mathematical Modeling*, Princeton University Press, 2007, pages 12–15, http://press.princeton.edu/chapters/s8446.pdf.

image:

sunflower showing radial patterns of Fibonacci numbers: Flickr. Depending on how they are counted along each spiraling axis, there will always result a Fibonacci number of 21, 34, 55. http://momath. org/home/fibonacci-numbers-of-sunflower-seed-spirals/.

text:

Binet formula, http://mathworld.wolfram.com/BinetsFibonacciNumberFormula.html.

Induction proof for: $F_1{}^2 + F_2{}^2 + F_3{}^2 + \ldots + F_n{}^2 = F_n F_{n+1}$

1) Show a base value is true:
 let n = 3
 $F_1{}^2 + F_2{}^2 + F_3{}^2 = F_3 F_4$
 $1 + 1 + 4 = (2)(3)$
 $6 = 6$

2) Hypothesis, assume that this is true for some **k**, a counting number:

$F_1{}^2 + F_2{}^2 + F_3{}^2 + \ldots + F_k{}^2 = F_k F_{k+1}$

3) Prove that the next **k** value, **k + 1**, is also true. If so, then by mathematical induction, $F_1{}^2 + F_2{}^2 + F_3{}^2 + \ldots + F_n{}^2 = F_n F_{n+1}$ is true for all values:

$F_1{}^2 + F_2{}^2 + F_3{}^2 + \ldots + F_k{}^2 + F_{k+1}{}^2 = F_{k+1} F_{k+2}$

show that left side of equation is equal to the right side:
from hypothesis, since $F_1{}^2 + F_2{}^2 + F_3{}^2 + \ldots + F_k{}^2 = F_k F_{k+1}$ substitute into proof:
$F_k F_{k+1} + F_{k+1}{}^2 = F_{k+1} F_{k+2}$
factor out F_{k+1} from both terms of left side:
$F_{k+1} (F_k + F_{k+1}) = F_{k+1} F_{k+2}$
since the definition of a Fibonacci number is the sum of the two previous numbers, substitute $F_k + F_{k+1} = F_{k+2}$
$F_{k+1} F_{k+2} = F_{k+1} F_{k+2}$
By induction, the proof holds true for all Fibonacci numbers.

image:

Galaxy M51, showing spiral arms of stars. Also known as the Whirlpool Galaxy, it is 23,160,000 light years distant, in the Canes Venatici constellation. Taken by the Hubble Space Telescope. Credit: S. Beckwith (STScI), Hubble Heritage Team, (STScI/AURA), ESA, NASA, additional Processing: Robert Gendler. Retrieved from Wikimedia Commons.

image:

Leonardo da Vinci, *Vitruvian Man*, 34 cm x 26 cm, ink drawing, 1492. From Wikimedia Commons.

image:

Le Corbusier, *Modulor*, 1943, http://en.wikiarquitectura.com/index.php/File:Esquema_modulor.jpg.

image:

Mario Merz, *Spiral Drawing*, given to the author at the Guggenheim Museum opening exhibition, September 27, 1989.

Below, photograph by Marilyn Mazur, Guggenheim Museum, of the author with Merz at the same event:

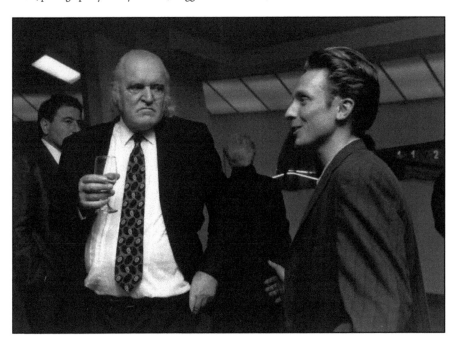

Hilbert:
D. Hilbert and S. Cohn-Vossen, *Geometry and the Imagination*, translated by P. Nemeny, Chelsea Publishing Company, New York, 1952, Introduction, page iii and iv.

text:
Hilbert problems: http://en.wikipedia.org/wiki/Hilbert%27s_twenty-fourth_problem.

Franks:
Curtis Franks, lecture and text from brochure: *Simplicity: Ideals of Practice in Mathematics & the Arts*, City University of New York, Proshansky Auditorium, 365 Fifth Avenue, New York, April 3–5, 2013.

Mandelbrot:
image:
Mandel zoom 11 satellite double spiral. Image created by Wolfgang Beyer with the program Ultra Fractal 3. Description: Partial view of the Mandelbrot set. Step 11 of a zoom sequence: Double-spirals with satellites of second order. Analog to the "seahorses" the double-spirals can be interpreted as a metamorphosis of the "antenna." https://en.wikipedia.org/wiki/File:Mandel_zoom_11_satellite_double _spiral.jpg

text:
Benoit Mandelbrot, *The Fractal Geometry of Nature* (1982), New York: W.H. Freeman and Company, introduction, page 1.

identity of a vertex
prologue: mapping ideas

Ford Madox Ford wrote in 1911 that "poetry, like everything else, to be valid and valuable, must reflect the circumstances and psychology of its own day. Otherwise it can be nothing but a pastiche." This statement epitomizes the new modern era in English poetry, one which eschewed the kind of popular verse that progressives likened to a "civic menace," among them Ezra Pound who called it a "horrible agglomerate compost, not minted, most of it not even baked, all legato, a doughy mess of third-hand Keats, Wordsworth, heaven knows what, fourth-hand Elizabethan sonority blunted, half-melted, lumpy." Instead of existing in isolation, modernists in art, literature, and poetry promoted universality by embracing changes in the external world, including new discoveries of nature seen through the lens of science.

The next section of this work is an experimental map that joins three separate themes: there is a brief historical comparison of some early twentieth century advances in art and science; there is a description of ideas that are aligned with a specific geometric dimension; and throughout the chapter is juxtaposed Wallace Stevens' *Thirteen Ways of Looking at a Blackbird* (1917), intended to both reflect and promote reflection.

Stevens' poem has a constant play of action and reaction, comparing imagery of the part to the whole, of time and no-time, of sense and experience; it is both understated and vast, a complexity reduced to a simplicity through its spare *haiku*-like format. It is conceivable during this period that Stevens was influenced by the parallel currents of Cubism, spacetime mathematics, and quantum physics as the shifting of perspectives in his work joins the smallest macrocosm with the largest microcosm, meeting somewhere in the middle as a series of impressions. The poet urges us to look beyond superficial observations and shadow effects to discern an original cause ...

identity of a vertex
mapping ideas

<div style="text-align: right">

4

</div>

I am convinced that creativity is *a priori* to the integrity of the universe and that life is regenerative and conformity meaningless.
> — Buckminster Fuller, *I Seem to Be a Verb*, 1970

I

Among twenty snowy mountains,
The only moving thing
Was the eye of the blackbird.

focus on the early twentieth century

Historically, it has been widely held that there are two distinct types of knowledge in the world: *empirical* knowledge, based upon observations and experience, and *intuitive* knowledge, which is based upon theory and insight. It is often said that the former allows for the advancement of science (an objective process), while the latter is crucial to artistic creation (a subjective process). But that would seem to be an oversimplification because we can easily find examples of art that are analytic and mathematics that might be driven by aesthetics. At the very least, it could be argued that there is to some degree an active mixing of both types of knowledge because discovery and innovation often occur in unexpected ways—these ideas are central to epistemology, which investigates the nature of truth and justified belief. They are also relevant in educational theory that emphasizes investigation, debate, critique, and the presentation and defense of a thesis in the liberal arts and sciences. Related to this discussion are some unresolved questions such as: What is the relative balance of intuition and reason in experimentation and how important are those characteristics? Are there overlapping processes, complementary freedoms, and restrictions? How can we recognize the significance of unforeseen events and the usefulness of residue from experiment?

This topic was especially relevant in the early twentieth century when developments in physics and art highlighted not only some of those distinctions in method but also their cross-disciplinary influences. For instance, in 1905 Albert Einstein formulated the special theory of relativity, which demonstrated that there could be relative conditions for space, time, and motion, even simultaneity, depending upon the position of an observer.

II

I was of three minds,
Like a tree
In which there are three blackbirds.

Einstein also said that the speed of light was constant, and based his theory upon experimentation, as opposed to conforming experiments to an already existing theory. Two years later Henri Bergson published *Creative Evolution*, describing a force of consciousness he called the *élan vital*, perhaps as a response to relativity theory (at least one author has translated *élan vital* as "the explosive force—due to an unstable balance of tendencies"). It was Bergson's view that this "impetus" is a viable mechanism that affirmed the domination of innate perceptions over empirical reason, contrary to the prevailing philosophy of positivism which rejected any form of introspection in favor of logically analyzing the sensory data of phenomena. In 1922, Einstein and Bergson would famously meet in Paris for a debate at the *Société française de philosophie*, where there was overwhelming agreement that Einstein's "rationality" was victorious over Bergson's "intuition," especially with regard to the flow of time.

Nevertheless, Bergson's philosophy has continued to be embraced by artists and writers alike not only as a theory and rationale for creativity, but also as a point of inspiration, whether accurately understood or not, because it validates subjective experiences. Like a Greek muse, this unseen force of nature becomes a guiding principle to the artist through dreams and subconscious impulses allowing for process to evolve alongside theory in creating abstractions, eccentric juxtapositions, and overt gestural work, as opposed to that which might be considered descriptive or illustrative. Many types of visual art, literature and poetry, film, and photography, rely on this sensitivity as evidenced in surrealism, expressionism, and stream of consciousness writing.

III

The blackbird whirled in the autumn winds.
It was a small part of the pantomime.

It was during this same time period that Pablo Picasso created the influential but controversial painting, *Les Demoiselles d'Avignon* (1907). He was joined by other artists, among them Juan Gris, Georges Braque, Robert and Sonia Delaunay, who were all painting in the style of Cubism and Orphism, by describing space and time as broken planes interacting with light—the viewer is stationary, observing and discerning the flux, flow, and movement of simultaneous events in spacetime. But when *Les Demoiselles* was first exhibited in 1916, there was outrage, even among the artist's most avid supporters. The Museum of Modern Art, which owns *Les Demoiselles*, describes the initial reaction: "Angered by the painting, artist Henri Matisse assumed that Picasso was ridiculing the modern movement; he thought Picasso might have been trying to wrest not a third, but a *fourth* dimension from the flat picture plane.... Even his fellow founder of Cubism, Georges Braque, expressed dismay, claiming that Picasso must have drunk petroleum to spit fire onto the canvas." Yet today, the work is considered a masterpiece of modern art, and one of the heralds of a new age.

Perhaps the only contemporary rival to the outrage expressed about *Les Demoiselles* was that in response to Marcel Duchamp's *Nude Descending a Staircase (No. 2)*, 1912, when it was first exhibited at the famous Armory Show in New York in 1913. The painting, now considered an avant-garde archetype, was originally derided by critics as "The Rude Descending the Staircase (Rush Hour at the Subway)," and "Explosion in a Shingle Factory." As is still the case, scandal is often accompanied by notoriety, and Duchamp was delighted by new opportunities in America, where he moved in 1915.

IV

A man and a woman
Are one.
A man and a woman and a blackbird
Are one.

His painting went well beyond static Cubist portraits (even that group of artists rejected the painting in 1912 by claiming that "a nude never descends the stairs—a nude reclines") to bring an element of motion to the canvas:

Duchamp reduced the descending nude to a series of some twenty different static positions whose fractured volumes and linear panels fill almost the entire canvas. The faceted disintegration of the mechanized figure and the monochrome tonality are typical of Cubist painting at the time. However, the serial depiction of movement goes beyond Cubism in its attempt to map the motion and energy of the body as it passes through space.

V

I do not know which to prefer,
The beauty of inflections
Or the beauty of innuendoes,
The blackbird whistling
Or just after.

Interpretations describing objects and motion in spacetime can also be seen in the Italian art movement, Futurism, originated by the writer Filippo Marinetti in 1910, in which artists like Severini, Balla, and Carrà were making gestural images about the dynamics of modernity: speed, sound, machinery, and cities. Umberto Boccioni, another artist influenced by Bergson, perhaps best evokes the fourth dimension in his bronze sculpture of a striding figure, *Unique Forms of Continuity in Space* (1913), which seems to have broken the all the rules of physics and geometry:

While there remains an active debate among historians regarding the influences, relationships, and discoveries in early twentieth century science and art, there is no doubt that the spirit of the time—ingenuity and radically new visions—was best exemplified by Einstein and Picasso.

VI

Icicles filled the long window
With barbaric glass.
The shadow of the blackbird
Crossed it, to and fro.
The mood
Traced in the shadow
An indecipherable cause.

However, another influence on modern artists came from Henri Poincaré, the philosopher, scientist, and mathematician, who believed that it is only *by convention* that we accept the postulates of Euclidean geometry, when it could just as easily be non-Euclidean. As Poincaré wrote in *Science et méthode* (1908):

> ... by natural selection our mind has adapted itself to the conditions of the external world. It has adopted the geometry *most advantageous* to the species or, in other words, the *most convenient*. Geometry is not true, it is advantageous.

This creative period also witnessed the discovery of two remarkable scientific facts, namely that the universe is expanding (by Vesto Slipher and Edwin Hubble) and that gravitation has a geometry (Einstein's General Relativity, in 1915, verified by Eddington in 1919). Such ideas, along with Esprit Jouffret's influential *Traité élémentaire de géométrie à quatre dimensions* (1903), suggest that discussions of space, geometry, and the fourth dimension were prevalent at this time. It is known that Picasso's *Bateau-Lavoir* circle of artists also included the mathematician Maurice Princet, who was familiar with Jouffret's work and became instrumental in providing a foundation for the Cubist movement by describing to artists the latest developments in physics and geometry, such as Poincaré's theories. Princet "conceived of mathematics like an artist and evoked continua of *n* dimensions as an aesthetician. He liked to interest painters in the new views of space ... and he succeeded in doing this." Such topics were surely explored by Picasso and his contemporaries, including the regulars attending Gertrude Stein's soirées: William James, Matisse, Gris, Apollinaire, Jacob, and others.

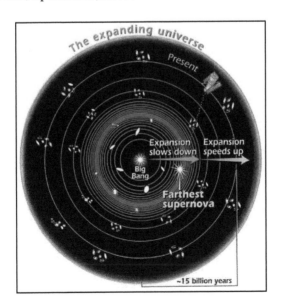

VII

O thin men of Haddam,
Why do you imagine golden birds?
Do you not see how the blackbird
Walks around the feet
Of the women about you?

interpreting the zero-dimension: a mapping example

Thus, there were many radical theories and approaches in the early twentieth century and if there was any crossover between disciplines it only served to enhance each of them. The laws of nature, formerly held inviolate, were fractured by relativity and quantum mechanics, and by observations of the expanding universe. New concepts and works of art flourished when academic authorities no longer held sway over creativity with long-held dogma. (Here it must be said that the enduring value of artistic freedom and breaking with tradition had been recognized as necessary to creativity since at least 1863 when Édouard Manet's *Le Déjeuner sur l'herbe* was bluntly rejected by the Academy of Fine Arts and famously placed in the Salon des Refusés along with James McNeill Whistler's masterpiece, *Symphony in White, No. 1*). Of course, besides Cubism and the Dada movement, the early twentieth century saw the beginnings of Surrealism, Russian Constructivism, and the Bauhaus design school, compositions by Erik Satie, Arnold Schoenberg, Maurice Ravel, and Claude Debussy, as well as groundbreaking works in literature by James Joyce, Hermann Hesse, T. S. Eliot, and Wallace Stevens.

While *Sensing Geometry* is not meant to be an historical account, one of its guiding principles is to find similarity by connecting distant relationships— extremities that would coincide in terms of a mutual intention, but not necessarily in content. Of course, connections will vary from person to person, producing a multitude of possibilities, but we also might also consider that it is the actual process of deciding the placement of affinities that potentially makes new interpretations evolve that were formerly unknown.

VIII

I know noble accents
And lucid, inescapable rhythms;
But I know, too,
That the blackbird is involved
In what I know.

With this in mind, we could select elements from art, literature, and philosophy and group them in a network of associations according to what we believe is symbolically most appropriate, specifically aligned with the characteristics of a certain geometric dimension. In that manner, like geometry itself, there would be a gradual construction of resonating ideas, building from point-associated ideas to line-associated ideas and so on, eventually forming some kind of comprehensive map. Theory would evolve alongside experience.

As an example, throughout this chapter the placement of Stevens' poem was selected as an element of the modernist spirit, written concurrently with those events previously discussed. The poem was also chosen to represent impressions associated with the zero dimension as they might apply to a particular state of being where the vertex is taken to be a unit of consciousness: connecting the eye of the blackbird to a vertex and the vertex to stillness, awareness, and identity.

To further construct this network, compare artist Yves Klein's *zone de sensibilité picturale immatérielle* with John Cage's *four, thirty-three* as they might symbolically relate to the zero-dimension. This analogy is certainly novel, but when considering the attributes of a single vertex, it might be worth exploring. Recall, a zero-dimensional point is a geometric concept, and philosophically it could represent a monad—it therefore also has an identity, or existence, but perceives only itself.

IX

When the blackbird flew out of sight,
It marked the edge
Of one of many circles.

There is no notion of time because there is no relation, instead there is only a void and each moment is an endlessly occurring original one. We might consider the vertex to be, like the monad, its own universe.

Both of these conceptual artworks are poetic performances about the roles of identity and perception in a surrounding void where the event is witnessed by others as a specific "happening." They essentially contain an embedded subject, namely, the actor (symbolically, a vertex), along with interpreters who verify the action or non-action from a meta-position outside the field (symbolically, from a higher dimension). In the case of Cage's piece, the artwork was silence, recorded by the memory of others and this text:

four, thirty-three

Note: The title of this work is the total length in minutes and seconds of its performance. At Woodstock, N.Y., August 29, 1952, the title was 4'33" and the three parts were 33", 2'40" and 1'20". It was performed by David Tudor, pianist, who indicated the beginnings of parts by closing, the endings by opening, the keyboard lid. After the Woodstock performance, a copy in proportional notation was made for Irwin Kremer. In it the time lengths of the movements were 30", 2'23" and 1'40". However, the work may be performed by any instrumentalist(s) and the movements may last any lengths of time.

With Klein, the artwork was also ephemeral. He established a ritual involving a "zone" that existed without dimension, which was purchased for bits of gold and then returned to nature—half of the gold was thrown into the Seine River, Klein kept the other half. The buyer subsequently burned his receipt, symbolically returning the artwork to an original state, which in our network of ideas is represented by the zero-dimension. Several of these *zones* were sold by Klein and the events were recorded:

X

At the sight of blackbirds
Flying in a green light,
Even the bawds of euphony
Would cry out sharply.

Every possible buyer of an immaterial zone of pictorial sensibility must realize that the fact that he accepts a receipt for the price which he has paid takes away all authentic immaterial value from the work, although it is in his possession. In order that the fundamental immaterial value of the zone belong to him and become a part of his life, he must solemnly burn his receipt.

Cage's musical composition is an abstraction, allowing space and time to freely intervene upon the audience as a pure experience. Klein established himself as an artist who can create works that may not necessarily exist in space. In fact, he is perhaps most famously known for a black and white photograph where he fully hurls himself from a building. He is seen stretched out, embracing the flight and oblivious to consequence, as if knowing that the ground does not even exist for him (see Harry Shunk, *Leap into the Void*, 1960). Recall the "Jump Program" scene from the film *The Matrix* (1999) where Neo first attempts to leap across two buildings to follow Morpheus. Neo failed in this simulation because he believed that physical rules still applied to him; instead, if he believed this was action in some sort of lucid dream state, freedom from gravity might be attained by sheer will. Symbolically, Klein's *Leap* is also like that scene, but in the photograph, he is captured in midflight. We can assume he is successful, even victorious, because his attitude telegraphs that message.

XI

He rode over Connecticut
In a glass coach.
Once, a fear pierced him,
In that he mistook
The shadow of his equipage
For blackbirds.

Besides "The Immaterial Zone," Klein produced another work, *La spécialisation de la sensibilité à l'état matière première en sensibilité picturale stabilisée*, or simply, *Le Vide* (The Void, 1958). This was an exhibition at Galerie Iris Clert in which Klein displayed no physical works of art; rather, his "composition" involved an empty space, except for a glass cabinet (also empty), with the walls painted white. The gallery "space" became the work of art. This experience was further enhanced by inviting 3,000 Parisians who lined up outside the empty gallery, ushered in by a tuxedoed Klein; from 28 April until 15 May, there were nearly 200 visitors a day. Klein later remarked, "Frequently people remain inside for hours without saying a word, and some tremble or begin to cry."

Zero-dimensional attributes might also apply to mythology and modern cosmology. Geometrically, the vertex is a point with no dimension and therefore it is also the beginning of geometric constructions—since a point is the original state from which all other dimensions and theorems are compounded, these properties might also relate to genesis ideas. For example, briefly consider James Frazer's account of *The King of the Wood*, the "strange and recurring tragedy" of an early priesthood from the legend of Diana of the Wood (Diana Nemorensis).

XII

The river is moving.
The blackbird must be flying.

The myth of this ancient cult tells the story of a central figure who is a priest guarding a sacred tree, the Golden Bough. He remains "king" until replaced by another who assumes the new role, a position attained only through murder. The agonizing ritual revolves around the main subject who exists in this isolated state, devoted to his goddess Diana who will receive him in the afterlife.

Here, in J. M. W. Turner's, *The Golden Bough*, unfolds the ancient myth. Ironically, the painting shows an idealized vision of Arcadia, while in reality the circumstance describes isolation and the tenuous relationship between man and nature:

> In this sacred grove there grew a certain tree round which at any time of the day, and probably far into the night, a grim figure was seen to prowl.... A candidate for the priesthood could only succeed to office by slaying the priest, and having slain him, he retained office till he was himself slain by a stronger or a craftier.... The post which he held by this precarious tenure carried with it the title of king; but surely no crowned head ever lay uneasier, or was visited by more evil dreams than his. For year in, year out, in summer and winter, in fair weather and in foul, he had to keep his lonely watch, and whenever he snatched a troubled slumber it was at the peril of his life.

XIII

It was evening all afternoon.
It was snowing
And it was going to snow.
The blackbird sat
In the cedar-limbs.

fiat lux

Modern cosmology has supplanted creation myths with supporting experimental evidence; although no human witnessed the Big Bang, it has become the keystone of physics' standard model. The "primeval atom" was first proposed by the Belgian priest Georges Lemaître in 1927, and more sophisticated versions of this theory eventually displaced Fred Hoyle's Steady State theory by mid-century. Supporting the Big Bang theory is a substantial body of observational evidence, first and foremost the discovery by Hubble that the universe is expanding. Hubble and other astronomers found that the wavelength of light emitted by receding galaxies was shifted toward the red end of the spectrum, in the same manner that sound emitted by a receding siren is lowered in pitch.

What most scientists now regard as convincing evidence of the Big Bang was provided by the accidental discovery of the cosmic microwave background radiation in 1964 by Arno Penzias and Robert Wilson. That radiation is actually a remnant of the oldest light in the universe, corresponding to a temperature of 2.725 degrees above absolute zero. Thus, we have a concept adjoined by experimentation that supported it. But which came first, the chicken or the egg? Observation or theory? It seems natural to assume that many cultures have historically used similar models without knowing particle physics to describe genesis, and perhaps the "egg" is the same as the "primeval atom." But symbolically, these are both the same as a geometric vertex.

We might regard this initial state of the universe as the "first vertex," a singularity. If, just after a primeval explosion, the universe had a uniform temperature, that is, if it were completely smooth with no variation in structure, matter would not have clumped together to eventually form galaxies, stars, and planets. But our present condition is witness to the fact that the early universe was *not* homogenous. The Wilkinson Microwave Anisotropy Probe (WMAP), a satellite launched in 2001, discovered this early structure in the form of tiny fluctuations generated during a period of rapid expansion, known as inflation, in which the universe theoretically increased in size a trillion-trillion-fold in less than a trillionth of a trillionth of a second. WMAP also discovered that:

- the universe is 13.77 billion years old, to within an accuracy of 0.5%;
- the curvature of space is within 0.4% of "flat";
- ordinary atoms account for only 4.6% of the mass of universe;
- matter not made of atoms, "dark matter," accounts for 24% of the universe
- 71.4% of the universe consists of "dark energy," which also accounts for its expansion

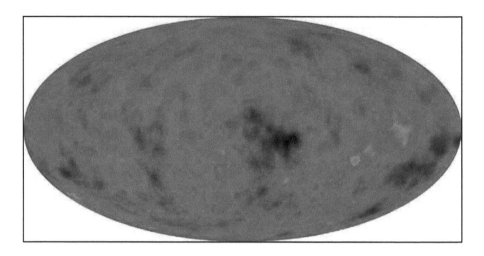

The Big Bang theory predicts that our universe emerged from a singularity about 13.7 billion years ago, and has been expanding ever since…. At first, photons of light were completely trapped by the cloud of hot, charged, primordial matter that made up the early universe. As the Universe continued to expand, it began to cool, and there came a point in time when the interactions subsided enough to allow the light to escape into space. When scientists measure cosmic microwave background radiation they capture a glimpse of the faint "afterglow" of the radiation that initially escaped into space about 379,000 years after the Big Bang and has now only reached the Earth.

In the larger sense, both examples (*The King of the Wood* and the Big Bang) symbolically relate to the zero-dimension because of the geometric meaning for the location of potential space and time. We could regard the ancient priest as a temporary vertex, or the variable "X," knowing that one day another will replace him. And further relating that particular myth to geometry, a "transformation" will inevitably occur that changes his representation (life to death), but not identity (rebirth in an afterlife). For him, like Abbott's Point, there would be limited external sensations and a heightened self-awareness from living at the expense of the outside world.

Unlike historians, astronomers are able to directly look back in time because the oldest objects in the universe are also the most distant, and the radiation they once emitted is still observable, still traveling through space as it has for billions of years at 299,792,458 metres for every second of time. Those distant objects may now be billions of years old but they still appear to us exactly as they were at that historical moment. It is believed that WMAP recorded remnants of the first flex and subsequent ripples of the universe—a "noise" seen as temperature. Cosmologically,

this would mean there was a singularity that contained all potential states of matter and energy in a zero-dimensional space. In other words, like an idealized geometry, a Point where everything came from nothing.

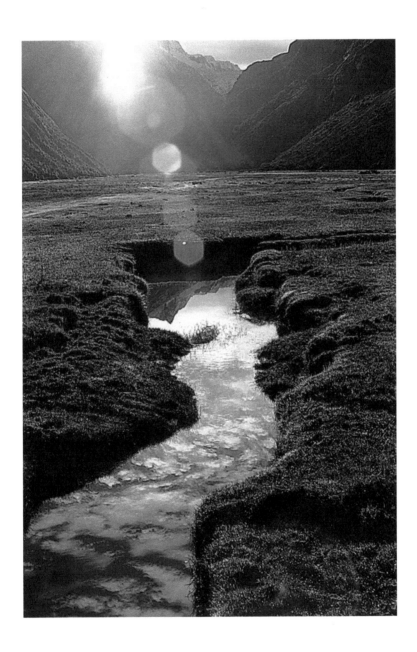

endnotes: *identity of a vertex*

prologue:
Hugh Kenner, *The Pound Era*, University of California Press, Berkeley, Calif., 1971, page 80.

In "The Multi-faceted Blackbird," Peter McNamara suggests the poem is symbolic of Stevens' desire to write about harmony as the collection of vital forces in nature: "The poet emphasizes the importance of delving into life and seeing, understanding, and enjoying it fully. Contrasted here with the majestic mountains, the blackbird seems insignificant; knowledge of even the least significant aspect of nature is, however, the ideal to be realized." Peter McNamara, "The Multi-Faceted Blackbird," from *Critics on Wallace Stevens: Readings in Literary Criticism*, Peter L. McNamara, editor, University of Miami Press, 1972, page 83.

throughout the chapter:
Wallace Stevens, "13 Ways of Looking at a Blackbird." First published in 1917 in *Others: An Anthology of the New Verse* and in the December 1917 issue of *Others: A Magazine of the New Verse*, then included in Stevens' first collection of poetry, *Harmonium* (Knopf, New York, 1923).

Fuller:
R. Buckminster Fuller, *I Seem to Be a Verb: Environment and Man's Future*, 1970.

image:
detail of Venus transit: *"Sequence of images from Solar Dynamic Observatory (SDO) in ultraviolet wavelength of 171 angstroms the Venus transit, merged together to show path of Venus across the Sun."* Credit: JAXA/NASA/Lockheed Martin. On June 5, 2012 at sunset on the East Coast of North America (and earlier in other parts of the United States), the planet Venus made its final trek across the face of the sun as seen from Earth until the year 2117. https://www.nasa.gov/mission_pages/hinode/hinode_transit1.html; https://www.nasa.gov/mission_pages/sunearth/multimedia/venus-transit-2012.html#.VkEl 0mSrRFQ.

special relativity:
Max Planck Institute for Gravitational Physics (Albert Einstein Institute), http://www.einstein-online.info/elementary/specialRT/relativity_space_time.

Bergson:
"Henri Bergson may have been for Brancusi what Baudelaire was to Rodin. Brancusi's art was responsive to the climate in Paris, influenced by Bergson, that saw life as lived in the irrational, expressed in vital urges, and which affirmed intuition as a reliable path to truth." Albert E. Elsen, *Origins of Modern Sculpture: Pioneers and Premises*, George Braziller, Inc., New York, 1974.

élan vital:
Hisashi Fujita, "Bergson's Hand: Toward a History of (Non)-Organic Vitalism," translated by Roxanne Lapidus, *SubStance*, issue #114 (vol. 36, no. 3), 2007, pages 115–130, https://muse.jhu.edu/journals/sub/summary/v036/36.3fujita.html

Einstein/Bergson debate:
Jimena Canales, *Einstein, Bergson, and the Experiment that Failed: Intellectual Cooperation at the League of Nations*, *Modern Language Notes* 120 (2005): 1168–1191.

Les Demoiselles:
Museum of Modern Art Education website: http://www.moma.org/learn/moma_learning/pablo-picasso-les-demoiselles-davignon-paris-june-july-1907.

Duchamp:
Marcel Duchamp, *Nude Descending a Staircase (No. 2)*, 1912, oil on canvas, Philadelphia Museum of Art. Image: Wikipedia. Text from label and painting description on PMA website, http://www.philamuseum.org/collections/permanent/51449.html, and in Ann Temkin, *Philadelphia Museum of Art: Handbook of the Collections* (1995), p. 307.

Boccioni and Bergson:
Marianne W. Martin, *Futurist Art and Theory*, Hacker Art Books, New York, 1978, page 343.

image:
Umberto Boccioni, *Unique Forms of Continuity in Space* (*Forme uniche della continuitá nello spazio*), 1913. Bronze, 47¾ x 35 x 15¾ in. Courtesy Metropolitan Museum of Art/Wikimedia Commons. "As art historian Joshua C. Taylor wrote: 'The figure in *Unique Forms of Continuity in Space* strides forth, a symbol of vitality and strength, yet its impetuous step rests lightly on the ground as if the opposing air gave the figure wings. It is muscular without muscles, and massive without weight. The rhythms of its forms triumph over the limitations of the human stride to suggest unending movement into infinite space.' " (*The Heilbrunn Timeline of Art History*, Metropolitan Museum of Art.)

Poincaré:
He is also quoted in *The Value of Science* (*La valeur de la science* (1905) as saying, "Behold the rule we follow and the only one we can follow: when a phenomenon appears to us as the cause of another, we regard it as anterior. It is therefore by cause we define time." Both quotations are taken from James R. Newman, editor, *The World of Mathematics*, commentary on "An Absent-minded Genius and the Laws of Chance." Simon and Schuster, New York, 1956, page 1378.

Princet:
Arthur I. Miller, *Einstein, Picasso: Space, Time, and the Beauty that Causes Havoc*, Basic Books, New York, 2001, page 101. The quotation is from painter Jean Metzinger.

image:
Expanding Universe, Space Telescope Science Institute (STScI) NASA

four, thirty-three:
John Cage: *four, thirty-three*, http://www.medienkunstnetz.de/works/4-33/.

Klein images and text:
"Transfer of a Zone of Immaterial Pictorial Sensibility [Sensitivity] to Michael Blankfort, Paris, February 10th, 1962."
Left image translation: "14 bits of gold are left. Yves acts on behalf of Nature: 7 bits… and he reserves his part: 7 bits — Michael Blankfort burns his Receipt …"
Right image translation: "Zone No.1, series No. 4 of Immaterial Pictorial Sensibility [Sensitivity] belongs to M. Blankfort and just became a part of him, because … the gold was returned to Nature…"
http://www.yveskleinarchives.org/works/works18_us.html.
Text: Klein Archive, via Thomas McEvilley, *Yves Klein: Conquistador of the Void*, p. 56. Yves Klein Retrospective 1928-1962, Institute for the Arts, Rice University, Houston, 1982.

Le Vide:
http://www.yveskleinarchives.org/documents/bio_us.html.
http://www.academia.edu/2392813/Making_something_out_of_nothing_Yves_Kleins_Le_Vide.
https://imageobjecttext.com/2012/06/01/a-blank-canvas/#more-2238.

image:
J. M. W. Turner, "*The Golden Bough,*" 1041 mm x 1638 mm, 1835. Collection: Tate Museum, London;
Golden_bough.jpgen.wikipedia.org

Frazer:
James George Frazer, "The King of the Wood," *The Golden Bough,* Macmillan: New York, 1922. And
from "The Whitsuntide Mummers," *The Golden Bough*:

> But if these personages represent, as they certainly do, the spirit of vegetation in the spring,
> the question arises, why kill them? What is the object of slaying the spirit of vegetation at any
> time and above all in spring, when his services are most wanted? The only probable answer to
> this question seems to be given in the explanation already proposed of the custom of killing
> the divine king or priest. The divine life, incarnate in a material and mortal body, is liable to
> be tainted and corrupted by the weakness of the frail medium in which it is for a time
> enshrined; and if it is to be saved from the increasing enfeeblement which it must necessarily
> share with its human incarnation as he advances in years, it must be detached from him
> before, or at least as soon as, he exhibits signs of decay, in order to be transferred to a vigorous
> successor. This is done by killing the old representative of the god and conveying the divine
> spirit from him to a new incarnation. The killing of the god, that is, of his human incarnation,
> is therefore merely a necessary step to his revival or resurrection in a better form. Far from
> being an extinction of the divine spirit, it is only the beginning of a purer and stronger
> manifestation of it." (Frazer, *The Golden Bough,* p. 349.)

Eddington source:
http://astro.berkeley.edu/~kalas/labs/documents/kennefick_phystoday_09.pdf.

image and text:
Wilkinson Microwave Anisotropy Probe, WMAP: "This is a map of the universe depicting radiation
produced by the primordial explosion, Big Bang, 13.7 billion years ago. It is a measurement of
temperature fluctuations in the microwave spectrum (20 to 100 gigahertz) showing the cosmos when it
was about 379,000 years old. The temperature at this time is 2.725 degrees Kelvin. The map's color
variations show regions slightly hotter, 0.0004 Kelvin, than the surrounding areas, producing essential
variations in the cosmic structure — future galaxies." NASA photo and caption,
http://map.gsfc.nasa.gov/.

image:
Photograph by Sam Oppenheim, *Cordillera Sunrise*, Cordillera Blanca Mountains, Peru, July 2007.
Artist's remark: "This image was captured while hiking as the sun rose in the high Andes, along a
mountain stream flowing from melting glaciers."

concurrent identities 5

X's voice: *Yet you already know these baroque ornaments, these decorated lintels, these scrolls, this stucco hand holding a cluster of grapes... The extended forefinger seems to be holding back a grape about to fall.*

(This text, offered as an example, happened to correspond to the actual setting used for this shot.) The description should be very anonymous, suggesting the "commentary" in an art film. Then the *you* reappears...

— Alain Robbe-Grillet, *Last Year at Marienbad*

Carte blanche, or "free will," originally meant a signed blank check or document given to another person who fills in any desired amount or action. Today, it defines a discretionary power. In the surrealist painting by René Magritte (1898–1967) entitled *Le blanc-seing* or *The Blank Signature*, he has created a contradiction of imagery that is at once familiar and just as suddenly, unfamiliar—the artist has placed the horse and rider in the ordinary context of a wooded landscape, but with a juxtaposition that is ambiguous and unsettling.

What are the explanations for this uncertainty? Is this event real, a dream-state, or memories? The main subject of the work is actually the rift itself, a type of fractured zone where two distinct spatial media share concurrence. In a sense, it also represents a superposition of moments as the rider both is and is not, appearing and disappearing—perhaps she has the ability to travel at will between the dimensions of ordinary space and time. Her action overlaps with the non-action of the forest, displacing its stillness as a simultaneous event: an actual co-incidence of identities. As Suzi Gablick writes, Magritte's paintings represent the paradox of precision and indefiniteness often associated with modern physics:

> This plural significance of experience, in which spatio-temporal measurement is seen as the relation between observer and phenomena, corresponds to Einstein's theory of relativity in physics, which abolished the 'absolute' space and time of Newtonian theory. Relativity represented the demise of any view of the universe as static and predictable. It represented the shift from a timeless, Euclidean world in which all is precise, determinate and invariable, to a dynamic universe where everything is relative, changing, and in process.

The unfolding woodland scene gives us the feeling that what we are witnessing is commonplace and nonthreatening, an ordinary event like any other. And why should it not be possible? When we recall memories, overlapping images can occur in a single place with a history of several different times; but if this painting recreates a single event when time remains constant, then the disjointed geometry must be a type of hyperspace. A skilled painter can create alternate realities through technique, and Magritte has succeeded in skewing the canvas along with our perceptions. Where dimensional space is usually implied in a painting, the artist here is twisting reality by replacing what we *expect*, based upon experience, with a graphic legerdemain. The occurrence of this phenomenon is counterintuitive and therefore resides in a place beyond the ordinary, an effect also depicted in M.C. Escher's prints *Waterfall*, *Belvedere*, and *Andere Wereld*. Surrealism is a type of carte blanche; it shows the possibility of what was formerly prohibited.

If Magritte's rider is a denizen of this parallel universe, then the artist has cap-

tured her at the transitional moment between states. The forest, horse, and rider are continually pressed back and forth in three-dimensional space by positioning the tree along her right elbow, which is simultaneously in front of, and behind, the central tree that she passes. The horse's rear leg is similarly straddling two spatial levels; furthermore, the reins of the horse are literally broken by the narrow fissure of vertical forest, enabling *this* rider "free rein." With the shifting of visual alignments in the painting, a transformation has taken place in terms of space and time. We could say that *The Blank Signature* is an expression of interdimensional geometry, not unlike a fractal space.

> Abrupt cut: although X and A are still close to each other, evidently at the same place on the screen as in the preceding shot, the scene is now entirely different: a dance in another salon; X and A are dancing and talking together in the middle of a crowd of other dancers, but not too thick a crowd, for the couples are not in each other's way.
>
> A's first phrase sounded as though it belonged to the same conversation as in the preceding shot...

heraldic identity

Historically, shields, banners, and flags were meant to quickly identify a person, clan, affiliation, or country. A country projects its identity through its flag, and in turn the flag is emblematic of that country, serving as a place-marker or representation. The heraldic signature is a specific device of identity, and there is a particular geometry and language associated with coats of arms and badges. As a point of comparison, in this section we will investigate the language and meaning of identity through the device of heraldry, which has many close

associations with geometry not only in terms of design and the coordinate-like system of placement, but also with regard to its specialized terminology and rules for practice.

The shield itself, which is known as an *escutcheon*, displays a family name through the design on the *field*, that is, the ground upon which the *tinctures* (colors and patterns) are emblazoned as a coat of arms—this has been regulated for nearly

900 years. *Blazoning* is the stylized verbal description of a shield's design, usually an anglicized version of Norman French, hence the terms used for color types are *gules* (red), *azure* (blue), and *vert* (green), metals are termed *or* (gold), and *argent* (silver), and patterns, known as *furs*, are the animals *ermine* and *vair*. The blazon is a rigid formula of grammar in describing the features of the shield, such as that of Sir Paul McCartney: "Or between two Flaunches fracted fesswise two Roundels Sable over all six Guitar Strings palewise throughout countercharged."

The *charge* on the field is the shield's main emblem, and its location is described by nine geometric points: the top three positions are named *chief*, the bottom three are *base*; *dexter* is the left side and *sinister* is the right side, from the viewpoint of an observer. It should be noted that from the perspective of the person who wears a coat of arms (and thus owns it), sinister is his left side, because it is attached to him. Thus, a charge from sinister chief to dexter base is a *bend sinister*, a sign of bastardy in the Middle Ages, marking the bearer as illegitimate, not unlike a brand. This sense of ownership is a key concept and all heraldic markings are referenced from the viewpoint of the owner, not the observer. This is equivalent to the reverse orientation of left and right in a mirror reflection, a type of geometric transformation. Thus, *my* shield is a *pre-image*, while an observer will simultaneously see the very same emblem as an *image*, post observation, post reflection, with the orientation changed by symmetry.

The central points, running vertically from top to bottom, are named *honour point*, *fess point*, and *nombril point*. Furthermore, the escutcheon can vary using more than one tincture, thus dividing the field through geometric patterns, known as *party*. Besides party (divided into two sections), the field can be divided into three sections (tierced), four sections (quarterly); it can be radiating (gyrony), have horizontal stripes (barry), vertical stripes (paly), or designed with geometric crosses, chevrons, and lozenges.

In the battlefield, the shield immediately and necessarily identifies the bearer of arms as friend or foe, thus bold patterns, which could be easily recognized at a distance, were favored among early designs. Identity, in the form of a coat of arms, was like a passport and character was assured by the brand of the signature on the field as a representation of the person to whom it was attached. With heraldic shields, an escutcheon is explicitly governed by rules and convention; the same is true in mathematics, which likewise has a particular meaning for both field and identity.

> A (continuing): *Why are you staring at me like that?*
> X does not answer immediately. After another silence he says, in a lower voice:
> X: *You hardly seem to remember me.*
> This is a stationary shot, and after a few exchanges, because of the movement of the couples, X and A have gradually shifted to the background

and soon other dancers come between them and the camera, just when X has spoken his last phrase and as A looks at him with evident astonishment ...

algebraic identity

In abstract algebra, a field refers to a distinct set of elements using the binary operations of addition or multiplication that satisfy axioms of the commutative property, the associative property, and the distributive property. A binary operation maps every ordered pair to exactly one element, like the way "(5 x 8)" maps to "40." To allow for the operation of subtraction, every element in the set must have an additive inverse; for division, there is a multiplicative inverse for every element except zero. Another requirement is that every field must have an "identity element," which in the mathematical sense, like heraldry, is very specific to its function. Any number combined with its inverse will always yield the identity, such as:

$$(7) + (-7) = 0, \text{ and } (7) \times (1/7) = 1.$$

For addition, the identity element is zero because any number added to zero will remain unchanged, and for multiplication the identity is one, because multiplying any number by one also remains unchanged. An identity element is essential in performing mathematical operations and simplifications because it ensures equal values, both before and after the operation. For example, we could consider an original expression, 3, to be like a pre-image having the same value of 3 as its image after a transformation of *multiply by 1* because this particular transformation is an identity movement. More generally, we might say that the number 1 is the identity for multiplication allowing 3 to retain its identity, which is the value of "threeness," throughout the process. Perhaps a better example can be seen with more complicated expressions, where two values may not appear to be the same thing, but actually are; for instance, $\frac{7}{4-\sqrt{2}}$ can be multiplied by one (written as $\frac{4+\sqrt{2}}{4+\sqrt{2}}$), to get an equivalent expression of $2 + \frac{\sqrt{2}}{2}$. That is, both $\frac{7}{4-\sqrt{2}}$ and $2 + \frac{\sqrt{2}}{2}$ have the same numerical value of 2.707106781... because multiplying by one, no matter what form it takes, does not change the inherent value of the original number.

A further stipulation of the mathematical field is that the sum or product, after the operation, must still be in that set—this is known as *closure*. For example, the set of counting numbers is not a field because both inverses are no longer a member of that set: the multiplicative inverse of 2 is ½, and the additive inverse of 2 is –2, neither of which is a counting number.

The simplest field can be constructed with only two elements, such as *a* and *b*, and it will still have all of the necessary conditions, including the identities for addition and multiplication. {0, 1} are the elements of F_2, a *finite field*, which is also known as a Galois Field, named after the mathematician Évariste Galois (1811–1832):

$$0 + 0 = 0 \qquad 0 \times 0 = 0$$
$$0 + 1 = 1 \qquad 0 \times 1 = 0$$
$$1 + 0 = 1 \qquad 1 \times 0 = 0$$
$$1 + 1 = 0 \qquad 1 \times 1 = 1$$

As can be seen from this example, all properties hold for these two elements; they can be combined in any way and the field will always remain closed. Examples of groupings are $(0 + 1) + 0 = 1$ and $(1 \times 0) \times 1 = 0$, but can also include the unfamiliar $(1 + 1) + 1 = 1$. In this field, the implication from $1 + 1 = 0$ is that $-1 = 1$, and from $0 + 0 = 0$ that $-0 = 0$. It also means that $2 = 1 + 1 = 0$ and $3 = 2 + 1 = 0 + 1 = 1$, and so on for any integer. This can be visualized by using a clock with only two positions, 0 and 1. For example, the number 16 is equivalent to 0 and 817 is equivalent to 1, based upon counting as you go around it in one direction. The reverse order gives you opposite numbers: begin at "1" and add "1" will take you to "0" on the clock, and if you begin at "1" and reverse your direction, you still end up at "0".

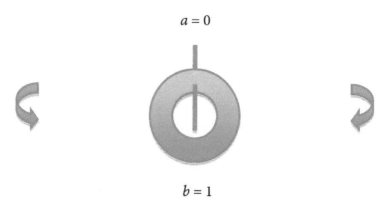

Not only are *a* and *b* set members existing as numbers, objects, and elements, but they can also be *congruence motions*. This is a set of motions that realigns an object after a movement, such as rotating an equilateral triangle, so that its vertices coincide with each other after turning. Unless the original points are labeled, by all appearances it would be impossible to tell if there had been any movement at all. By analogy, the potential alignments of the triangle through time are reminiscent of the concurrence of the rider and woodland in Magritte's painting. We might interpret that scene to be an incomplete congruence motion.

For the equilateral triangle, motion *a* is equivalent to a 120 degree counter-

clockwise turn through its center, and motion **b** is 240 degrees. Thus, if the initial position of a triangle is:

then, after **a**, vertex #1 now coincides with the former position of #3, #2 coincides with #1, and #3 coincides with #2:

If **ab** represents motion **a** followed by motion **b**, then all points will return to their original position, representing the identity, **I**, and **a** followed by **a**, or a^2, is equal to **b**. Thus, a^3 is also equal to **I**. In fact, all members of the set { I, a, b } can be represented by powers of **a**, which makes it a set generator { a, a^2, a^3,...}.

By using particular mathematical conditions, these restrictions are the foundation for number theory, an abstraction that seeks to resolve some fundamental mathematical notions, similar to the deconstruction of the atom in particle phys-

ics. In mathematics, the field becomes a body of work in its own esoteric universe; ironically, the French term for a mathematical field is *corps* and the German word is *Körper*, both of which mean "body," a reference to something that is fundamentally real and organic. Here is a brief list of the different ways that "field" can be used in English:

the field as woodland	copse, thicket, grove, forest
the field as grassland	meadow, veldt, steppe, lea
the field as marshland	swamp, mire, bog, fen
the field as cropland	garden, farm, ranch, pasture
the field as wild	range, prairie, heath, moor
the field as enclosure	non-empty subset, glade
the field as force	vector, matrix
the field as vibration	magnetism, electricity, color
the field as signature	shield, badge, emblem
the field as language	words, sentences, paragraphs
the field as geometry	points, line, planes, volumes
the field as algebra	properties of set elements
the field as architecture	objects, experiences, time

The shot lasts a few seconds more after they have completely disappeared.

It is followed by a more comprehensive view of the room and of the crowd of dancers—a view taken from as high up as possible. A slow, rhythmic but orderly animation is observable, suggesting Brownian movement ...

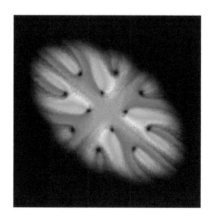

atomism and identity

Whole bodies, like triangles and cubes, can be transformed because they actually contain smaller and smaller parts, being composed of a multitude of points and lines. Each point is given the same instructions to do something, and the aggregate follows. From an atomic viewpoint, physical things are made of discrete and indivisible particles, from which more complex structures can be made because those original particles are the building blocks of matter. Physics has experimentally found evidence for atoms within matter, protons within atoms, and quarks within protons. There is an increasing chain of complexity and it would seem reasonable, at least philosophically, to extend this concept beyond physical things to include those which are not. In fact, we have already seen how Leibniz put forward this very argument in *La Monadologie*.

Historically, this idea can be traced back to the ancient Greeks, Democritus among them, who theorized that nature was made of colliding atoms in a surrounded void. Of course, this was the pre-scientific era of natural philosophy, so these *atoms* (meaning "uncuttable") were elements existing as theory instead of empirically, that clustered together forming substances. It was much later, in 1808, that John Dalton was credited with presenting the first empirical evidence that matter is a composition of other physical elements. In borrowing Leibniz' atomism of consciousness, twentieth century philosopher and psychologist Jean Piaget created a theory of a biological organization that began with the monad concept. As Webster Callaway writes in *Jean Piaget: A Most Outrageous Deception*:

> In the beginning all that existed was the Continuum, Absolute Subject, Group, Field or Form. All of these terms refer to the Primordial Biological System of Monads as the "simple starting point." The "simple starting point ... has a history ... going back to the laws of the Biological Organization." It all started with the "atomic elements" or monads which make up the Absolute Entity with many names, and will end with the same elements forming a completed Biological System.

Piaget seems to be referencing an evolutionary system that successively builds complexity, not unlike a geometric structure that begins with a vertex, or thoughts that are made from monads. It follows that if we can transform a triangle shape from here to there, then we can also map the content of a triangle along with it, especially since those very points are conceptual and theoretically cannot be drawn. To further this interpretation, we could consider that this triangle, like every triangle, has two separate elements that signify meaning: its content and its form.

For example, it is assumed that if we take our geometric triangle and change its position then this same process will also apply to any triangle because that preimage represented all triangles, and it can happen any number of times, because the

transformation is a repeatable operation. Our shape has three sides and three vertices, which makes it a triangle, and it is still a triangle after we have moved it. So on a deeper level, that composite triangle must also have some characteristic which does not change through the process—we might call this an "identity." All of its physical parts have moved but also its non-physical parts have moved with it, providing us with the attached idea of a triangle instead of a square with three sides. There is a combined message that gives it meaning. Therefore, we might say that the triangle can move from one location to another, and with that motion is carried both its form and content, which essentially do not change. By analogy, that particular triangle standing for every triangle is also the result of a symbolic transformation that attached the idea to the shape and the shape to the idea; that action instantly took place in our minds as the surfaced thought, "triangle."

To summarize, here are some observations and theories:

- physical things are made of constituent particles, i.e., quarks
- nonphysical things might also consist of particles, i.e. monads
- geometric things are made of idealized particles, i.e., vertices
- vertices and monads are ideas
- geometric things are both ideas and shapes
- geometric things can be transformed
- transformations illustrate a process that connects ideas and shapes

If we accept all of these conjectures, then what are the roles of pre-image and image? The spoken word, "pre-image," immediately refers to the image as a necessary result of nomenclature; it is grammatically implied that the image already exists. For example, to reflect a triangle you simultaneously place in your mind the shape—this is the pre-image—and the idea of reflection—this is the image—to achieve that result. That is, there is no pre-image without an image, which might be said to hold the content of the form; in other words, the image defines the pre-image in the same sense that a subject might define an object. Likewise, a parallel argument would be that there is no content without form; that is, the triangle idea cannot exist without flat three-sided shapes attached to it.

As already suggested, a broader definition of a transformation takes into consideration those conditions: a transformation is an event where representation can change but not identity. Since we believe that the triangle has the same basic characteristics before and after its transformation, then both the pre-image and image would share the same identity that defines the triangle. This, in turn implies that an identity is transferred in the process. Here, identity is taken to mean the essential characteristic that gives a triangle its meaning in the same manner that any sign is similarly recognized.

However, in order for our triangle to be understood, during the transformation process both the pre-image and image states would collapse into a simultaneity of meaning once either word is spoken. There is the "before-state" that immediately references the "after-state," and that again refers back to the generator of the original transformation, which is checked for truth-value. Again, this same situation is found in heraldry where the holder of a shield is represented by that object's description, which serves as the embodiment of that person. It figuratively reflects him. Thus the message of identity is conveyed to anyone who sees the shield, banner, flag, or emblem. As long as the identity of the transformational subject is returned to the object, and the correspondence is witnessed by others as true, then the composition process can be repeated again and again from pre-image to image, as a symbolic conveyance of information.

Eventually, an instruction is given to the last image, "do nothing," which would also mean "identity" because that is the final position for the transformation. If one individual transformation can take place then others will follow, each time transferring the original identity in a chain of events from A to B to C, and so on. It may have changed its appearance, either by orientation through symmetry, or scale through dilation, or location through translation and rotation, but not its essential character, that is, it is still a triangle. This is true because the assignment of a single part applies to the whole structure:

pre-image ←→ image

- a pre-image exists if and only if an image exists
- an object exists if and only if a subject exists
- a shape exists if and only if its concept exists.

Abruptly: after a climax of the music, cut short at its peak, a silent motionless shot. Five or six men are standing in a row in a shooting gallery. They are no longer in evening clothes, but are scarcely less 'dressed up,' even so (smoking jackets, dark colors). They are facing the camera with their backs to the (invisible) targets. They are standing motionless and rigid, arms alongside their bodies with pistols in their right hands, barrels pointing; their eyes are staring into space like soldiers at attention. No one moves ...

the analogy of quanta

In 1801, Thomas Young devised an experiment to settle a longstanding argument about the nature of light: does it consist of particles or waves? By passing a beam of light through two narrow slits, the captured pattern on a screen seemed to confirm the view that light was composed of waves, evidenced by diffraction patterns similar to those created by dropping two stones into a clear lake and watching the radiating

patterns coincide and cancel. But light can also "choose" to go through only one slit at a time, leaving no wake but a staccato of bunched particles. Physicists have found that experiments to determine either state will obtain results that confirm whichever aspect is sought. In other words, if we ask light to behave as a wave, the experiment will produce that detection, and if we are seeking particles, experiments will verify that aspect as well.

This implies that the outcome is a result of the experiment itself and the questions researchers ask: Will the quantum go left or right as a particle? Or will it pass through the double-slits as a wave? This can create a paradox of time referred to as "reverse causality," which happens when the detectors are changed *after* the quantum has entered the experiment. Like a transformation where the rules change while in the actual process, somehow it will instantly communicate with its pre-image self retroactively and alter its nature, from wave to particle, or particle to wave, according to the changed conditions of the experiment. In other words, a later action can seemingly influence the quantum's original state, reversing the cause ← effect relationship, sharing a similarity in meaning with Carl Jung's acausal connecting principle, the "meaningful coincidence" he called synchronicity.

Attempting to clarify the issue, in 1978 astronomer and physicist John Wheeler created a series of thought experiments (*Gedankenexperimente*), published under the title, *The 'Past' and the 'Delayed Choice' Double-Slit Experiment*. Experimentally, it had already been found that radiation can take both forms, particle and wave, but not simultaneously. As to "when" a particle decides its state of being, his experiment posed the question: "What if the particle was several billions of years old, having departed a distant quasar and is now at this moment being perceived by our telescopes?" Along its journey, it encounters a gravitational lens, such as a massive galaxy, acting as an interferometer in space, essentially splitting the quantum's path into two possibilities, just as in Young's double-slit experiment. Two telescopes could be used to see if the photon travels left or right around the intervening galaxy, as a particle-decision, or through the field thus splitting the beam, which would be evidence of a wave-decision.

Astronomers measuring these effects would be influencing the starlight's decision retroactively, across space and time, because its path had already been decided in the past. The choice of measuring instruments was decided after the inception of photon's journey, yet somehow that decision will still influence its present path, almost as if by instantaneous communication. Whatever is expected experimentally is granted by the quantum and detected as such, as wave or particle; with a delayed choice experiment the detectors are changed once the quantum is in flight, apparently after its state has been decided, yet it would now be observed to behave according to any new conditions. The conclusion physicists have come to is that if wave/particle duality is valid, then a cause can occur later than an effect. The implication is that quanta are capable of paradoxically interacting with each other instantaneously across any gulf of spacetime, sharing information that could only have been gained from a mutual point of origination—Einstein called this effect *Spukhafte Fernwirkung*, "spooky action at a distance."

This phenomenon, also known as the EPR paradox from a 1935 paper by Einstein, Podolsky, and Rosen, continues to be the subject of much debate and investigation by scientists. On December 16, 1997, *The New York Times* reported that a group of physicists in Austria had achieved the transfer a physical property from one particle of light to another, which theoretically could be billions of light-years away. "An entangled pair of particles was created by passing a photon of ultraviolet radiation through a special crystal that split it into two photons of lower energy. These daughter photons sped apart in different directions but remained correlated with each other; their inseparable bond could span any distance. If one of these entangled photons is measured so that its quantum state collapses into a definite property the quantum state of its distant partner will instantly collapse to the opposite form." Although the speed of light is an absolute, it would appear that any message or "text" would be conveyed instantaneously, whatever the distance involved.

Newer models of the universe have attempted to correlate some of these quan-

tum effects by using a cosmology based upon the roles of observers and their action or inaction. In *Einheit der Natur* (1971), Carl Friedrich von Weizsäcker proposed non-spatial bits of potential information as the simplest units in quantum theory, calling them *ur-objects* and *ur-alternatives*, again, reminiscent of the monad. Additionally, the "It from Bit" viewpoint put forward by Wheeler (1990) states that all particles, all entities, result from analysis of binary (yes/no) conditions; that is, reality is determined solely upon information in a participatory universe.

More recently, in *The Grand Design* (2010), Stephen Hawking describes *model-dependent realism*, which is "based on the idea that our brains interpret the input from our sensory organs by making a model of the world. When such a model is successful at explaining events, we tend to attribute to it, and to the elements and concepts that constitute it, the quality of reality or absolute truth." Taking a position similar to Poincaré's assertion that "our mind has adopted ... the geometry *most advantageous*," he further states that the universe can accept many interpretations of observations, each being genuine if connected to rules previously defined in models: "But there may be different ways in which one could model the same physical situation, with each employing different fundamental elements and concepts. If two such physical theories or models accurately predict the same events, one cannot be said to be more real that the other; rather, we are free to use whichever model is most convenient."

As with any written text, there is an associated meaning; similarly, the pre-image and image can represent the coinciding values of shape and content because they also occur simultaneously when there is some type of understanding in our minds. Those linked impressions are not dissimilar from holographic image recordings or sunlight, as each photon carries identical information in the general beam of light from moment to moment as it travels through space. This is why multiple solar eclipse images can be projected through multiple pinpoints in a sheet of paper. Each picture is identical to the others because they all depict the same event carried by the particles. In essence, the whole story collapses into only one particle; from the macrocosm of the sun to the microcosm of a single photon, the transferred message is an encapsulation. By analogy, this is the transformative process of the pre-image and image; like the duality of light, their state remains indeterminate until directly observed, thought of, or spoken about.

If a type of "collapse" represents this process, then what might be some of the broader implications? As a possible answer to this hypothesis, consider *Empire of Signs*, a somewhat fictionalized account of Japanese culture written by the philosopher Roland Barthes. In it, he seems to want to move away from the content and text of Western language in favor of a type of emptiness and stillness that might ideally come from an inner understanding—the message instantly conveyed. He imagines a system in which "the text does not 'gloss' the images, which do not 'illustrate' the text ... each has been no more than the onset of a kind of visual

uncertainty, analogous to that *loss of meaning* Zen calls a *satori*."

Referring once again to Magritte's painting, we might interpret that scene as a type of partial transformation. By comparison, it is also like the ambiguous data held by quanta from a distant galaxy that are billions of years old passing through a gravitational field. In undergoing the transformation, the rider has not fully materialized and if there is some message it remains unclear. In fact, the layered uncertainty of *Le blanc-seing* is a depiction of how complete phenomena from a higher dimension would appear as incomplete emanations to three-dimensional beings—our perceptions are necessarily limited and inaccurate.

For example, if a sphere could pass through a sheet of paper, it would first appear as a dot, then be seen as an expanding circle that then gradually decreases, becomes a dot again, and finally disappears. Its spherical nature would be unknown in that second dimension. A treatment of this concept is found in Abbott's *Flatland* in which a three-dimensional shape explains his true nature to a two-dimensional being:

> I am not a plane Figure, but a Solid. You call me Circle; but in reality I am not a Circle, but an infinite number of Circles, of size varying from a Point to a Circle of thirteen inches in diameter, one placed on the top of the other. When I cut through your plane as I am now doing, I make in your plane a section which you, very rightly, call a Circle. For even a Sphere— which is my proper name in my own country—if he manifest himself at all to an inhabitant of Flatland—must needs manifest himself as a Circle.

While the Flatlander is not easily convinced of this other realm, his realization soon becomes enlightenment. He then tries to convey this to his fellow two-dimensional beings, but is unable to do so, having no ability to indicate the "direction" of

"upwards." His words fail where demonstration would succeed because there is a loss of text.

Just as points make lines, lines make planes, and planes make cubes, what does the cube make? The perception of a sphere in two dimensions is the same as the unresolved transformation of data from some higher dimension to our world such as the hypercube, which can only exist mathematically as an abstraction. A three-dimensional model of it represents a projected shadow of the actual form; and if that other realm is taken to be a source for the "true" nature of things, then those objects, like the hypercube, could be considered archetypes. This idea shares the Platonistic view that abstractions exist which are non-physical and non-mental, like the number 3 representing "threeness," as opposed to the numeral 3, which is the designation of "threeness." This does not imply that hyperspace is the location of those abstractions, for then they would have a physical location. Rather, the archetype interpretation is a metaphor, linking geometry and perception, that somehow familiar things might be broadcast to us from the meta-position of a higher dimension. In the process, there would be a loss of information due to the interdimensional interface. Platonism has also been argued against, with the main reason being that if purely abstract mathematical objects exist, then we, as humans could not attain knowledge of them; however, we do have mathematical knowledge, therefore Platonism must be incorrect.

This may or may not be true, but to continue with our analogy, at the very least we could say that while some transmissions contain incomplete messages, using nonconventional methods to sense that structure or geometry might enhance them. In return, of course, a deeper understanding is revealed. Across the universe, the stories that starlight tell through telescopes are one example of communication that wasn't discovered until the early 1600s, as were the later discoveries of radio waves and other electromagnetic radiation from space. Undoubtedly there are other messages that are present even now, but we can't receive them until a new system is found to sense information differently. Such a case is the gravitational antenna.

By using this technology, astronomers and physicists confirmed for the first time that the universe is a dynamic and flexible fabric whose geometry is warped around massive bodies, and that it is still actively communicating across space and time. On September 14, 2015 an actual message from another time and place in the form of a gravitational wave was detected. A faint rising tone, sounding like a "chirp," was detected by gravitational observatories in Washington State and Louisiana. The discovery of such waves seems to confirm Einstein's general relativity theory and the ideas of later scientists, namely Kip Thorne and Ronald Drever, who first proposed using this instrument. Researchers observed the sound *signature* to be the exact one predicted by theory for heavy masses such as two neutron stars rapidly spinning around each other. In this case, the detected wave was emitted 1.2 billion years ago from two black holes, one of them 36 times and the other 29 times the mass of our

sun, that spun around each other at half the speed of light and 250 times per second. They collided and merged, releasing a huge amount of energy. The boundary where the event occurred created shock waves that literally distorted space and time and that just now has been detected on earth, albeit faintly as the instruments measured a fluctuation of only four one-thousandths of the diameter of a proton:

> Lost in the transformation was three solar masses' worth of energy, vaporized into gravitational waves in an unseen and barely felt apocalypse. As visible light, that energy would be equivalent to the brightness of a billion trillion suns.

While *The Blank Signature* is an artistic statement, it is also emblematic of advances in modern physics, such as quantum mechanics and relativity, that shifted the predominant viewpoint away from a static universe to a dynamic one. An underlying interpretation of the painting is the convergence of space and time currents definable through physics and geometry—Magritte shows just one such possibility from among many chance permutations. The mathematical analog to this work of art would be the result of four-dimensional spacetime vector components at a single point, namely, the convergence of horse and rider with the woods at a specific time. Yet, from our perspective, the woodland event still remains paranormal due to the overlapping artistic imagery.

Yet this feeling should not be unexpected. As Lewis-Williams notes, there is a continuum of alternative expressions among modern humans that dates back 35,000 to 40,000 BP, to shamanistic cultures. Through both biophysical laboratory research and anthropological studies, it has been found that dreams, hallucinations, and visions are naturally occurring phenomena in the human brain, producing visual and aural sensations that are common across many cultures. Altered states of reality produce images and sounds that apparently are universal signatures. These expressions are found throughout the history of modern man, from Paleolithic cave art to contemporary art forms of painting, music, dance, and writing. Currently, archeologists are attempting to reconstruct neurological states as well as artifacts. In all, there seems to be a connection between these trance states and their representations in art, perhaps also unraveling ancient myths.

When walking through the deep woods of the Dordogne, where many of the Paleolithic caves are found, alone with one's thoughts about the past and its link to the present, it is almost possible to open that door and sense a different time. The ruin of Commarque is one such place—a site that has been continuously inhabited for tens of millennia. Passing close by is a trail, marked on trees by small red and white painted stripes, that leads through the Pyrénées to Spain. The surrounding area feels mysterious, ancestral and ancient; through the enfolding density of the trees one seems to glimpse an intermittent light blue haze, like ozone. There is a

slight movement within the stillness of nature. It feels very much like Magritte's painting and at once calls to mind the words of Lewis-Williams:

> Allied to the resolution of such irresolvable oppositions is mystical experience, transcendence, or "Absolute Unitary Being," the sense of being overwhelmed by ineffability and thereby achieving insights into the "mystery" of life but without, necessarily, contact with spirit beings. As Wordsworth memorably expressed it,

<div align="center">

That serene and blessed mood,
In which affections gently lead us on,
Until, the breath of this corporeal frame
And even the motion of our human blood
Almost suspended, we are laid asleep
In body, and become a living soul:
While with an eye made quiet by the power
Of harmony, and the deep power of joy,
We see into the life of things.

</div>

endnotes: *concurrent identities*

throughout the chapter:
Alain Robbe-Grillet, *Last Year at Marienbad (L'Année Dernière à Marienbad)*, Grove Press, Inc., New York, 1962, pages 46–47.

image:
René Magritte, *The Blank Signature,* oil on canvas, 1965. The National Gallery of Art: http://www.nga.gov/fcgi-bin/tinfo_f?object=66422.

Gablik:
Suzi Gablik, *Magritte*, New York Graphic Society, Boston, Massachusetts, 1976, page 123.

image:
Coat of Arms: Coat of arms of Richard de Clare, Earl of Hertford. This file is licensed under the Creative Commons Attribution-Share Alike 3.0 Unported License.
McCartney blazon: International Heraldry and Heralds, http://www.internationalheraldry.com/

Évariste Galois:
Galois (1811–1832) was a French mathematician, known for his contributions to abstract algebra, notably Galois Theory, and his resolution to the historic problem of polynomial solutions. His life was surrounded by political intrigue, imprisonment, and controversy; he died prematurely from a festering wound brought about in a duel. The identity of his opponent remains uncertain.

groups:
Groups and Their Graphs, Israel Grossman, Wilhelm Magnus, The Mathematical Association of America, Washington, 1964, 1992.

fields:
Wolfram MathWorld: http://mathworld.wolfram.com/Field.html and http://mathworld.wolfram.com/FiniteField.html

image:
Bose-Einstein Condensate, National Institute of Standards and Technology, NIST.
"This state could never have existed naturally anywhere in the universe. So the sample in our lab is the only chunk of this stuff in the universe, unless it is in a lab in some other solar system." —Eric Cornell, University of Colorado, July 13, 1995.

Callaway:
Webster R. Callaway, *Jean Piaget: A Most Outrageous Deception*, Nova Science Publishers, Inc., Hauppauge, N.Y., 2001, page 89.

double-slit:
See Richard Feynman's 1964 lecture, "The Character of Physical Law, Part 6" on YouTube, in which he describes the double-slit experiment and paradox.

image:
A gravitational lens is a dense cluster of galaxies positioned between a very distant object and an observer. The light from the distant object (usually a quasar or galaxy) is bent around the dense intervening cluster which acts like a lens. This is because the fabric of space is literally warped by gravitation (quasar5p2_hst.jpg apod.nasa.gov).

Lyre:
Holger Lyre, *The Quantum Theory of Ur-Objects as a Theory of Information*, Cornell University, 1996. arXiv:quant-ph/9611048v1.

Wheeler:
John Horgan, *The End of Science: Facing the Limits of Knowledge in the Twilight of the Scientific Age*, Bantam Doubleday Dell Publishing Group, Inc., New York, 1996, and *suif.stanford.edu/~jeffop /WWW/wheeler.txt*.

Hawking:
Stephen Hawking and Leonard Mlodinow, *The Grand Design*, Bantam Books, New York, 2010, page 7.

image:
Alain Resnais, *Last Year at Marienbad*, film still, 1961. RGR Collection/Alamy.

Abbott:
Edwin Abbott Abbott, *Flatland: A Romance of Many Dimensions*, Princeton University Press, Princeton, 1991, page 73 and pages 93–94.

Platonism, and the epistemological argument against Platonism:
http://plato.stanford.edu/entries/platonism/.

Barthes:
Roland Barthes, *Empire of Signs*, translated by Richard Howard. Hill and Wang, New York, 1982.

LIGO gravitational wave discovery:
Dennis Overbye, "With Faint Chirp, Scientists Prove Einstein Correct," *New York Times*, February 12, 2016.

Lewis-Williams:
The Mind in the Cave: Consciousness and the Origins of Art, David Lewis-Williams, Thames and Hudson, London, 2002, page 290. In November, 2018, it was reported that scientists had discovered the oldest Paleolithic cave art yet. It is located in the Borneo jungle and features the same expressive style and handprints as does Chauvet: https://www.nytimes.com/2018/11/07/science/oldest-cave-art-borneo.html? emc=edit_th_181108&nl=todaysheadlines&nlid=431294611108.

Wordsworth:
William Wordsworth, "Composed a Few Miles Above Tinturn Abbey, on Revisitng the Banks of the Wye During A Tour. July 13, 1798."

image:
Photograph by Sam Oppenheim, *Daisetsuzan Dragonfly*, Daisetsuzan National Park, Hokkaido, Japan, August 2008.

one among many 6

The world is given to me only once, not one existing and one perceived. Subject and object are only one. The barrier between them cannot be said to have broken down as a result of recent experience in the physical sciences, for this barrier does not exist.

— Erwin Schrödinger, *Mind and Matter*

a free translation

Paul Landacre (1893–1963), an artist known for highly detailed wood engravings, developed his talent at the Los Angeles-based Otis College of Art after graduating from Ohio State University, where he was a star athlete on the track team. While in Ohio, he was stricken by an infection that left him permanently disabled, and in moving to California he found the climate both physically and spiritually regenerating. From that time onward, from the 1930s to the 1950s, he became known as a master printmaker and meticulous draftsman who transformed the natural landscapes of the western United States into unique artistic visions. In *The Relief Print: Woodcut, Wood Engraving & Linoleum Cut*, Landacre says:

> The outstanding virtue of a wood engraving perhaps is its strength. The contrast of its strong blacks and whites combined with delicacy of line gives it an infinite range of color and texture. To achieve the particular quality of beauty inherent in the medium of wood engraving one must learn to think in terms of white on black an obvious statement, certainly, but this does not mean a simple, literal reverse of a design conceived in black on white. Until thinking in terms of white on black becomes natural or instinctive like learning to think in another language, the best solution is to make a free translation.... Again, while it is true that slavishly following a pencil sketch in white, line for line, will result in a design, it will be a shallow thing, a sort of negative, and will possess little of the true character or possibilities of a wood engraving.

The line itself, incised into the end-grain of a block of boxwood, is paramount to the process, imbuing the artwork with expressive character. Wood engravings are small, precise, and suffused with compressed energy. The line is responsible for carrying the artist's vision into a two-dimensional expression; multiple lines also create tonality and an illusion of volume, thus extending the image into space.

Since the wood engraving is a relief print, the ink remains on the top surface and every cut line will lie below that plane, remaining white. The black velvety color surrounds the lines and cross-hatchings, giving them depth either in the foreground or background, thus reversing the common notion of writing with a pencil on white paper. The negative space can almost be regarded as antilines comprised of antiparticles. Similarly, we can easily see the line and not-line as a binary relationship, like 1s and 0s used in computer code which determine "yes" or "no" pathways of logic; this, in effect, is symbolic of all oppositional relationships. As Landacre states, "make a free translation" between different structures, languages, and perceptions— this would include the structure of a line itself, which is defined as the "breadthless length" (Euclid) uniquely determined by two points. In turn, those two vertices can represent dichotomies.

The multiplicity of alternating line–space–line–space, etc., in a wood engraving has the cumulative effect of creating a tightly organized field, but within that space there still remains freedom of expression. Landacre was more than a skilled drafts-man because he introduced the indefinable quality of an artistic vision to his work, turning the commonplace into something poetic.

Geometrically, instead of thinking that successive objects, like individual wood-cut lines, are labeled image #1, image #2, etc., is it not possible that given any trans-formation, each image would be instantly reborn as a new pre-image, ready to resume the process indefinitely? Then the entire composition could be considered a summation broken into stages where every successive transformation shifts the original shape along with its concept. This viewpoint would mean that with any pre-image A, the image A' must simultaneously be named a new pre-image after the transformation, because in turn it can make another image from itself when it receives a new set of instructions. And in order to create the next image of A'' then A' must also be a generator—the pre-image for the next transformation. Here, in the grammatical sense, "subject" does the action, such as a geometer whose directions are "reflect a triangle shape," and the "object," or pre-image, receives it. Even if the last stage of the composition remains suspended for the next second or for millions of years, since it has the potential to continue the process, that former image would now be the action's pre-image because it holds information about the original iden-tity and has acquired a form.

This geometric shift acts like a leapfrogging chain of copies that constantly refer back and forth to each other and to the primary pre-image as well. Because this remnant is still extant, but is now more like an ancestral shell, it marks the initial

state of the process and could be considered an archetype for this transformation. Since the pre-image and image are a symbolic weave of form and content, the transformation of physically sliding a triangle from one quadrant to another also carries the signature of that triangle. And multiple compositions theoretically correspond to the recurrence of transforming an identity along a pathway from subject to object to subject....

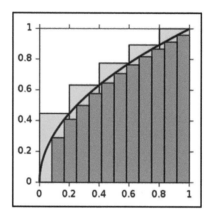

countable and uncountable

There is an explicit relationship between the designation of a geometric dimension and the number of points required to make a form within that space—the description is always one less than the minimum number of vertices. For example, a line is one-dimensional, but at least two vertices are needed to express that idea of linearity. Since geometry is an idealized system, we cannot really draw a one-dimensional line because any ink from our pen will spill into both the second dimension of width and the third dimension of thickness. We can still call this form "a line" because it is structurally defined that way and the shape is referenced in our minds as a particular thing. But the paradox remains that the line also contains an infinite number of points, each being of zero-dimension, that extends indefinitely in opposite directions—again, points that we cannot actually draw—and thus form is created out of nothing, the non-existent "point." A line segment, being only part of a line, contains a point at either end and stops there; however, there is still an infinite number of points between those two end-points as well.

For that reason, a triangle is the most basic of all planar shapes since it can be described by using only three points, any two of which form a line with the third "outside" the boundary of the line, if only by a fractional amount. It has exceeded the first dimension to become a two-dimensional shape by pressing into a new region. Again, there are points between the points on each side of the triangle, with points between all of those points as well. Yet, for the purpose of the transformation

and compositions of transformations, we only need to refer to those three vertices, A, B, C as the pre-images, and A', B', C' as their images after the transformation. As already mentioned, all of the rest of the points, those lying along \overline{AB}, \overline{BC}, and \overline{CA} will follow the same instructions of the transformation process, carried along as a group like the bundled contents of a suitcase. We can count the three vertices that make a triangle, but can we count all of the points between those points?

This question is related both to the number of elements, or size, of a given set, called the *cardinality*, and the idea of *infinity*. A finite set such as {23, 37, 16, 88, 9} is countable, having five elements, and thus a cardinality of 5, because there is a one-to-one correspondence with the set {1, 2, 3, 4, 5}, each matched with exactly one partner until they are all used and none are left behind:

$$1 \to 23, 2 \to 37, 3 \to 16, 4 \to 88, 5 \to 9$$

It should be noted that the sets are *equivalent* because they have the same cardinality, but not *equal* to each other since the individual elements are different. But how many counting numbers are there? Since there is also a one-to-one correspondence between the sets {1, 2, 3, ...} and {1, 2, 3, ...} they are equivalent, having the same cardinality, which is defined as *aleph-null*, \aleph_0, the smallest version of infinity; and so the set of numbers, $N = \{1, 2, 3, ...\}$ is countable but still infinite. The answer to "How many?" is "There are \aleph_0 of them." Aleph-null is considered to be a different type of infinity, one that is countable.

Surprisingly, the set of whole numbers, $W = \{0, 1, 2, 3, ...\}$ contains the same number of elements as $N = \{1, 2, 3, ...\}$ because there is still a one-to-one correspondence between them:

set N		set W
1	\to	0
2	\to	1
3	\to	2
n	\to	n − 1

Even though set W contains one more element (the number 0) than N, and intuitively should therefore be larger, in fact they both have the same cardinality of \aleph_0, since they have a one-to-one correspondence. That is, $\aleph_0 + 1 = \aleph_0$. The same matching of pairs can be also proven to be true for both the set of integers, Z =

{... -3, -2, -1, 0, 1, 2, 3, ...} and the set of rational numbers, $Q = \frac{p}{q}$, where p and q are integers. All of those sets are countable, containing the same number of elements, aleph-null.

However, as Georg Cantor (1845–1918) proved in 1874, counting numbers, like 1, 2, 3, cannot be mapped to real numbers, which include irrational numbers like π and $\sqrt{2}$, because the *uncountably infinite* set of real numbers is "larger" than the *countably infinite* set of natural numbers. He showed there are different sizes of infinity by looking only at part of the number line, between zero and one, in the same manner as a geometer might attempt to count the number of vertices between two endpoints of a line segment. As we shall see, his innovations in mathematics led to set theory, which, like poetry or art, is meant to symbolically fuse the parts and the whole, by potentially presenting a larger vision of the world. In essence, this idea is encapsulated by something that Cantor himself said: "A set is a Many that allows itself to be thought of as a One."

Imagine a microscope that enlarges a number line between zero and one, showing only a view of the decimals between 0.25 and 0.75 with 0.5 in the middle. Numbers like 0.26967400811... and 0.28399760017... would now be in that field of vision. But there are still numbers between those, so another close-up view would be needed to show 0.27883400765... and 0.28396653078... To make a general argument, the list of decimal expansions could be written as $0.\ a_1,\ a_2,\ a_3,\ ...\ ,\ 0.\ b_1,\ b_2,\ b_3,$ $...\ ,\ 0.\ c_1,\ c_2,\ c_3,\ ...$, etc., with each decimal corresponding to a counting number, and each digit from the set {0, 1, 2, 3,...9}. If every real number in the interval from 0 to 1 can be found in the list, then they would be countable, even if infinitely so, because each number would correspond to a partner with the set of **N**, having cardinality aleph null.

Cantor's proof *assumes that every decimal is in the list*. But if we can find at least one decimal that is not on the list, then there is a contradiction, because there is no longer a one-to-one correspondence with the counting numbers, which would mean a different cardinality. Here is just one example of Cantor's "diagonal argument," where *n* is a counting number that is mapped to a corresponding decimal, a function of *n*:

n			$f(n)$
1	←	→	0.3141592653...
2	←	→	0.3737376737...
3	←	→	0.1428571428...
4	←	→	0.7071067811...
5	←	→	0.3752000009...
.			.
.			.
.	etc.		.

Suppose every decimal is in this list. On the diagonal line where the first decimal in the first row and column is highlighted in red and the second decimal in the second row and column is highlighted, etc., {a_1, b_2, c_3, ...}, is the number 0.37210... If we make some arbitrary rule such as "add or subtract 1 to each of those digits" (it could be any number or any rule), we obtain a number that cannot be found in that table of numbers, no matter how far down the list we go. By our rule we have created a new decimal, $K = 0.k_1 k_2 k_3 ...$, where $k_1 \neq a_1$, $k_2 \neq b_2$, $k_3 \neq c_3$, ... etc., that differs in at least one digit from any others on the list because *we have changed all of the original numbers*, both going down the list and to the right.

By adding +1 to each digit of our original number 0.37210 ..., we obtained a new decimal 0.48321 ..., which cannot be found in the list because it differs from the first decimal in at least the first digit, from the second decimal in at least the second digit, from the third decimal in at least the third digit, and so on. Even if we looked at the 10,279th digit of the 10,279th decimal on our list, by our rule it would also have been changed from its original value in creating our new decimal. The beauty of this construction is that we don't need to write an infinite list of decimals to prove that there is no relation between our new number, $K = 0.48321...$ and a counting number, like 10,279. Cantor's contradiction proved that there can always be found another number in this list that has no corresponding partner, and thus the infinity of real numbers between zero and one exceeds all of the counting numbers.

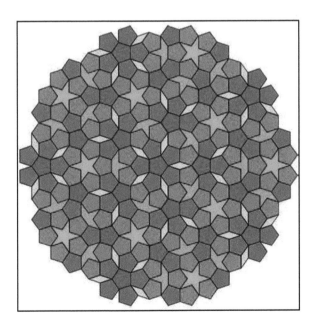

complementarity and signs

Although lines, planes, and volumes are composite structures, each made up of an infinite collection of points, only two vertices are actually needed for practical depictions of line segments, three for planes, and a minimum of four points to delineate a volume in space, like a pyramid. Yet, knowing this, there remains an obvious disconnection between the physical action of constructing a whole triangle using only three points and three lines, and the abstraction of its parts, namely, the uncountably infinite number of points between those very same endpoints. A striking conclusion is that mathematically the cardinality of points in a triangle, large or small, is the same as the set of real numbers because the triangle's edges are line segments, representative of the kind of infinity that Cantor proved was a size larger than aleph-null. Thus, infinity, like the vertex, is a concept, not a substance, but nevertheless it can still be represented in our world by the symbol ∞. And just as geometry is progressively built from elementary vertices, axioms, and theorems, physical matter is also comprised of aggregate pieces, ever smaller and smaller, as famously observed by Jonathan Swift:

> So, naturalists observe, a flea
> Hath smaller fleas that on him prey;
> And these have smaller still to bite 'em;
> And so proceed *ad infinitum.*
> Thus every poet, in his kind,
> Is bit by him that comes behind…

Presently, the most widely accepted theory of physical structure is the standard model, which seeks to explain how the building blocks of matter interact with the forces of nature. This theory is supported by empirical evidence that seems to confirm it on every level except for the most basic force that we all encounter, gravity, which remains unexplained. According to the model, there are two basic types of matter, quarks and leptons, with each type consisting of related pair generations, based upon how stable they are in the world. Quarks combine, or "mix," according to their "color"; leptons either have an electric charge and significant mass or are neutral with very small mass:

3 PAIRS OF QUARKS

1st generation: lightest, most stable	*up* quark, *down* quark
2nd generation	*charm* quark, *strange* quark
3rd generation: heaviest, least stable	*top* quark, *bottom* quark

1st generation	*electron*	*electron neutrino*
	charge and mass	neutral charge, little mass
2nd generation	*muon*	*muon neutrino*
	charge and mass	neutral charge, little mass
3rd generation	*tau*	*tau neutrino*
	charge and mass	neutral charge, little mass

These two groups of six elementary particle pairings combine with force-carrier particles, or *bosons*, which act as a relay between the quarks/leptons and the four fundamental forces. They transfer discrete amounts of energy by exchanging bosons with each other:

- the strong force is carried by the *gluon*
- the electromagnetic force is carried by the *photon*
- the weak force is carried by the *W* and *Z bosons*
- the gravitational force is carried by the hypothetical *graviton*

In particle physics as with number theory there are fundamental units or essential concepts that constitute nature, and the interpretation of those components forms a vision of the larger whole. This is also true in geometry where axioms are elementary "observations," assumed to be indisputable; yet, that basis in turn creates an idealized approach to objects and the ideas about them. We are often left to wonder whether truths are discovered and therefore inherent to the universe, or manufactured by human minds to conform to a predetermined model. Essentially, the analytic process is what fosters new knowledge; that is, the deconstruction and re-assembly of those pieces (triangles, text, history) is an attempt to replicate the original structure, as with a subatomic particle accelerator, or to create a new one, as with a network or a philosophy.

This idea calls to mind Eadweard Muybridge's photographic studies of motion in the 1870s and 1880s, which resulted in proving that all four of a horse's feet leave the ground at once, a hotly contested issue at that time. The artist broke the fluid motion into a sequence of single photos by using twelve cameras at once, and then reassembled the frames to show the running horse. From an atomic point of view, he deconstructed an action into its constituent parts. From a mathematical point of view, the racing horse was separated into discrete units, each representing an arbitrarily small change in the function. In a certain geometric sense, Muybridge recorded a composition of individual transformations—the whole picture was resolved from the summation of moments.

Parallel to this notion is the construction of a sign, or unit of perception, which

could also be considered a type of transformation. According to semiotics, the theory of signs and symbols, perceptions are made of complex associations blending content and expression in the same manner that words have both denotations (a literal/objective meaning) and connotations (a suggestive/subjective meaning). That compound structure carries what Roland Barthes describes as the "iconic message." As we have seen, by naming an entity pre-image, it necessitates that there also exists an image, and to borrow a term from semiotics, they are joined in a mutual relationship as *relata*. Since all representations are made of unique associations, objects cannot exist without an attached idea, and no abstraction, like a memory, can stand without a tangible reference in place and time. As intervals of thought become smaller and smaller they might theoretically approach the monad level, and an approximation of the units develops a bundled package based upon the original content and form. Like Muybridge's horse, the compound structure of reassembled elements delivers the true message.

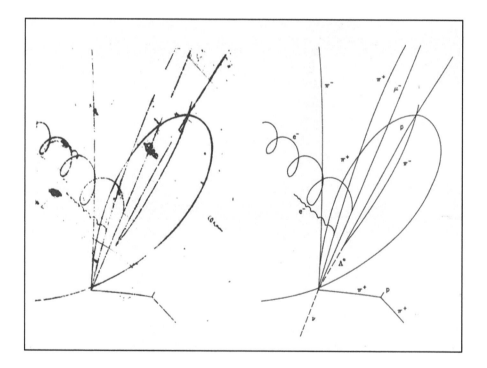

Using geometric transformations as an analogy, we could say that messages received in our minds are the result of the combined action of relata, form and content, as pre-image and image. The triangle signature comes from its three-sidedness and the attached idea that defines it, which in a sense was the composition of those two elements. Further, impressions from the aggregate sign would be complemen-

tary and reliant upon reciprocal characteristics, such as contrast and comparison, whether present or absent as affinities or dissimilarities, and therefore could also be considered undefinable by themselves. Symbolically, they are like two opposable vertices of a line segment that are in relation to each other by the edge that connects them as context: there is a dichotomy in terms of nomenclature (pre-image/image), usage (before/after), and message (form/content).

These dualities mutually define each other and, like photon-pairs, might be considered inseparable and entangled, sharing the same reciprocal properties as quanta. As Werner Heisenberg showed in 1927, it is impossible to accurately determine both an atomic particle's position and momentum. Its hybrid status is conjoined, and only determined *a posteriori* through observation. The following year Niels Bohr made the general observation that Heisenberg's uncertainty principle is an example of the *complementarity* of nature: an experiment which illuminates one aspect, such as position, will simultaneously obscure its complementary aspect, momentum.

As a geometric example, a triangle's reflection from one place to another requires a reference in time: before the transformation and after; but during the process it might be in both positions at once, because the triangle is acting as both pre-image and image until resolved. To clarify, consider the questions, "If I say 'pre-image,' when does the 'image' begin to exist?" and "When does that transformation take place, once the directions have been assigned to the pre-image?" Both answers would seem to be "immediately," because even thinking "transformation" will initiate the process, which can be seen as a mental picture with information about its beginning and ending. And the whole meaning of the triangle is delivered at once with that thought and those instructions separate from physically moving it; merely stating "pre-image" will simultaneously create "image," even without describing its future location. Our statement, "reflect a triangle," implies that before a transformation the triangle's identity is somehow contained in the pre-image because it was essentially known to be a triangular shape, and we can expect an image of it to be made afterwards also holding those same basic characteristics.

Bohr's complementarity describes systems whose undisturbed behavior cannot be separated from their interactions with the measuring instruments revealing their behavior. In the case of signs, that measuring instrument is our observation of the form that is connected to a meaning. With geometric transformations, the pre-image and image are immediately entwined throughout the process, which results in changing their representations in space and time, but not the constant identity. For radiation, complementarity refers to the split personality of light which exhibits both wave and particle characteristics. Once you measure its nature, the duality collapses into that selected aspect, after the light has been collected. But it could also be argued that there should really be no distinction among relata at all, because they are always taken together, as a bundle—the pre-image and image are really the same

thing, just temporarily separated for the purpose of analysis. To paraphrase, all these binary relationships seem to share a common origin that was perhaps best expressed by Richard Feynman:

You can't say A is made of B or vice versa. All mass is interaction.

In Saussurean terminology (named after the Swiss linguist Ferdinand de Saussure), the classification of signs has two related components: the signified concept (*signifié*), and its representation, the signifier (*signifiant*). Together they act to give meaning to a thing, to signify something through both its idea and shape, and there is a mirror-like imagery of words here, both containing the same root meaning, "sign." They describe a physical form that is a reflection of an inherent content, which likewise refers back to the form, endlessly shifting the "meaning" back and forth. There are more geometric connections: a pre-image is like the initial representation of the triangle, which is attached to its concept, the image, and together they construct the characteristic signature of the triangle that we recognize at once. With regard to Magritte's painting, *Le blanc-seing*, how do we relate this philosophy to a "blank signature"? As an incomplete message, or the power to be any thing, with different interpretations and meanings? Perhaps the artist was not aware of these underlying concepts, but his "sign," the painting itself, clearly stands for something other than the assembly of mixed pigment over stretched canvas.

In the *Course in General Linguistics*, a series of lectures at the University of Geneva (1907–1911), Saussure further detailed his ideas about the structure of language. He stated that not only is the sign dyadic, it is also:

- arbitrary—the signifier is joined to the signified without reason
- relational—the sign must operate relative to other signs in the same system
- differential—defining things by what they are not as opposed to what they are

But these terms can also apply, at least abstractly, to geometric transformations. The pre-image and image must likewise be joined "without reason," because their existence is automatic and takes place once a transformation is thought of; furthermore, there is no special case for particulars, which means *any* vertex can assume the role of pre-image as an arbitrary choice. Once joined, two vertices form a line segment that immediately creates a partitioned relationship between them. This, in turn, is just part of the geometric system of shapes and ideas that is dimensionally built by joining points, lines, and planes, to make volumes. This pairing creates a spectrum of values, a sliding scale to either vertex that also contains all of the points between points, which are themselves defined by their positions relative to the endpoints. Along this segment, relational judgments about perceptions can symbolically define two contrasting elements by degrees of similarity or equivalence, such as whether or not "harmony" is associated with "symmetry":

non-symmetry point ⟵——— **"harmony"** ———⟶ **symmetry point**

It could also be said that the signature, "tree," is this entire linear pathway, which can be represented by a transformation that coincides pre-image and image, denotation and connotation, shape and idea. The perception of "tree" would be like a single vertex resulting from the linear collapse of both endpoints at once, as if they each instantly roll up and become the inseparable sign labeled in the middle, recognized as something familiar:

the tree form ⟵——— **"tree"** ———⟶ **the tree content**

To summarize, it can be shown that there is a similarity among several varied concepts, all broadly associated with geometric transformations because they share some of the characteristics of complementarity. By analogy, the symmetrical structures of identity, language, signs, and perceptions could be viewed as "unbroken" until investigated, all exhibiting reciprocal characteristics. They are dynamic, inbuilt, and potentially endless as a series of "compositions." As William James wrote in *The Stream of Consciousness*, "Every definite image in the mind is steeped

and dyed in the free water that flows round it …"; furthermore, the consciousness of that "halo of relations" he called "psychic overtone," or "fringe." His description involves a relationship between things, even non-material ones, and their attached meaning—symbolically, this can be compared to the relationship between a pre-image and image in terms of an external phenomenon, or object, and the presentation of its content, or subject-matter. With this interpretation, the overarching question might be to ask whether an object can precede its associated meaning and, if not, then how could a concept come first, as a pre-image without reference to any originating entity?

One way around this paradox, similar to the long-standing question of *the chicken or the egg*, would be to say that form and content appear simultaneously, but only as the result of a collapse in the sequence once investigated. Given that philosophy, there is some merit in exploring the idea of a geometric transformation which begins with a *form* that is somehow primary, as the original "entity," "unit," "expression," or "being" that embodies an object—it might exist independent of observation. By extension that object, or pre-image, is a formal denotation of thought, as opposed to the image—an equivalent reflection of the object—which contains all of its conceptual associations. In this sense, the image is a subject that is capable of transferring content back to the object as an artifact that connotes a message, rather than creating the material text itself. There is an overlapping of value that superimposes meaning through the properties of objective things and their subjective context. To continue this line of reasoning, if the pre-image can stand for any object, then it is like a signifier and the transformational image is like a subject, or signified concept. Both pre-image and image remain unresolved until we describe a transformation and speak their names: pre-image and image. Together, their composition is a recognized sign. In most respects, the words listed here have been historically used for each category, but not necessarily associated with geometric transformations. Furthermore, it could be argued that by common use, some are interchangeable, particularly within the groups of external properties such as "shape," "representation," "form," and internal properties such as "idea," "concept," "content." There is an implied correlation across each row to illustrate an equivalence:

GEOMETRY	IDENTITY	LANGUAGE	SIGN	PERCEPTION
(set of points)	(character)	(message)	(construction)	(meaning)
pre-image	object	denotation	signifier	representation
image	subject	connotation	signified	concept

sensing geometry

Walking in everyday life is also like a sequence of transformations, but we are generally not conscious of that fact, nor does its knowledge make any difference to our progress. The brain keeps sending signals to muscles along neural pathways until you decide to stop. When you walk along a straight line, how long will it take to make that journey? The time required is the total distance traveled divided by your speed; if the distance is increased and the speed remains constant, then the trip will take longer. And if you only go half-way to your destination in successive intervals, that is, half-way again, half-way again, etc., then theoretically, it will take an infinite amount of time—but practically speaking, of course the end will be reached. For those same reasons, our walkable line is not really a one-dimensional structure contained in a plane that is two-dimensional. It is three-dimensional and so is the traveler who moves through time, which means that the event happens in four-dimensional spacetime. The actual geometry is conceptual, but we sense it as an everyday occurrence.

Therefore, we are detached from both the word "geometry" and its meaning, the definition and its practical use. How much time would it take to cut a series of fine lines as Landacre did? Or to traverse their individual pathways just by sensing their particular arrangement? That trip takes place without walking because the artwork, made of many lines, delivers an understanding of relations within the viewer as set forth by the artist. Each directed line is like a singular intention, with the assembled result being different for each observer. The structure of associations, taken as a whole, is greater than the total sum of individual lines, and this differentiates artwork from illustration: its value is recognized as the larger collection of multiple viewpoints that can effect a transcendent feeling in the individual ... a transformation of senses.

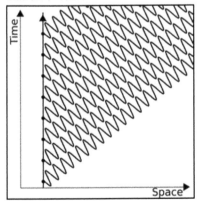

As previously described, geometric dimensions are successively built by the selective placement of new vertices outside their original boundaries. It is also possible to classify those geometric dimensions according to some of their subjectively chosen characteristics and group them together, such as the zero-dimensional network of affinities. It is suggested that when the structure increases, so does the complexity of associations, and it will continue to evolve this way until becoming dense enough to be simplified:

singularity = timeless location = idea = monad = identity = vertex →
2 connected vertices = line = duality = relation (time begins) →

3 connected vertices = plane = complexity = function →
4 connected vertices = volume = unity = synthesis →
more vertices = hyperspace = unknown multispatial and temporal properties

But once again, where does this construction end? The hyperspace exists abstractly but physically cannot be directly experienced. We have also seen that, historically, these higher dimensions have been viewed as a spiritual realm or the theoretical location of archetypes projected to our world; these emanations would be witnessed in three dimensions only as shadows.

These interpretations share some of the same ideas found not only in Platonism but also the Indian Upanishads, or ancient Vedic text from which sprang Hinduism and Buddhism. Reality, illusion, and the unity of the world and consciousness, are described as different aspects of the One, i.e., Brahma. As Vedic scripture describes it, "The mystic meaning (upanishad) thereof is the 'Real of the real.' Breathing creatures, verily, are the real. He is their Real" (Brihad-Aranyaka. 2.1.20). And further, in Maitri 6.3 and 6.15, "There are, assuredly, two forms of Brahma: Time and the Timeless. That which is prior to the sun is the Timeless without parts. But that which begins with the sun is Time, which has parts. Now, that which is the formed is unreal; that which is the formless is real." Formless, that is, like a mathematical idea without time and space, existing as location for potential structures to be built—this describes a geometric vertex.

According to this philosophy, nature is split into two realities but is actually reconciled as one completeness, one basis: "the real" is the familiar world, comprised of illusory phenomena, and "the Real" is a transcendental state. As Robert Hume notes in his translation of *The Thirteen Upanishads* (1921), "That is the real Brahma, the undifferenced unity. The lower Brahma of sense-manifoldness, in which everything appears as a self-subsistent entity, is merely an appearance due to a person's ignorance that all is essentially one." Pure thought, as Brahma, is not an attribute of reality, but rather is its principle substance, leading to the concept of the universe as a living brain, organic and not mechanical.

$$H(t)|\psi(t)\rangle = i\hbar\frac{\partial}{\partial t}|\psi(t)\rangle$$

Although the Upanishads are ancient (~1000 BCE) religious scriptures, their philosophical influence continues to be found across many other disciplines. Erwin Schrödinger (1887–1961), the Nobel Prize-winning quantum physicist who is best known for his pioneering work in wave mechanics, wrote a surprisingly introspective and philosophical work, *Meine Weltansicht* (*My World View*), in which he upholds some of those same ideas. In the section titled "In Search of the Way" (written in 1925), Schrödinger attempts to correlate the philosophy of Vedanta with some of the issues raised by quantum mechanics, mainly how multiple viewpoints can influence the outcome of events, such as position and momentum:

> [T]he plurality that we perceive is only an appearance; it is not real. Vedantic philosophy, in which this is a fundamental dogma, has sought to clarify it by a number of analogies, one of the most attractive being the many-faceted crystal which, while showing hundreds of little pictures of what is in reality a single existent object, does not really multiply the object.

Perhaps based upon these ideas, he later proposed a hypothetical experiment in which a cat is placed in a windowless box with a lump of radioactive matter that has a 50% chance of emitting a particle in a one-hour period. When the particle decays, it triggers a Geiger counter and a hammer smashes a flask of poison gas, killing the cat. Quantum mechanics dictates that after one hour, if no one has looked inside the box, the radioactive lump is both decayed and undecayed, and the cat is both dead and alive—a simultaneity of parallel and indistinguishable states. Since, as we saw earlier, recent experiments have shown that light will be forced to choose between

going through a single slit or double slit depending on the experiment, physical phenomena may somehow be defined by the questions we ask of them. Quantum interactions are neither waves nor particles but are intrinsically undefined until the moment they are measured, existing in a state of superposition where time extends indefinitely.

In *Schrödinger: Life and Thought*, Walter Moore writes:

> Here [in "In Search of the Way"] Schrödinger attempts to find a solution to the problem raised by the spatial and temporal multiplicity of observing and thinking individuals. Vedanta teaches that consciousness is singular, all happenings are played out in one consciousness only, and there is no multiplicity of selves. Schrödinger does not believe that it will be possible to demonstrate this unity of consciousness by logical or rational argument; in order to reach any understanding of it, one must make an imaginative leap, guided by communion with nature and the persuasion of analogies.

fractal dimensions

Not unlike the Vedas, included in Euclid's *Elements* are axioms, or "common notions," that are less about geometry *per se* and more related to a description of nature in an almost metaphysical sense, dealing with the larger questions of phenomena and reality:

Things which are equal to the same thing are also equal to one another.
If equals be added to equals, the wholes are equal.
If equals be subtracted from equals, the remainders are equal.
Things which coincide with one another are equal to one another.
The whole is greater than the part.

It is true that when atoms are split into quarks, their constituent parts and energies can be reconstructed as interactions—but have all the visible and invisible pieces been accounted for? In the macrocosm, when things such as trees, which are made of those same quarks, are broken down, examined, and reassembled, the whole of their "treeness" exceeds the sum of all the parts because that description holds many additional meanings. Along with its inherent physical structure, there are attached subjective associations, memories, and hitherto unknown unique connections that go beyond scientific analysis made in that very moment and perhaps not ever duplicated again. For instance, in recounting the history of a certain tree during a certain spring there may have been a type of fungus in the root system which later disappeared, or a bird that nested there and later moved on after her eggs hatched, leaving no trace of their presence. Ideal tree descriptions may vary among individuals, but its representation in a forest is undeniably equivalent to its name "tree," along with any symbol meant to convey that meaning. While there may be variability with external descriptions, the tree itself nevertheless remains in the woods with its internal identity unchanged. This concept can be seen in the misnomers of "morning star" and "evening star," which the ancients believed to be two separate entities, appearing just before dawn in the east and just after sunset in the west. In fact they are both the same thing, namely Venus, which is not a star, but the second planet from our Sun. It existed before humans named it, and its name is arbitrary.

But there are also certain shapes in nature that are called self-similar because they contain identical smaller copies of the larger shape or organism, such as the proportional size of each chamber in a nautilus shell as it spirals outward. This is a type of embedded structure, a form within a form. When a shape is self-similar, each part is a likeness of the whole figure; in other words, its growth is a self-contained transformation. It can be statistically similar, such as an island's coastline, or exactly self-similar, which would mean that it is scale-invariant—at any level of magnifica-

tion, there are duplicate images of its self. Examples of this natural structure are found in geometric fractal patterns.

We can also see this embedded structure in the infinite "nested radicals" shown

here: $\sqrt{1 + \sqrt{1 + \sqrt{1 + \sqrt{1 + \sqrt{...}}}}}$ Because this expression is self-similar, we can

represent it like this: $x = \sqrt{1 + x}$, and squaring both sides it becomes $x^2 = 1 + x$. Solving this equation is simple with the quadratic formula—and we have already seen this before! The solutions are $\frac{1 \pm \sqrt{5}}{2}$; in other words the Golden Ratio, φ and its negative reciprocal, $\frac{-1}{\varphi}$. This further illustrates why that particular mathematical constant is prevalent in natural forms and at the same time also related to the recursive mechanism of the Fibonacci sequence, an iteration that feeds the next number by adding the previous two values, extending indefinitely.

In the strict sense, a *dimension* is the number of parameters required to locate a point within that given field. It is an extent, a measure of where and when. Mathematically, it is also the exponent for length, area, and volume. For example, the number of units in an 8 x 8 grid is the same as its two-dimensional area, which is 8^2 = 64; here, the exponent of two describes a planar surface.

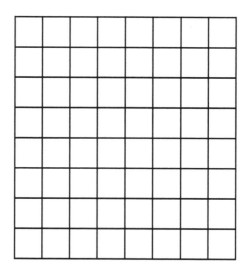

An example of three dimensions would be the exponent to find volume = 8^3, representing 512 individual self-similar units within this cube:

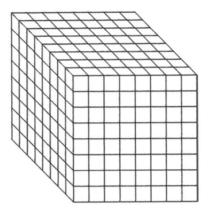

Using logarithms to rewrite the equations, $8^3 = 512$ becomes $3 \log 8 = \log 512$, or $3 = \frac{\log 512}{\log 8}$. In general, the dimensional state equals the log of the number of self-similar pieces divided by the log of the number of subdivisions along one edge. Felix Hausdorff (1868–1942), is credited with this evolved definition of a dimension, and it is especially useful when describing more exotic geometries:

$$D = \frac{\log N}{\log \frac{1}{r}}.$$

The Hausdorff dimension is D, where N is the number of self-similar pieces, and r is the ratio of the lengths of each part to the whole; that is, the ratio of each transformational image length to the length of the transformational pre-image. In the above example, the larger single cube was transformed into 512 smaller images, each similar to the pre-image, by a scale factor of 1/8 for each side. A second transformation would create 512 more images for each of those 512 cubes generated in the first event. Now the number of self-similar pieces is 262,144 and the original edge has been divided into 64 parts, which still has a dimension of 3: $64^3 = (512)(512) = 262,144$, and so on, with the next transformation yielding 134,217,728 smaller cubes. This process, of course, is only limited by the ability to physically draw the cubes, but not mathematically.

The question, "How long is the coast of Britain?" was answered by Benoît Mandelbrot in 1967 with his paper on statistical self-similarity and *fractals*, a term he invented to describe fractional dimensions, such as those between one and two. He found that as the length of the measuring instrument decreased, any irregular shape's length simultaneously increased. Nature produces rough surfaces, not smooth, and in the case of Britain, or any island for that matter, its perimeter will be infinite, but surrounding a finite area:

Geographical curves are so involved in their detail that their lengths are often infinite or more accurately, undefinable. However, many are statistically "self-similar," meaning that each portion can be considered a reduced-scale image of the whole. In that case, the degree of complication can be described by a quantity D that has many properties of a "dimension," though it is fractional. In particular, it exceeds the value unity associated with ordinary curves.

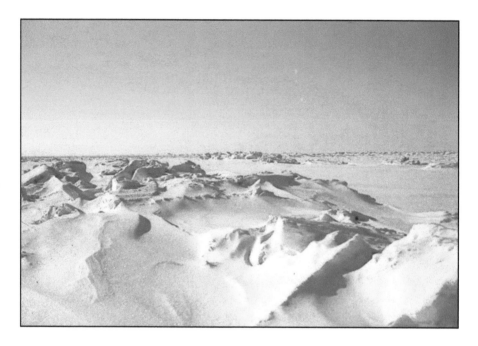

Self-similar shapes discovered by mathematicians are the Sierpinski triangle, Hilbert curve, Penrose tile, and the Koch curve—most of them can actually be drawn by anyone, given the correct formula for pattern making. The Koch snowflake is shown here in its initial state, as an equilateral triangle, followed by three iterations:

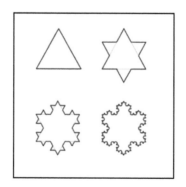

This shape was named after Helge von Koch, who in 1904 published a paper, "On a continuous curve without tangents, constructible from elementary geometry." Under this transformation the fractal is created by taking its pre-image, a straight line on one of the triangle's sides, and making four self-similar pieces, each of which is one-third as long as the original, to produce the image, a new triangular "bump" along the line. The fractal grows along every straight edge by making new equilateral triangles, all diminished in size by one-ninth. The fractal quickly becomes too complex to be drawn by hand, but the process can be mathematically repeated an infinite number of times.

This fractal's growth, like all others, is based upon a recursive formula, such as the Fibonacci sequence. In this case, the Koch formula, "take each line, cut it into thirds, remove the center third and replace it with two more equal lengths," is an example of an iterative process, that is, the repetition of a procedure applied to the result of a previous application. At any random point on the final snowflake, at every scale near or far, we can see the same structure along its edges:

How can we determine the length of this fractal? Or its number of sides? If a_n represents the iteration number, then a_0, the original figure, has three sides and:

$a_1 = $ **12 sides**

$a_2 = $ **48 sides**

$a_3 = $ **192 sides**

$a_n = $ **3*4n sides**

It can easily be seen that as the number of iterations increases, that is, $n \rightarrow \infty$, the perimeter increases as well, becoming infinite. The dimension of the Koch snowflake is:

$$D = \frac{\log N}{\log \frac{1}{r}} = \frac{\log 4}{\log \frac{1}{\frac{1}{3}}} = \frac{\log 4}{\log 3} \approx 1.2619 \dots$$

This number between one and two therefore represents an interdimensional space—something between length and area. The dimension 1.2619... is an irrational number, a non-fraction decimal like π that never repeats its digits or terminates, which also explains why its edge, like the coastline of Britain, is infinite. If it were a finite amount, then the snowflake could be "straightened out" and compared to a number line that has discrete intervals.

Analogous to this idea is Cantor's method of proving that every rational number

(any fraction) has a corresponding counting number associated with it, and is therefore the same cardinality, aleph-null, as that set of N = {1, 2, 3, ...}. A continuous chain can be formed along diagonals of this table which contains every fraction, and matched one-to-one with a number from the set of N. Thus, eventually each fraction will be found:

0/1 → 1/1 → 2/1	3/1 → 4/1	5/1 → 6/1	7/1	...
1/2 → 2/2 3/2 4/2	5/2	6/2	7/2	...
1/3 2/3 3/3 4/3 5/3 6/3	7/3			...
1/4 2/4 3/4 4/4 5/4 6/4	7/4			...
1/5 2/5 3/5 4/5 5/5 6/5	7/5			...
1/6 2/6 3/6 4/6 5/6 6/6	7/6			...

But if a number line is compared to the edge of Koch's snowflake, there is no one-to-one correspondence because $\frac{\log 4}{\log 3}$ is nowhere on that chain of fractions—it is located somewhere between $\frac{11}{9}$ and $\frac{12}{9}$. With the snowflake, this aspect is described by the linear "spikes" that simultaneously extend to the second dimension, producing the ambiguity of an infinite length surrounding a finite area. Mathematicians describe this type of curve, such as David Hilbert's, shown below, as "filling space."

It would seem that fractal geometry is not only a valid description of nature, but in some cases is a better one than Euclidean geometry, which is based on a universe built from conceptual zero-dimensional vertices. Yet, all systems must begin somewhere, as in Euclid's case with axioms which are themselves like mathematical points, and these two geometries could be synthesized around the analogy of a cognitive map. To freely interpret, because vertices can be regarded as hypothetical units of impulse and mind, then perhaps multiple perceptions can connect as a fractal boundary that encroaches upon another dimensional state, representing a type of space-filling web. The self-similar structure at each point would then contain the additive value of all the others, where vertex is the monad, monad is the thought, and thought is the association—all bound together in a graph. The aggregate of those individual singularities then becomes a complexity, resolved once again into a vertex:

●

This cell belongs to a brain, and it is my brain, the brain of the me who is writing; and the cell in question, and within it the atom in question, is in charge of my writing, in a gigantic minuscule game which nobody has yet described. It is that which at this instant, issuing out of a labyrinthine tangle of yeses and nos, makes my hand run along a certain path on the paper, mark it with these volutes that are signs: a double snap, up and down, between two levels of energy, guides this hand of mine to impress on the paper this dot, here, this one.

—Primo Levi, "The Periodic Table"

endnotes: *one among many*

Schrödinger:
Erwin Schrödinger, *Mind and Matter*, Cambridge University Press, 1958, page 127.

image:
A group of leaves all found within three minutes on 29 September, 2011 in Jackson Heights, New York.

image:
Paul Landacre, *Design*, number 5/35, wood engraving, 10 x 15 cm, 1932–1933, collection of the author. For details about wood engraving and Paul Landacre in particular, see: "The Relief Print: Woodcut, Wood Engraving & Linoleum Cut," edited by Ernest Watson and Norman Kent, Watson-Guptill Publications, 1945. http://johnsteins.com/landacre.html.

image:
Riemann Sum, credit: KSmrq, GNU Free Documentation License. Description: "Plot of approximations to integral of square root of 'x' from 0 to 1, with 5 right samples (above) and 12 left samples (below)." The Riemann sum is an approximation of the area under a curve, found by taking increasingly smaller widths of each rectangle, then adding their total—named after mathematician Bernard Riemann (1826–1866).

aleph-null:
From Rentein and Dundes (2005): "Aleph-null bottles of beer on the wall, Aleph-null bottles of beer. Take one down and pass it around, Aleph-null bottles of beer on the wall (repeat)." http://mathworld.wolfram.com/Aleph-0.html.

source: *set theory and Cantor:*
Cantor quote: "a set is a Many…" Rudy Rucker, *Infinity and the Mind*, Princeton University Press, New Jersey, 1995, page 40; Miller, Heeren, Hornsby, et al., *Mathematical Ideas*, 10th ed., Pearson, Boston, 2004; https://www.math.ku.edu/~jmartin/courses/math410-S09/cantor.pdf; http://mathworld.wolfram.com/CantorDiagonalMethod.html.

image:
Penrose tiles are irregular polygons that cover a 2-dimensional surface in infinitely complex ways, named after mathematician Roger Penrose (1970s). http://en.wikipedia.org/wiki/Penrose_tiling.

Swift:
Jonathan Swift, "On Poetry: A Rhapsody" (1733).

In the same poem, Swift compares the instincts of animals, which understand their role in nature, to that of man, whom he addresses as hopelessly challenging the universe:

Brutes find out where their talents lie:
A bear will not attempt to fly;
A founder'd horse wil oft debate,
Before he tries a five-barr'd gate;
A dog by instinct turns aside,
Who sees the ditch too deep and wide.
But man we find the only creature
Who, led by Folly, combats Nature;
Who, when she loudly cries, Forbear,
With obstinacy fixes there;

And where his genius least inclines,
Absurdly bends his whole designs.

standard model:
CERN: The European Organization for Nuclear Research, Geneva Switzerland: http://home.web.cern.ch
/about/physics/standard-model.

image:
Charm quark, Fermilab, National Particle Accelerator.

The observation of the production and decay of baryon charm by the interaction of high energy neutrinos on protons. The reaction is

$$\nu p \rightarrow \mu^- \Sigma_c^{++}$$
$$\quad \hookrightarrow \Lambda_c^+ + \pi^+$$
$$\quad \hookrightarrow \Lambda^0 \pi^+ \pi^+ \pi^-$$
$$\quad \hookrightarrow p\pi^-$$

where the Σ_c^{++} and Λ_c^+ are baryon charm states. (7' Bubble Chamber)

relata:
Roland Barthes, *Elements of Semiology*, translation by Lavers and Smith, Hill and Wang, New York, 1967, page 35. See also footnote: "This [the relation between two relata] was very clearly expressed by St. Augustine: 'A sign is something which, in addition to the substance absorbed by the senses, calls to mind of itself some other thing.'"

Feynman:
James Gleick, *Genius: The Life and Science of Richard Feynman*, Pantheon Books, 1992, Prologue, page 5.

Richard Feynman, *The Character of Physical Law*, MIT Press, 1965. See "Probability and Uncertainty: The Quantum Mechanical view of Nature," pages 127–148.

image:
"*Leonid meteors* seen from 39,000 feet aboard an aircraft during the 1999 Leonids Multi-Instrument Aircraft Campaign. Leonid meteor storms happen when Earth passes through clouds of dusty debris shed by comet 55P/Tempel-Tuttle when it comes close to the sun every 33 years." Credit: NASA/ISAS/Shinsuke Abe and Hajime Yano.

Saussure:
The Course in General Linguistics, outline: http://www.learn.columbia.edu/saussure/.

image:
Feynman diagram, 1948 diagram invented by Richard Feynman (1918–1988): a graphic representation of electron/photon interactions. When two electrons are in close proximity, one of them emits a virtual

photon (the electromagnetic force carrier) which is then absorbed by the second electron. http://www.physicsforidiots.com/particlesandforces.html.

This Feynman diagram is of a monochromatic light source. https://commons.wikimedia.org/wiki /File:Feynman_diagram_monochromatic_light_source.svg. Author: Sjlegg, 2009.

image:
Steve Deihl, *Landscape #32,* oil on galvanized steel, 37" x 43", completed January 2008. Collection: Regina Lee.

Upanishads/Hume:
Robert Ernest Hume, *The Thirteen Principal Upanishads,* translated from the Sanskrit with an outline of the philosophy of the Upanishads and an annotated bibliography (Oxford University Press, 1921). http://oll.libertyfund.org/titles/2058; http://oll.libertyfund.org/titles/upanishads-the-thirteen-principal-u panishads; and https://books.google.com/books?id=4oFCAAAAIAAJ&pg=PA37&lpg=PA37&dq#v=one page&q&f=false, pages 434, 425, and 37.

image:
Schrödinger Equation: Credit: Wikimedia Commons. The equation (linear partial differentiation) de-scribes the quantum state of a physical system as a wave function that varies with time. http://phys.org/news/2013-04-schrodinger-equation.html.

wave/particle paradox:
Numerous videos are available that illustrate the wave/particle identity paradox, including: http://video. mit.edu/watch/thomas-youngs-double-slit-experiment-8432/.

Schrödinger:
Erwin Schrödinger, *Meine Weltansicht* (*My World View*) or *My View of the World,* Cambridge University Press, 1964, page 18.

Moore:
Walter Moore, *Schrödinger: Life and Thought,* Cambridge University Press, Cambridge, 1989, page 171.

image:
Walter Tandy Murch, *The Gravity Experiment,* 1961, photograph by Walter Scott Murch; use granted by Walter Scott Murch, who owns the copyright to the painting.

Common Notions:
Sir Thomas Little Heath, Translation, *The Thirteen Books of Euclid's Elements,* Euclid's Axioms, Cambridge University Press, 1908.

Mandelbrot:
Benoît Mandelbrot, "How long is the coast of Britain? Statistical self-similarity and fractional dimension," *Science:* 156, 1967, pages 636–638. http://users.math.yale.edu/~bbm3/web_pdfs/howLongIsTheCoastOf Britain.pdf.

image:
Ice Ridges in the Beaufort Sea off the Northern Coast of Alaska, Spring 1949. Source: NOAA, At The Ends of the Earth Collection. Photograph by Rear Admiral Harley D. Nygren, NOAA Corps. Image ID: Corp 10014.

Hausdorff:

Additional source for Hausdorff: Paul A. Foerster, *Precalculus with Trigonometry Concepts and Applications*, Key Curriculum Press, 2007.

A list of fractals and their respective Hausdorff dimensions can be found at: http://en.wikipedia.org/wiki/List_of_fractals_by_Hausdorff_dimension.

image:

Koch Snowflake: This file is licensed under the Creative Commons Attribution—Share Alike 3.0 Unported license. Wikicommons.

image:

3-dimensional Hilbert Curve. The initial form is in red and two additional iterations, green and yellow, show how it will eventually fill a volume with successive applications. Image is public domain, uploaded by Stevo-88, created with Persistence of Vision.

Levi:

Primo Levi, *The Periodic Table*, translated by Raymond Rosenthal. Schocken Books, New York, 1984, page 233.

image:

Sam Oppenheim, *Saguaro Cactus*, 2014, Scottsdale, Arizona.

Artist's Remark: "Photograph was taken with a solarized filter and black and white conversion to study texture and contrast."

When the photographer shows us what he considers to be an Equivalent, he is showing us an expression of a feeling, but this feeling is not the feeling he had for the object that he photographed. What really happened is that he recognized an object or series of forms that, when photographed, would yield an image with specific suggestive powers that can direct the viewer into a specific and known feeling, state, or place within himself.

— Minor White, *Equivalence: The Perennial Trend*

"2.0232 Roughly speaking: objects are colourless"

Back in 1964, when Richard Long was 18, he went for a walk on the downs near his native Bristol. The countryside was covered in snow, and faced with a pristine expanse of silent whiteness, he began rolling a snowball through it. When the snowball became too big to push any further, Long took out his camera. He did not take a snapshot of the giant snowball; instead, he photographed the dark meandering track it had left in the snow. The ensuing image, one of his earliest works of what is now called land art, is named Snowball Track. Pure and simple. And, in its purity and simplicity, it denoted all that would follow.

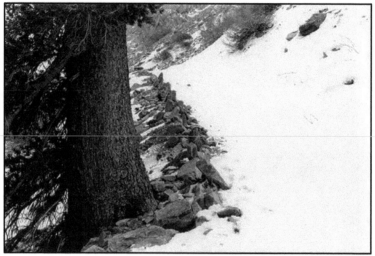

The artist Richard Long closely aligns his work with nature and time—he makes us aware of a certain place and feeling, an evocation of another realm, like a distant traveler who brings back an artifact of that journey. Those artifacts, as art made by walking, as stones, as river mud, as text, become impressions to the viewer who then associates their meaning in a personal way. This transposition of feeling is analogous to geometric transformations: the pre-image is a foot marking a time and place in the snow, the image is what remains after its passing – the figurative impression. In the case of "Snowball Track," the images vanished with the rising temperature of spring, but even a stone line is ephemeral in the larger sense of geologic time. What remains is the memory of the event, as Long writes on his website:

> In the nature of things:
> Art about mobility, lightness and freedom.
> Simple creative acts of walking and marking
> about place, locality, time, distance and measurement.
> Works using raw materials and my human scale
> in the reality of landscapes.

Lines of poetry, lines engraved into a woodblock, lines of stones carefully placed before a blizzard in California—the line itself is symbolic to meaning. It divides a space, or divides itself. It cuts in half or points the way. It is bidirectional, complementary, or shows unity. Because lines can be drawn from only two imaginary points, they can also represent a spectrum of sensations, such as the line where sky meets beach. But this horizon is a false line always shifting, a temporary reference between the media of air and land, water and air, time now and memory.

Linearity also depicts contrast and duality. Two endpoints are connected by a line segment just as the pre-image and image are connected by a transformation, but symbolically those points may have opposite values. It has already been suggested that there is an analogy between transformations and signs since they are comprised of two complementary aspects: there is some content that gives meaning to a form, which in turn is a representation of that meaning. This action might also broadly include evaluating the context of an artifact, the message in a spoken language, and the connotation of a document. Mathematically, the instructions to move points (representations, vertices, monads, ideas) from one location to another are equivalent to the directed assignment of a variable—they are a composition of data. Thus, another possible interpretation of a geometric transformation is a type of operator that transfers information, or more generally, symbolically mediates understanding, about perceptions from an object to a subject and back again.

Historic attempts to define *object* have proven to be difficult—it could be said that an object is an entity that is at once the most fundamental and the most abstract, being "anything presented to the mind." For instance, Descartes believed that there exist only subjects, because they have the power to doubt, and objects, some of which might not exist independent of the subject who observes them. In *Meditations*, he also reasoned that ideas come from external things—this notion also conforms to our model of the transformational image as a potential source for content. Here we might ask, Are an object's properties innate, or do they vary depending upon the observer? In his *Tractatus* (1921), Ludwig Wittgenstein compared *object* to a mathematical variable:

The propositional variable signifies the formal concept, and its values signify the objects which fall under this concept.

Every variable is the sign of a formal concept.

For every variable presents a constant form, which all its values possess, and which can be conceived as a formal property of these values.

So the variable name "x" is the proper sign of the pseudo-concept *object*.

Wherever the word "object" ("thing", "entity", etc.) is rightly used, it is expressed in logical symbolism by the variable name.

More commonly, these are some of the main points related to object and subject:

An *object* is an entity having properties, is acted upon by a subject, and is the thing observed. Strictly, it is any definite being. An object may be whatever we can think or talk about, material or non-material, but anything independent of mind is unknowable.

A *subject* has consciousness and agency, can propel itself, does action to an object, observes and decides about appearances based upon senses and experience. A subject has a relationship with something outside of itself.

Following this line of thought, we could imagine a situation where there is a conscious subject, such as a geometer, who senses a shape that presents properties to him. Since he directs his action to the pre-image, which is an object, we might conclude that this transformation of pre-image and image could also be designated as *object and image*. The image, then, would be like the projected idea of some unresolved shape, and, once resolved after the transformation, becomes a complete triangle that is a composite of both shape and content, ready for another transformation. In this sense, the transformation relays information from a pre-image, which is a form waiting for content (the geometer's definition of a triangle), to an image, which is waiting for a form that coincides with its content:

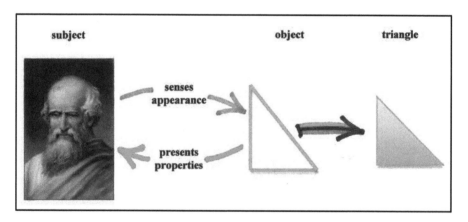

1. there is a geometer
2. there is a shape
3. the geometer senses the shape
4. the geometer's ideas are internal
5. the geometer is a subject
6. a subject does action
7. an object receives action
8. the shape is an object
9. the shape has physical properties
10. the shape's properties are external
11. the shape has three straight sides, three angles, and is flat
12. the content corresponds to triangleness
13. the transformation is simultaneous
14. the subject defines the object

15. the geometer defines the triangle

Also similar to a transformation between subject and object is the transfer of information between form and concept that combine as a sign. The triangle has a meaning that is made of both a form, or signifier, and the attached concept, that which signifies:

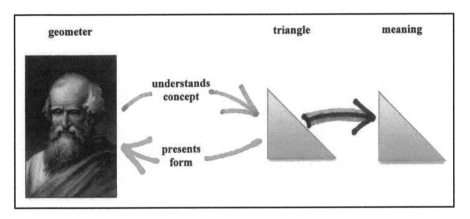

1. there is a geometer
2. there is a triangle
3. the triangle has a form
4. the form is a signifier
5. the triangle presents its form to the geometer
6. the triangle signifies some concept
7. the geometer understands the concept
8. the geometer verifies the concept attached to the form
9. the transformation is simultaneous
10. the concept defines the form
11. the form defines the concept
12. the triangle has meaning

Finally, a geometric transformation between a triangle and its reflection symbolically shows how the triangle's form and concept are transferred to a new object, or pre-image. The triangle form is projected along with the geometer's concept to flip the triangle. Pre-image and image combine in the transformation to give meaning to a newly formed object, a reflected triangle. Again, this is a change in representation, but not identity since the image still holds the essential information from the original pre-image:

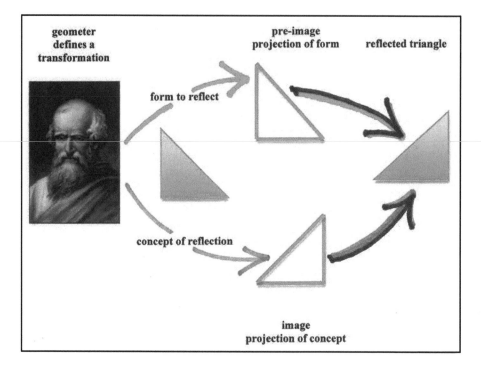

<table>
</table>

1. there is a geometer
2. there is a triangle
3. the geometer defines a transformation
4. there is a pre-image and an image
5. the pre-image is a projection of the triangle's form
6. the image is a projection of the geometer's concept
7. the concept is "reflect a triangle"
8. the image sends content to the pre-image
9. the pre-image sends form to the image
10. the transformation is simultaneous
11. the geometer verifies the transformation
12. there is a new form with content
13. the reflection defines a new triangle
14. the new triangle becomes the next pre-image

It would seem that whenever we consider objects there is always some decision made about them—appearance, shape, structure—that is then interpreted as impressions always linked to some attached meaning that places the object in context. But this viewpoint also parallels the *deconstructionist* claim that text and meaning, under critical analysis, have characteristics that are fundamentally unresolved, because, like the situation created by Bohr's complementarity principle,

those descriptions are irreducible and inseparable. The analogy with transformations is that this specific geometric action shows the relationship between pre-image and image as similar to object and subject, form and content, signifier and signified. If the monad is the philosopher's impulse, then the vertex becomes the geometer's impulse. Since the triangle is made from vertices, we could say that the geometer makes them his surrogates for the transformation—in effect, empowering points with ideas that define shapes.

Stimmung: "the essential spirit" of nature

Concept and form are decisively merged in expressions of artwork, which is often said to be a "transformative" experience, both for the viewer and the maker. Artists make subjective decisions to create expressions they believe are driven by objective, or universal, facts about the world. Symbolically, there is more parallel structure here, with the artist (geometer) sensing impressions from nature (pre-image) and transferring that information to the canvas (image), which conveys the intended meaning (transformation) as a representation, or painting. The artwork (triangle) is embedded with the overlapping values of concept and form. The role of the artist is to interpret truth and reality that others can witness. Thus, there is a definite transfer of information: the representation (symphony, novel, painting, poem) is the result of subjective decisions made to convey a concept (truth, beauty, social commentary) and those values are woven into the object (an empty platform), which can then be recognized and understood as meaningful. As Wassily Kandinsky defined it, *That is beautiful which is produced by the inner need, which springs from the soul.*

In 1914, Kandinsky (1866–1944) wrote *Concerning the Spiritual in Art*, originally published in English under the title *The Art of Spiritual Harmony*. In it, he describes a type of spiritualized sensing in art, or *Über das Geistige in der Kunst* (the original title), embracing the mental process as opposed to the physical. In his work, both as a theorist and a painter, Kandinsky attempted to unite an aesthetic approach of art with a spiritual one, which was thematically similar to that of his fellow abstract painters, Mondrian and Malevich—the goal being spiritual enlightenment through art. He believed that this could be accomplished through the selected use of form and color, and that sensations could be felt from the palette, evolving into a mystical experience. This, from a 2003 published lecture by art critic Donald Kuspit, was Kandinsky's motivation: "As he famously wrote in a letter to Will Grohman, the great German scholar, in 1925, 'I want people to see finally what lies *behind* my painting.'"

With those words, Kandinsky is describing a type of essential foundation in art. He hoped this in turn would produce a transcendent feeling in the viewer that evolved from form and color, where color was a vehicle that translated emotion, and "inner life had a necessary material medium, universally accessible and instantly

expressive (Kuspit)." Furthermore, Kandinsky fundamentally believed that non-objective art was the only means for this transformation from the objective and practical world to the spiritual one. Transcendence here involves what physicist David Bohm called "a state of mind in which one ceases to sense a separation between oneself and the whole of reality." In other words, it is the experience of unity with the cosmos.

This unity for Kandinsky was expressed through color and form, which like the geometric pre-image and image cannot be separated and are bound together by definition and usage. This notion is parallel with Wittgenstein's object definition, 2.0232, that separates objects from non-objects by their "color" attribute. Kandinsky insisted that certain colors and emotions were linked and explains this rationale in his work, both through example and theory. Again, from Kuspit's lecture: "Color and feeling were inextricable: sense experience was spiritual experience and spiritual experience took sensuous form. That is, the external, visible phenomenon of color seemed to be a spontaneous manifestation of the internal, invisible phenomenon of feeling. Feeling needed color to become consummate and color needed feeling to have inner meaning—to be more than a chemical matter of fact." Kandinsky himself, in his manifesto, said "The impressions we receive, which often appear merely chaotic, consist of three elements: the impression of the colour of the object, of its form, and of its combined colour and form, i.e., of the object itself." Thus, taken together, form and color also resemble the synthesis of impressions which we read as a signature, or meaning. What Kandinsky is describing resembles the symbolic geometric transformation, whereby there is an exchange of values between a representation and its content.

Kandinsky also considered the question of how the expressions of art are able to historically continue when cultures are constantly changing fashions. He was aware that there must be some sort of universal value which is constant and not subjective in terms of the ways that it is expressed, meaning that he believed in an "artistic truth." "The inevitable desire for outward expression of the *objective* element," he said, "is the impulse here defined as the 'inner need.' The forms it borrows change from day to day, and, as it continually advances, what is today a phrase of inner harmony becomes tomorrow one of outer harmony. It is clear, therefore, that the inner spirit of art only uses the outer form of any particular period as a stepping-stone to further expression."

In an effort to search for the origins of artistic expression, and perhaps uncover some of those ideas relating to an "inner necessity," we could investigate the messages from Paleolithic art, some of which are more than 35,000 years old. Undeniably, there is an artistic intent present. The artwork contains a spiritual quality that one immediately feels when entering these caves and it would be unreasonable to assume that there was no purpose for the images besides decoration, as they are often in the most remote and inaccessible regions of the caves. Not only are

these "sanctuaries" completely dark, there is also a noticeable drop in temperature. The natural geometry of limestone erosion over millennia has formed domes, arches, columns, and aisles; perhaps these forms, experienced in the past as both structurally safe and mysterious, led to the development of similarly engineered forms in later constructed sacred spaces such as temples and cathedrals.

In the cave of Pech Merle, in southwest France, is found a remarkable mural of two horses in opposition to each other, with overlapping hindquarters. Are they metaphorically opposed to each other, or is their coincidence an intersection of common elements, like a Venn diagram? Although there are numerous examples of sophisticated realism elsewhere, these horses have been purposefully abstracted and given disproportionately small heads and legs. There are also abstract symbols or "signs" in the form of spots, both surrounding the horses and as part of their markings or hair. Further signs are actual hand shapes that are negative images, as a footprint left in the snow, that might be seen as evidence of the passing of an individual. Maybe the message of the hands was, "I exist and I am here."

The physical process of creating those hand prints necessarily leads to questions about their symbolism. Because they were created with a positive and negative effect, again representing a binary linear relationship, there are also implications of "here and there" in the sense of space and time. A different interpretation could be that an individual was pressing through the rock surface to another dimension beyond that boundary, not unlike the fractal points on a Koch snowflake. In fact, there is strong ethnographic evidence that subterranean shamanistic cultures believed rock walls in caves were a membrane that separated the underworld from

the terrestrial one. According to anthropologist David Lewis-Williams, "However they are interpreted, the fundamental sensations of being underground or underwater remain universal: they are the most obvious, most logical explanations for the effects created by the behavior of the nervous systems in altered states. An 'introcosm' is projected onto the material world to create a cosmology."

From our point in history, looking back, perhaps the Pech Merle composition's meaning will never be known. Archaeologically, there are assertions that these paintings here and in other caves played an important role in shamanistic rituals, or that they were individual clan or tribe territorial markings. There may not have been a conscious separation between different realities, in which case these expressions are the result of the natural imagery encountered in altered states such as visions, dreams, hallucinations, and drug-induced trances. Whatever the purpose, it is undeniable that this artwork exists today and it was significant in the past, possibly forming the focal point for a group of people over many generations. The creation of this artwork and others like it would have required a stratified and organized community with artists and specialists to prepare the paints, build wooden scaffolds, hold torches, and to selectively participate in any type of use associated with the imagery, such as a ritual. Apparently many of these paintings were periodically added to by overlapping previous work with images from a much later time—this suggests both preservation of form and tradition, but at the same time, the need for embellishment or incorporating new ideas and imagery.

With the horse mural in Pech Merle there is evidence that this particular placement within the cave was carefully chosen. The stone wall is a freestanding structure set apart from the surrounding walls of a large open cavern, making its location significant. Many people could gather here at once. Additionally, the wall itself mimics the shape of a horse's head, drawing the viewer into the whole structure. One realizes that there is a conscious intent to create a parallel between the natural shape of the rock and the form painted upon it. Symbolically, perhaps the essence of the horse, its "meaning," was trapped within the limestone and the artist or shaman "released" it, as Michelangelo would similarly claim about emergent forms within marble. Therefore, the reflection of a form within another form is a type of embedded message. In the case of prehistoric art, we are left with evidence, but lack a context. This would be like an unconnected graph consisting of numerous vertices with no edges; ideas standing alone without reference.

Timelines are usually represented as linear constructions; along this line can be placed single events that additively make a history from beginning to end. Metaphorically, we can step along this line and remember the past. Mathematically, it is both possible and necessary to reverse our steps, checking for equivalence among the individual parts. Recall from Euclid that "things which are equal to the same thing are also equal to one another." Thus, every line of logical text or series of equations must be reversible back to the origin; along the way, the original state-

ment may change in form, but its inherent character or value remains constant.

the Euclidean algorithm

One of the oldest known processes in mathematics is the Euclidean algorithm, which Euclid described as a method for computing the greatest common divisor (the *gcd* is the largest factor of both numbers) of any two numbers. An algorithm is a sequence of unambiguous instructions to solve a problem, usually in a finite amount of time—it is also a self-contained process, meaning the actions are looped and repeated until a solution is found, without introducing any new elements. A key aspect of the Euclidean algorithm is the method that we use to divide two numbers. When two numbers are divided (the dividend and the divisor), the result is a quotient, plus its remainder: *Dividend = (Divisor)(Quotient) + Remainder*, such as $17 = 3(5) + 2$. On the other hand, if the remainder equals zero, then we have two factors, the divisor and quotient, such as $15 = 3(5) + 0$. The previous two statements are equivalent to writing $\frac{17}{3} = 5 + \frac{2}{3}$ and $\frac{15}{3} = 5 + 0$.

As a simple example of the Euclidean algorithm, consider the question, "What is the greatest common divisor of 48 and 18?"

48 divided by 18 equals 2 with a remainder of 12:
$48 = 18(2) + 12$ *the gcd of 48 and 18 = the gcd of 18 and 12*

18 divided by 12 equals 1 with a remainder of 6:
$18 = 12(1) + 6$ *the gcd of 18 and 12 = the gcd of 12 and 6*

12 divided by 6 equals 2 with a remainder of 0:
$12 = 6(2) + 0$ *the gcd of 12 and 6 = the gcd of 6 and 0 = 6*

the greatest common divisor of 48 and 18 is 6

Using Euclid's method, each former divisor and remainder becomes a new dividend and divisor; and we continue to divide until we get zero as a remainder. Since the greatest common divisors are linked step-by-step, the gcd of the first pair of numbers will be the same as the last pair of numbers, of which one of them will always be a zero, and then the algorithm stops. The answer will appear as the remainder on the previous line. Even if two numbers are *relatively prime*, meaning they have a gcd equal to one, such as 15 and 4, the algorithm will show that as well.

Here is the algorithm:

To find the gcd of any two numbers, **a** and **b**, where **a** > **b**, write the numbers in the form of dividend = divisor (quotient) + remainder:

a = dividend
b = divisor
q = quotient
r = remainder

If **b** divides **a**, such as 3 and 15, there is a remainder of zero. The divisor and quotient are factors, and **b** is the greatest common divisor.

If **b** does not divide **a**, such as 4 and 15, there is a quotient and remainder; use the algorithm until $r_n = 0$. **The gcd will be r_{n-1}.**

$$\mathbf{a} = \mathbf{b}\mathbf{q_0} + \mathbf{r_0}$$ In our example, $a = 48$, $b = 18$, $q_0 = 2$, $r_0 = 12$.

$$\mathbf{b} = \mathbf{r_0}\mathbf{q_1} + \mathbf{r_1}$$ The gcd of **a** and **b** is equal to the gcd of **b** and r_0 there is a new quotient and remainder.

$$\mathbf{r_0} = \mathbf{r_1}\mathbf{q_2} + \mathbf{r_2}$$ The gcd of **b** and r_0 is equal to the gcd of r_0 and r_1 there is a new quotient and remainder.

$$\mathbf{r_1} = \mathbf{r_2}\mathbf{q_3} + \mathbf{r_3}$$ Continue **n** times.

... Stop when remainder, $r_n = 0$.
The gcd will be the prior remainder, r_{n-1}

In addition to finding the gcd, a variation of the Euclidean algorithm can solve linear equations with two variables, such as $48x + 18y = 6$, where **x** and **y** are integers $\{... -3, -2, -1, 0, 1, 2, 3 ...\}$. By using the Euclidean algorithm in the reverse order and making substitutions along the way, we can arrive at two solutions for x and y.

We will solve for each remainder, beginning with the line where r = the gcd, until we have the original **a** and **b**, which in this example are 48 and 18:

$6 = 18(1) - 12(1)$
Go to the previous line in the algorithm:
$12 = 48 - 18(2)$
Substitute the first equation with $12 = 48 - 18(2)$:
$6 = 18(1) - [48 - 18(2)](1)$, which simplifies to $6 = 18(3) - 48(1)$.
Therefore, the solutions to $48x + 18y = 6$ are $x = -1$ and $y = 3$;
that is, $6 = 48(-1) + 18(3)$.

If we wanted to change the equation to $48x + 18y = 42$, or any other multiple of 6, we would go back to our original equation and multiply through by 7:

$7[48(-1) + 18(3) = 6]$ → $48(-7) + 18(21) = 42$. Now, $x = -7$ and $y = 21$.

Since the greatest common divisor of 48 and 18 is recognizable without using Euclid's method, the algorithm is not really needed in this case. But what of something much more complicated, such as solving $2778x + 582y = 18$? Using the Euclidean algorithm (the details are in the endnotes of this chapter), we arrive at the solutions, $x = 66$ and $y = -315$; that is, $2778(66) + 582(-315) = 18$. It can also be shown that there is an infinite number of integer solutions, with $x = 66 - 97n$ and $y = -315 + 463n$.

The Euclidean algorithm is an iteration that gives us multiple representations for the same number, such as $6 = 54 - 24(2)$ and $6 = 2778(22) + 582(-105)$. We also know that transitively, $54 - 24(2)$ is equal to $2778(22) + 582(-105)$, and thus $54 = 24(2) + 2778(22) + 582(-105)$. Thus, in an extreme case, the number six could be written as "nine hundred twenty-six times the quantity sixty-six minus ninety-seven times ten thousand one hundred seventeen plus one hundred ninety-four times the quantity negative three hundred fifteen plus four hundred sixty three times ten thousand one hundred seventeen." But mathematically, this is equivalent to:

$$6 = 926[66 - 97(10,117)] + 194[-315 + 463(10,117)].$$

Compared with the textual translation, the mathematical language is more direct and contains no ambiguity about the order of operations, but only if a person knows how to translate the meaning of the message, which is simply a different way of "writing" the quantity six.

geometric similarity and congruence

Consider again the actual structure of a line, made from a minimum of two points; symbolically, those vertices might represent opposable relationships such as good and evil, warp and weft, self and other, whole and broken, even and odd. In computer coding, binary is a number system using only the values of 0 and 1 to represent decisions or truth values, where "1" means "yes," "true," or "on," and "0" means "no," "false," or "off." Obviously, in everyday situations there are many different values that lie between yes and no, but some of them which initially appear to be dissimilar might actually be the same thing upon closer inspection.

Since mathematics is essentially a system that progresses from axiom to theorem to proof, it is a verification of an "informed intuition" that began the process; from a new proof comes a new discovery, which is the starting point for further discoveries. Along this path, we check each step for equality so that the line of logic can be traced back to the beginning. But if that sequence is part of a concept map, and the points A, B, C, etc., represent objects, ideas, and experiences, then our decisions about their placement within the network may continuously bounce back and forth until settling on a definite location within the map. In this case, we are looking for coinciding values, or similar intentions, that connect the network vertices, and we eventually reach a conclusion that is more subjective than cleanly objective. An oscillating series of decisions may converge to a new vertex somewhere between A and B, or we may discover that the original set of points on the line actually coincide as equivalent elements, such as "6" and the expression "908668064 – 908668058." This mental construction of relations takes place all of the time when making judgments about the ways that features are alike or unalike; their coincidence will be any underlying structure that A and B share together.

As a geometric example, we can compare two triangles by direct measurement. If they have the same area, is that a condition for equality? Must all of the corresponding sides and angles be the same? If the triangles are somehow different, but with the same area, can one of them be cut and reassembled to make the other, that is, "scissors-congruent"? This method of dissection can actually be done, according to an algorithm. We can also use parallel lines to show that two different

triangles having the same base would also have equal areas, since they both have the same height:

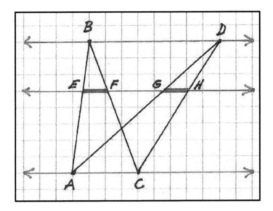

Triangle *ABC* is not mathematically similar or congruent to triangle *ADC*, but an interesting consequence of passing a third parallel line through the triangles is that it creates two segments of equal length, \overline{EF} and \overline{GH}.

The same structures can also be reproduced in three dimensions:

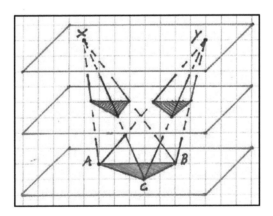

In the above example, two tetrahedra sharing one triangular base and two different apices on parallel planes will have the same volumes; furthermore, a third parallel plane will create two triangles with equal areas. Notice that a dissection within a given dimension makes a cross-section in a lower level dimension; that is, two-dimensional triangles are cut to form one-dimensional segments, and three-dimensional pyramids are cut to form two-dimensional planes.

It can be proven that given two planar shapes with equal areas, such as a rectangle and a triangle, it is possible to cut one of them a finite number of times so that by comparison, it will exactly fit into the space of the other one. But is the same also

true of three-dimensional polyhedra with equal volumes? This happens to be one of the 23 unsolved problems that Hilbert presented at the 1900 Congress of Mathematicians. Problem number three stated:

> Given any two polyhedra of equal volume, is it always possible to cut the first into finitely many polyhedra pieces that can be reassembled to yield the second?

Max Dehn, in 1900 and 1902, resolved the problem by showing that an inherent geometric value, the *Dehn invariant*, is equal to zero for a cubic prism, but is non-zero for a tetrahedron; thus, the two forms are not scissors-congruent to each other. This means that one cannot be mathematically cut and reassembled to produce the other—for example, a cube cannot be cut to make a pyramid, even if they have equal volumes.

In mathematics, the reflexive property means something is equal to itself, *a* = *a*, such as two coinciding angles, or two triangles sharing the same side. Philosophically, a reflexive statement of identity would be, "I am I," or "I am that I am." This equivalence relationship is useful in a geometric proof to establish the congruence of two objects. Triangles are often used in mathematics to demonstrate the continuity of *all* polygons since they require the least amount of vertices to create a two-dimensional shape. It is therefore the first possible planar object:

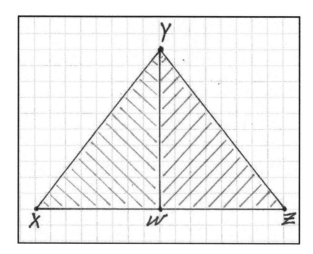

If **W** is a perpendicular bisector of straight line **XZ**, then triangle **XYW** is *congruent* to triangle **ZYW**; therefore, the two triangles are equal with respect to the measurements of all corresponding angles and sides. In geometry, it should be noted that there is a difference in terminology when expressing states of equality: measurements are equal but their individual parts are congruent. The parts may not

be considered equal to each other because then they would have the same identity, whereas in this case they are distinct entities. *XW* is distinct from *WZ*, but they share the same measurement.

A simple proof for the congruence of triangle *XYW* to triangle *ZYW* would state that since *W* is a midpoint, *XW* is congruent to *WZ*. Furthermore, since *XZ* is a straight line, and since *WY* is perpendicular, then angle *YWZ* is 90 degrees, and the supplementary angle, *YWX* is also 90 degrees. Also, we know that *WY* is equal to *WY* because both triangles mutually share the same side. Since *WY* *refers to itself*, it is reflexive, and broadly speaking is therefore self-referential. Because two corresponding sides and an included angle of one triangle are equal in measurement to the other triangle, the two triangles are congruent to each other, with all corresponding parts having equal measurement. Thus, to summarize:

> If two triangles have their corresponding sides and angles equal in measurement to each other, then the triangles are congruent: congruent means all embedded elements are alike.
>
> If two triangles have their corresponding angles equal in measurement and their corresponding sides are proportional, then the triangles are similar: similar means elements are related. *This could be interpreted to say that the triangles are still alike in some way, but to a lesser degree than congruence.*

Both triangles, *XYW* and *ZYW*, have maintained their separate identities, and yet are bound by a type of equality that can only be achieved mathematically as a congruence—again, this is an idealized situation. Such triangles could not actually be made so that their measurements are exactly alike for there is always a margin of error in construction or manufacture, if even microscopically. The geometric intention is to investigate the relationships of two separate objects and determine their status—are two elements alike in some way, or unlike? If alike, then how are they related? If unlike, then how are they unrelated? Bearing in mind that two things, like triangles, can be unequal but still related in some way (as triangles!), doesn't using the word "unrelated" also imply that more aspects within the elements might yet be found that have some likeness? In everyday life, there is also a range of values that are conceptual judgments, decided on the basis of whether or not the connections between them are strong or weak.

equivalence

To complicate the analysis of comparisons, there are many terms that are often used in common parlance that also have mathematical meaning—and as such are both precisely defined and at the same time more ambiguous when the context changes. One such word is "equivalent," which could be roughly defined as "equal in nature

or intent, but not in identity;" that is, two entities corresponding to the same value, effect, or meaning like "the spirit of the letter." Mathematically, it may be a slightly weaker state than equality because it compares things that by appearances do not look the same, but in fact have the same value, such as the equivalent fractions of $\frac{3}{8}$ and $\frac{1257}{3352}$, as opposed to $\frac{3}{8} = 0.375 = \frac{375}{1000}$, which arguably can be more readily seen with an intermediary step.

Carl Gauss developed modular arithmetic in 1801 as a way of showing equivalence between numbers based upon having the same remainder. The symbol \equiv means "is equivalent to." Modular arithmetic is commonly encountered in the form of clock-time for a 12-hour clock in a 24 hour day. Fifteen o'clock in Paris is read equivalently as three o'clock in the afternoon in New York, because 3 corresponds to going once around the clock from midnight to noon and adding three more hours. Mathematically, we would write that relationship as "12 evenly divides (15 − 3)." In general, if a and b are integers, they are *congruent modulo m* if there is an integer k such that $a - b = km$, which formally is written as $a \equiv b \bmod m$. Therefore, 15 o'clock corresponds to 3 in the afternoon, and we would write that as $15 \equiv 3 \bmod 12$ because when 15 is divided by 12, there is a remainder of 3. This is the same as saying that 75 also corresponds to 3 o'clock, $75 \equiv 3 \bmod 12$, or any $a = 12k + 3$. For this example $k = 6$, but it could be any integer because any multiple of 12 will take you around the clock; however, you will always need to add on 3 more steps to reach 3 o'clock. That is why with clock arithmetic of modulus 12, $3 \equiv 75 \equiv 2247$.

Another example would be a clock with just five points on it: 0, 1, 2, 3, and 4. Starting at zero, where would you end up on the clock if you counted 317 steps, landing on each number as you go around? This is the same as saying, "What is the remainder when 317 is divided by 5?" We would go around 63 times and land on 2, because that is the remainder. In other words, 317 is equivalent to 2 modulus 5, or $317 \equiv 2 \bmod 5$. But this is easy to see, since 315 (divisible by 5) would correspond to 0 on the clock (no remainder) and two further steps is 317.

This same idea is found in the complex number system, where i is defined as $i = \sqrt{-1}$. By taking successively increasing powers of i, a pattern develops, repeating the same value with every fourth exponent:

$i^0 = 1$	$i^4 = 1$	$i^8 = 1$...etc.
$i^1 = i$	$i^5 = i$	$i^9 = i$	
$i^2 = -1$	$i^6 = -1$	$i^{10} = -1$	
$i^3 = -i$	$i^7 = -i$	$i^{11} = -i$	

To evaluate i^{119}, simply divide the exponent by 4 and use the corresponding remainder to find your location on this clock, having only 4 points on it. For instance, if we start at 0 and take 119 steps, we land at space number 3. This means that $i^{119} = -i$ because 119 divided by 4 has a remainder of 3, or $119 \equiv 3 \bmod 4$, which corresponds to $-i$. There are no other possible values than $\{\, 1, i, -1, -i \,\}$.

a network of affinities

Although words like "distinct," "irregular," "dissimilar" and *equivalent, congruent, similar* are frequently used to compare things, conceivably they might have different interpretations among different people depending on their use; even so, there is usually general agreement about what they mean. It can also be seen that both groups of these words parallel each other by assessing degrees of likeness or unlikeness, with the first group somehow opposed to the second. These relational decisions are open judgments that can be both lyrical and analytic, but ultimately are subjective impressions of non-subjective things, such as "winter," "rock," and

"snow," which also have varied connotations. It might be the desire of a poet to combine those elements into a single impression, while "season," "granite," and "weather" would mean something entirely different to a geologist. But to continue Kandinsky's reflection, we could just as easily substitute the word "science" or "mathematics" for "art" with his observation: "In short, the working of the inner need and the development of art is an ever advancing expression of the eternal and objective in the terms of the periodic and subjective."

Likewise, everything we encounter as objects, ideas, and the experiences that surround them are constantly being compared to each other at some level, and placed into a personal system built around the strength of their characteristics, like a network. In fact, it could be said that every moment, if we are aware, is filled with examples of things that are physical and non-physical, along with their surrounding interactions, and assessed. Neurologically, it has been found that activating and reactivating circuits, along with increasing the efficiency of synapses, can engrave long-lasting pathways in the brain—mathematically, this is like mapping two formerly unconnected elements that become relational through a context. One possible interpretation of this process would combine these features, making an equivalence, or affinity, among them:

elements:	objects	ideas	experiences
and			
context:	application	theory	time

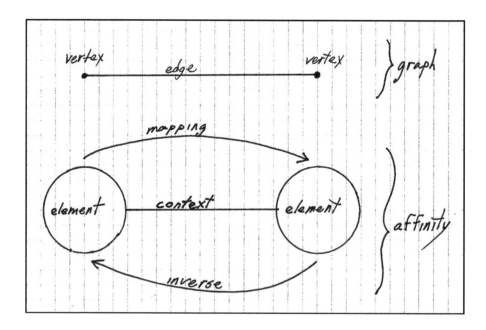

To further this analogy, two connected elements could crystallize into a new vertex within the surrounding group of others that are just like it, developing more complete associations. Graphically, the affinity can be considered the same as a vertex because it is a symbolic point, like the variable x, and here it represents any location for shared characteristics as well. Their specific placement is made subjectively through sensory confirmation of any prior correspondence and interaction, and verified individually through testing potential meaning to establish a new order that is clear. In this manner, fresh objects, ideas, and experiences, join affinities that already contain groups of attached vertices—connections are made among individual elements to become an affinity, and among vertices to become a network:

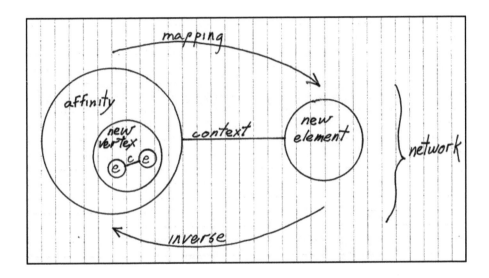

As already mentioned, such a concept map might be progressively built from a taxonomy of geometric dimensions from zero onwards, with each level containing affinities for that specific dimension. Conceivably, when this graph increases in complexity each dimension becomes more complete to the user until a density is achieved that might culminate in a new type of understanding—thus, we have a system that actively percolates, distills, and solidifies the number of relationships that align with each other.

For instance, assume that someone finds two elements that immediately appear to be oppositional, but with some consideration at least one connection can be made between them, either a strong or weak bond. Originally, within this cloud of ambiguity a value judgment is made: if they are objects, then how is their application to each other alike or unalike? If they are ideas, how does any theory between them correspond? If they are experiences, then how does their historical position relate?

The set of objects, **O**, ideas, **I**, and experiences, **E**, potentially has six arrangements of two elements each, {**OO, OI, OE, II, IE, EE**}, and this system could form the basis of our network construction. Combine any two elements, then add a third, which again refers to the binary operation for a mathematical field—taking things two at a time. Of course, this can repeated infinitely many times, and the binding contextual edge, here represented by "∗," may be considered the right mixture of application, theory, or time, that makes sense as the new affinity:

$$(O * O) * O = (OO) *O \qquad (O * O) * I = (OO) *I \qquad (O * O) * E = (OO) *E$$
$$(O * I) * O = (OI) *O \qquad (O * I) * I = (OI) *I \qquad (O * I) * E = (OI) *E$$
$$(O * E) * O = (OE) *O \qquad (O * E) * I = (OE) *I \qquad (O * E) * E = (OE) *E$$
$$(I * I) * O = (II) *O \qquad (I * I) * I = (II) *I \qquad (I * I) * E = (II) *E$$
$$(I * E) * O = (IE) *O \qquad (I * E) * I = (IE) *I \qquad (I * E) * E = (IE) *E$$
$$(E * E) * O = (EE) *O \qquad (E * E) * I = (EE) *I \qquad (E * E) * E = (EE) *E$$

If they are alike in some way, there is a conjunction and the affinities are tested on an ascending spectrum from being weakly alike to strongly alike; in other words, increasingly convergent on a pathway to equality. If the elements are unalike in some way, there is a disjunction and the affinities are tested as being weakly unalike to strongly unalike; they become increasingly divergent until they are determined to be unequal. But this final state means that there is absolutely no relation possible because together the elements have no singular identifying characteristic, which is impossible because everything existing must have a context, if only distantly. If the element has no identity, there would be no possible vertex here, as an identity is taken to be an inherent characteristic. The elements are rejected and that comparison is returned to the ambiguous state, whereupon it could be once again processed.

Referring to the diagram on the next page, this analysis shows that there are several interdisciplinary terms that share the same structure as that found in the language of mathematics. It can also be just as interesting to seek affinities as it is to understand why two elements are not alike. A synthetic process can be made to show how learning is achieved by investigating different comparative states: one that tends toward homogeneity, and the other towards heterogeneity.

resolved homogenous state

convergent

g
n **strongly**
i **alike**
s
a
e
r
c
n
i
 weakly
 alike

= EQUAL
identical elements
 singularity

≡ EQUIVALENT
coincident elements
 concentric
 circles=analogy

≅ CONGRUENT
embedded elements
 many common
 points=metaphor

~ SIMILAR
related elements
 2 common
 points=simile

./ ADJACENT
tandem attachment
 1 common
 point=tangential

conjunction

alike in some way?

ambiguous state → **comparative decisions about elements** → value judgment

(elements are objects, ideas, experiences)

unlike in some way?

disjunction

i
n **weakly**
c **unalike**
r
e
a
s **strongly**
i **unalike**
n
g

≈ APPROXIMATE
proximal elements
 $\pi \approx 3.14$
 close to actual

~ IRREGULAR
random elements
 14159265359
 inconsistent pattern

≅ DISSIMILAR
contrary elements
 $A = B, B = C, A \neq C$
 illogical relation

≡ DISTINCT
separate elements
 $A \neq B$
 context detachment

≠ UNEQUAL
without identity
 $A \neq A$
 no relation

divergent
 not possible ⇒ outlier

 ↵ return

resolved heterogeneous state

If there can be found a minimum of only one common point between elements then it is like a mathematical tangent, defined as a line that touches a circle at only one point, and whose radius is perpendicular to the tangent line. This attachment is a loose conjunction of a singular formerly unconnected idea—linguistically, this is a tangential relationship. Intersecting Venn rings, a diagrammatical device developed by the mathematician John Venn in the 19th century, represent a slightly stronger bond between two related elements. Originally intended to show inclusion and exclusion, here it can symbolically connote "like" and "as" comparisons in the figure of speech known as a simile.

If the Venn rings are filled with an area, then many associations can be found at this intersection. Elements join other elements, becoming molecular affinities in larger sets. This conjunction contains many elements that have further embedded or implied comparisons, which are a stronger bond between the two sets as there are more of them; furthermore, these elements then "stand for" or replace a larger framework. Thus, the literary device of metaphor can become synonymous with the mathematical idea of congruence.

Investigating parallel structures continues with converging affinities that are nearly equal, or equivalent, as elements that begin to coincide with each other. They could have formerly been associated, or are simply unrecognized together as being the same element within a new context. Here, we can represent this idea as a series of concentric circles or three-dimensional orbits all sharing the same center; its literary comparison is that of analogy. Analogy is a more complete device than simile or metaphor as it links formerly unconnected ideas and concepts through familiar or common expressions. In the process, new structures are created that are stronger than before the comparison was made.

Finally, if the elements share the same identity, then they are in fact equal, acting as a singularity—the result of a compression of affinities. This is a return to the original vertex state as a complex structure that has been reduced and simplified. Thus the question, "Are two elements alike in some way?" was resolved into a completely homogenous state with the original two elements actually being identical; this state was either unknown to the questioner at the beginning of the process or was resolved along the pathway of discovery.

Returning to the initial state of comparison, our investigation might find that the elements are more unrelated than they are related, meaning there is a disjunction based upon proximity of values. If indeed everything is connected to each other in some way, here it might prove to be more valuable to illustrate a contrast instead of a comparison. Contrasting elements is essential to building a network of affinities, for the very reason that knowing their differences will also create an attachment somewhere. Disjunctions are weakly unconnected elements that may be nearly touching other connected groups, through a context that is more of a cloud than an edge, but gradually become further separated like stars in expanding space. There is

a spectrum of values that parallels this divergence as the contrasting elements are found to have less and less in common, both with each other and any previously established connections in the concept map.

If the value decision finds that two elements are related in some way, but still subjectively appear to be more of a disjunction than a conjunction, then they are considered approximate, that is, nearly connected, like $\pi \approx 3.14$. An example of a further divergence in proximity could be a completely random string of numerals such as .14159265358979323846264338327950288419716939937510582. The pattern is inconsistent and irregular and without context, but once connected to π it immediately becomes resolved as a known that was formerly unknown because it is the first 53 digits after the number 3, representing a circle's circumference divided by its diameter. π is connected in some ways and unconnected in other ways, depending on the contextual questions asked and the relative strength of its location within a network of concepts.

Continuing along the pathway of increasing divergence, we can make parallel comparisons with the mathematical structure found in equivalence relations. Dissimilar or contrary relationships should be more strongly unalike than proximal ones, and symbolically this could be represented as the illogical statement, if A = B and B = C, then A should equal C, but in this case it does not, $A \neq C$. In other words, the chain of reasoning was broken at some point. Taken from the transitive argument of deduction, this statement would be inconsistent with logic and therefore fallacious.

A more distant relationship involves two distinct elements detached from each other with no connecting context. The symmetric equivalence, if A = B, then B = A, would be broken when no shared values could be found between A and B, giving the statement $A \neq B$. Here, "distinction" has stronger implications of divergence than "dissimilar" because at this level in our relational decision-making we have considered at least two elements, which are found to have nothing in common. Their distinctions clearly outweigh any small characteristic that might still be found, so they are not connected in the network as associations.

Distinct elements could be considered unequal elements, that is, sharing no context in the network. If a single element, taken to be a zero-dimensional vertex, is completely isolated, then its state is self-aware and reflexive, A = A. But here we will temporarily assign it no value, or no identity, $A \neq A$, because we cannot find a context that joins it to our network of other elements that are alike. Symbolically, there is no relation within it or without it since it has no identity, even to itself. However, this is impossible because all forms are connected to their inherent meanings and all experiences are connected to historic memories. It may be more appropriate to call this state "inhomogeneous" rather than unequal, since the connections, whether physical or conceptual, must actually exist in some manner.

This anomaly is like a statistical outlier that belongs to a data set, but at this point the affinity is missing, so the inequality is rejected because the original question, "Are these elements more alike, or more unalike each other?" has been resolved into a heterogeneous state that is unacceptable. A better explanation is that the two elements, A and B, have diverged with no relation only because none was actually found. They are distinct and momentarily cannot be paired through a context, which means that our network must be reconstructed to somehow include it, if we choose.

When considering if two elements are alike or unalike and their suitable placement within a network of affinities, we make relational decisions about them whether or not we are even conscious of this process. If the path to discovery includes not only black and white decisions, but also the infinite scale of grey values between them, then it becomes a subjective issue that can vary from one person to the next. These decisions effectively take place within the brain and therefore have a physiological component as well as a perceptive one that is based upon past experiences and relationships, which is one of the reasons why artificial intelligence is difficult to achieve. Since computers are imprinted with no/yes binary code, there is no spectrum of possibilities between the "0" and "1." The algorithm outlined here relies on a general consensus of opinion about how to compare things and their placement into a framework of ideas, which may or may not be programmable. The experiences of one person versus those of another will influence their relational decisions, with each one scaling "likeness" differently, depending upon what they consider to be of predominant importance.

It should also be noted that these phenomena are not static but are free to change over time as new information is discovered, influencing future comparisons about any distinctions between A and B, or A with itself. If that is the case, the element then becomes a new unknown value in relation to other knowns or unknowns; this is yet another reason to reject A at the final stage and return it to the general pool of ambiguous elements. Eventually a context will be found as a connector—edges of similarity continuously spread out like tree roots as they search for nourishment and stability, which may be near or distant. Once found, other elements will also traverse this path.

impressions of light

As an example, consider all the complex and subjective impressions related to "sunlight," which might begin with "Capulet's Orchard" and include along the path "star-crossed," "parallax," "radiation," "Maxwell," "peat," "photosynthesis," "cider," and "golden," leading back again to sunlight. Each of those associations is a vertex in a map, all connected by contextual edges relating to sunlight, and they become a link in this particular chain, but this affinity group is also attached to other chains as well. The cluster joins others and the complexity grows. Yet, given all of the possibilities, somehow there is a concurrence of sunlight's meaning and representation because its character can be recognized by anyone, that is, things which *coincide* with each other are equal to each other.

As Newton discovered in 1666, passing a beam of sunlight through a prism will bend its path, somehow revealing its constituent parts. He then reassembled this mixture by passing it back through another prism where it emerged once again as a coherent beam of white light, like an inverse process, and correctly surmised that sunlight is actually composed of all the colors of the rainbow. Newton observed that red light bent the least, and also saw that the colors stayed in the same order each time the experiment was repeated. It is now understood that different colors represent different wavelengths, with violet having the shortest wavelength and red the longest one.

Within the framework that *yellow* light has a frequency of approximately 517 trillion hertz (or cycles per second), "yellowness" can also be a subjective perception, just like sunlight. How would this electromagnetic radiation be described to an alien visitor to Earth who cannot perceive this frequency (but may be able to perceive others, such as infrared)? Is there some kind of intrinsic vibration in the universe to which we could translate this frequency of yellow like a dictionary, allowing any perceptive being to understand its meaning?

One possible unit of frequency corresponds to the wavelength of approximately 21 centimeters, or 1420.40575177 megahertz, found in the microwave range. Radiation of this wavelength is emitted by cold neutral hydrogen in interstellar gas clouds, and is caused by the interactions of subatomic proton/electron magnetic moments: when parallel "spins" randomly flip to non-parallel "spins," a photon is released as excess energy, in a process called *hyperfine splitting*. This signature in the spectrum, always located at 21 cm, serves as a benchmark for measuring the Doppler shift of distant galaxies, an effect of frequency change toward the red end of the electromagnetic spectrum that results from the expansion of the universe.

Radio astronomers have used data from their observations to look back in time, as archaeologists would, to see features of the primordial universe. Doing so would not be possible save for the fact that light (and all other forms of electromagnetic radiation) travels at a finite speed. Therefore, the light we receive today actually carries information as old as 13.7 billion years. Cosmologists and astrophysicists have also inferred that 400,000 years after the Big Bang, the universe cooled sufficiently for protons and electrons to combine to form atoms, joining together as the simplest element, hydrogen. More importantly, radio telescopes, the Hubble Space Telescope, and the Wilkinson satellite gathered information that show our early universe to be inhomogenous by only one part in 100,000, which, as a minimum, was necessary for structures to form.

It has been conjectured that the 21 centimeter wavelength emitted by interstellar hydrogen could represent a standard unit for cosmic frequencies and therefore serve as a common basis for communication with other sentient extraterrestrial life forms. This idea was first suggested in 1959 when physicists Philip Morrison and Guiseppe Cocconi were considering how distant civilizations might communicate with each other across many light years of space. It was determined that this frequency of ~1420 MHz easily penetrates the interstellar medium without being absorbed, allowing signals to travel through space unimpeded. However, one difficulty involves distinguishing an intentional broadcast for communication purposes from that of natural hydrogen emissions.

With this in mind, the SETI (Search for Extraterrestrial Intelligence) Institute was initiated in 1984, with a mission to "explore, understand, and explain the origin and nature of life in the universe." One of its founders, the astronomer Frank Drake, famously created the "Drake Equation" that attempts to calculate the likely number

of civilizations in our galaxy technologically capable of communicating with us across interstellar space. Although the various terms in the equation are not known precisely enough to calculate a reliably precise result, the equation has encouraged an open dialogue among scientists about this matter, a dialogue both technical and philosophical. Today, SETI researchers are trying to construct a universal language that conveys our humanity, and also, perhaps more importantly, they are exploring what our reply would be if we received an extraterrestrial message first. The implications of such a communication would undoubtedly be of planetary proportions. Thus astronomers, mathematicians, and sociologists are working to broadcast messages with embedded information about our civilization by constructing a method to convey those ideas to any other life form capable of receiving it. Researchers believe that messages could be encoded in the 21cm spectrum because it is a universally known standard, independent of human language or perceptive ability such as color sense.

Imagine an extraterrestrial intelligence incapable of sensing visible light but able instead to perceive some other form of electromagnetic radiation, such as microwaves. Those signals and patterns would then become the familiar world of pictures and images; their values on that other world would depend not only on specific wavelengths, but also the interpretation of shades and hues. Visible light is just one form of radiation, and in fact occupies an extremely narrow band of the entire electromagnetic spectrum from gamma rays to extremely low-frequency radio waves. This means that humans are actually extremely limited in the range of perception available to them without any intermediary instruments. On this planet, color and color interpretation along with sound and music dominate our senses and are most often used as vehicles of artistic expression. For more than 35,000 years artists have used paint to express ideas in color, but there are other possibilities as well, with contemporary artists increasingly using multimedia in their work.

For many years, the artist James Turrell worked as an aerial cartographer, having learned to fly when he was 16. This experience, along with his university studies of perceptual psychology, mathematics, and astronomy, led to an unusual synthesis of abilities, expressed through his non-traditional artwork in which he most often uses light itself as his palette. Many viewers of Turrell's work feel that the way he uses light imbues it with a physical presence that becomes a transcendent experience for the individual because it resonates with them, both literally and figuratively. In an interview with Julia Brown for his Museum of Contemporary Art (Los Angeles) exhibition, *Occluded Front*, Turrell explains:

> Light is a powerful substance. We have a primal connection to it. But, for something so powerful, situations for its felt presence are fragile. I form it as much as the material allows. I like to work with it so that you feel it physically, so you feel the presence of light inhabiting a space. I like the quality of feeling that is felt not only with the eyes. It's always a little suspect to look at something really beautiful like an experience in nature and want to make it into art. My desire is to set up a situation to which I take you and let you see. It becomes your experience. I am doing that at Roden Crater. It's not taking from nature as much as placing you in contact with it.

His project, *Roden Crater*, began in 1974, is meant to "disclose the manifold of time—a manifold ranging from the geologic and astronomic to the immediate and transient—by revealing the interconnections between light and space." At present, Turrell continues to work on the unfinished project, which is an extinct volcanic cone 600 feet tall that is roughly 400,000 years old, located in the Painted Desert of Arizona. This monumental work is a transformation that is partly a sensory experience and partly a celestial observatory as it incorporates some of the designs from ancient wonders of the world that historically served as astronomical calendars and maps. There are interior architectural spaces and tunnels that allow starlight, moonlight, and sunlight to penetrate the deep core of the mountain and interact within it, "energizing" the spaces. Turrell explains that the inherent neutrality of the interiors will focus our attention on the light and the space, as it works in phase with the celestial sphere above it.

With *Roden Crater*, Turrell is transforming a natural entity into an artistic experience by directly using the medium of light to "reflect" the changing universe. His interventions and refinements of the volcanic cone, by tunneling pathways and chambers deep within it, are the tools of his sculpture. Viewers perceive the sky and become connected to it, but these sensations must remain essentially subjective for each person as they encounter the nuances of time, light, and space. Thus, a spectrum of impressions evolves...

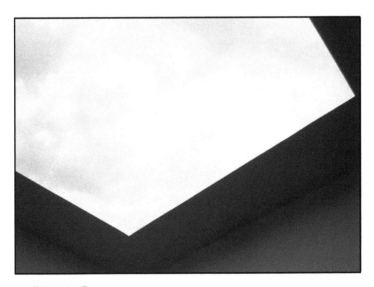

... *"Meeting"*

endnotes: *relational decisions*

image:

Alfred Stieglitz, *Equivalent,* 1926, 4 5/8" x 3 5/8," gelatin silver print. Metropolitan Museum of Art.
http://www.metmuseum.org/collection/the-collection-online/search/269404

"By photographing clouds, Stieglitz meant to demonstrate how 'to hold a moment, how to record some-thing so completely, that all who see [the picture of it] will relive an equivalent of what has been ex-pressed.' Stieglitz's choice of intangible vapors as his ostensible subject was telling, for the vagueness of transcendental meaning is not easily sustained by material objects. Whether his equivalents achieved their goal is a question each viewer must answer for himself or herself; that they demonstrated the inef-fable dimension of inspiration is without doubt."

text:

http://www.metmuseum.org/art/collection/search/269404

White:

Minor White, "Equivalence: The Perennial Trend," 1963, *Photographers on Photography,* Prentice-Hall, 1966, Nathan Lyons, ed.

image:

Mosaic of Europa's Ridges, Craters, Jet Propulsion Laboratory (JPL), California Institute of Technology, Pasadena, California. Photo caption from JPL, April 9, 1997. "This view of the icy surface of Jupiter's moon, Europa, is a mosaic of two pictures taken by the Solid State Imaging system on board the Galileo spacecraft during a close flyby of Europa on February 20, 1997. The pictures were taken from a distance of 2,000 kilometers (1,240 miles). The area shown is about 14 kilometers by 17 kilometers, with a resolution of 20 meters per pixel. One of the youngest features seen in this area is the double ridge cutting across the picture from lower left to the upper right. This double ridge is about 2.6 kilometers wide and stands some 300 meters high. Small craters are most easily seen in the smooth deposits along the south margin of the prominent double ridge, and in the rugged ridged terrain farther south. The complexly ridged terrain seen here shows that parts of the icy crust of Europa have been modified by intense faulting and disruption, driven by energy from the planet's interior."

Dyson:

"Every time there is a major impact on Europa, a vast quantity of water will be splashed from the ocean into the space around Jupiter. The water will partly evaporate and partly condense into snow. Any creatures living in the water not too close to the impact will have a chance of being splashed intact into space with the water and quickly freeze-dried. Therefore, the easy way to look for evidence of life in the Europa ocean is to look for freeze-dried fish." Freeman J. Dyson, *The Sun, The Genome, and The Internet,* Oxford University Press, New York, 1999, p. 81.

2.0232:

Ludwig Wittgenstein, *Tractatus Logico-Philosophicus,* D.F. Pears and B.F. McGuiness, translators, London: Routledge and Keegan Paul, 1961 (2.0232).

Long:

Sean O'Hagan, "One Step Beyond," *The Guardian,* 9 May 2009.
http://www.theguardian.com/artanddesign/2009/may/10/art-richard-long

image:
Richard Long, *A stone line before a blizzard, A fifteen day walk into National Forest, California, Winter, 2000.*

Long:
Richard Long website, http://www.richardlong.org/index.html

Wittgenstein:
Ludwig Wittgenstein, *Tractatus Logico-Philosophicus*, Pears and McGuiness, trans. (4.127 – 4.1272).

subject/object:
Stanford Encyclopedia of Philosophy: http://plato.stanford.edu/entries/object/

image:
Archimedes: "This tobacco card included in packs of cigarettes was issued by Cigarette Oriental de Belgique in 1938. It is card 26 from a set of 100 cards entitled *Famous Men through the Ages.* The back of the card contains a brief biography of Archimedes in French and Dutch. It measures 6.0 x 8.8 centimeters."
https://www.math.nyu.edu/~crorres/Archimedes/Pictures/ArchimedesPictures.html

Stimmung:
The translator of Kandinsky's *Concerning the Spiritual in Art*, M.T.H. Sadler, describes *Stimmung* as "almost untranslatable. It is almost 'sentiment' in the best sense, and almost 'feeling.' Many of Corot's twilight landscapes are full of a beautiful 'Stimmung.' Kandinsky uses the word later on to mean the 'essential spirit' of nature" (page 2).

Kandinsky:
Wassily Kandinsky, *Concerning the Spiritual in Art*, translated by M.T.H. Sadler, Dover Publications, Inc., New York, 1977, pages 31, 34, 55.

Kuspit:
Donald Kuspit, "Reconsidering the Spiritual in Art," Blackbird Archive, Spring 2003, Vol. 2, No. 1: http://www.blackbird.vcu.edu/v2n1/gallery/kuspit_d/reconsidering_text.htm

image:
Paleolithic mural on limestone (Magdelanian period, ca. 16,000-13,000 BCE). Pech Merle, Lot, Dordogne, France. Source: Claude Valette/flickr.

Lewis-Williams:
David Lewis-Williams, *The Mind in the Cave: Consciousness and the Origins of Art*, Thames and Hudson, 2002, p. 146.

the Euclidean algorithm: *solving* 2778x + 582y = 18
To solve a linear combination with integer solutions (a Diophantine equation in two variables), we will first use the Euclidean algorithm to find the gcd, and then reverse the order of each line, solving for the remainder of each and substituting it into the next line. This will give us two integer solutions for x and y; then we will solve for a general equation with *n* solutions, where *n* is an integer. Integer solutions are found when the gcd of **a** and **b** is also divides the right-hand side of the equation, in this case, 18.

For our example of 2778 and 582, **a** = 2778 and **b** = 582:

$$\mathbf{a = bq + r}$$
$$2778 = 582q + r$$

$$2778 = 582(4) + 450$$
$$582 = 450(1) + 132$$
$$450 = 132(3) + 54$$
$$132 = 54(2) + 24$$
$$54 = 24(2) + \mathbf{6}$$
$$24 = \mathbf{6}(4) + 0$$

Therefore, the greatest common divisor of 2778 and 582 is 6.

Once the gcd (2778, 582) is found, the original question can be resolved since 18 is a multiple of 6, finding values of **x** and **y** for $2778\mathbf{x} + 582\mathbf{y} = 18$. This process solves each remainder in terms of the previous equation, back-solving from $\mathbf{6} = 54 - 24(2)$ to eventually reach our two numbers of 2778 and 582. Each successive step in our continuous line of reasoning contains truth values traced back to the beginning, with all of the following statements equal to 6:

$6 = 54 - 24(2)$, and since $24 = 132 - 54(2)$, substitute for 24
$6 = 54 - [132 - 54(2)](2)$
$6 = 54 - 132(2) + 54(4)$, combine like terms of 54,
$6 = 54(5) - 132(2)$, and since $54 = 450 - 132(3)$,
$6 = [450 - 132(3)](5) - 132(2)$
$6 = 450(5) - 132(15) - 132(2)$, combine like terms of 132,
$6 = 450(5) - 132(17)$, and since $132 = 582 - 450(1)$,
$6 = 450(5) - [582 - 450(1)](17)$
$6 = 450(5) - 582(17) + 450(17)$, combine like terms of 450,
$6 = 450(22) - 582(17)$, and since $450 = 2778 - 582(4)$,
$6 = [2778 - 582(4)](22) - 582(17)$
$6 = 2778(22) - 582(88) - 582(17)$, combine like terms of 582,
$6 = 2778(22) - 582(105)$

Thus 6 can be rewritten, without changing its identity of "sixness," so that it is equal to $6 = 2778(22) + 582(-105)$. And to solve $2778x + 582y = 18$, simply multiply both sides of the equation by 3, to get $\mathbf{2778(66) + 582(-315) = 18}$, which gives the solutions $\mathbf{x = 66}$ and $\mathbf{y = -315}$.

But this is just one of an infinite number of combinations that will solve this equation! The others can be found by algebraically rewriting $2778(66) + 582(-315)$ as

$2778(66 - 582) + 582(-315 + 2778)$
(since $ab + cd = a(b - c) + c(d + a) = ab - ac + cd + ca = ab + cd$)
We are adding and subtracting the same quantity, 2778(-582) + 582(2778)
$2778(66 - 582) + 582(-315 + 2778) = 18$
$2778(66 - 582n) + 582(-315 + 2778n) = 18$, for **n**, any integer

Next, we will reduce $582n$ and $2778n$ by the gcd to get the smallest increments for our solutions:

$$2778\left(66 - \tfrac{582n}{6}\right) + 582\left(-315 + \tfrac{2778n}{6}\right) = 18 \qquad \text{(divide by the gcd = 6)}$$

$$2778(66 - 97n) + 582(-315 + 463n) = 18$$

Thus, for $\mathbf{2778x + 582y = 18}$, there are an infinite number of integral solutions, where:

relational decisions

$$x = 66 - 97n$$
$$y = -315 + 463n$$

For example, let $n = 10,117$:
$2778(66 - 97(10,117)) + 582(-315 + 463(10,117)) = 18$.

image:
Steve Deihl, *Twin Rocks*, Narrowsburg, January 18, 2016.

Dehn invariant:
http://mathworld.wolfram.com/DehnInvariant.html
http://math.umn.edu/~bashk003/docs/slides/hilbert3.pdf

image:
congruent triangles

Equivalence note:
While we have already seen several different references to "equivalence" in earlier discussions, it should also be mentioned that there is a strictly mathematical definition for an *equivalence relation*, similar to algebraic properties of equality.

An Equivalence Relation, R, on a set A must satisfy the following three properties:

x relates to x, for all elements x in set A: reflexive property
x relates to y implies y relates to x, for all x,y, in A: symmetric property
x relates to y and y relates to z imply x relates to z, for all x, y, z, in A: transitive property

image:
Steve Deihl, *Winter Rock (detail)*, Narrowsburg, January 18, 2016.

image:
white light prism: Wikimedia Commons.

21 centimeter wavelength:
Jonathan Pritchard and Abraham Loeb, "21-cm cosmology in the 21st Century,"
Institute for Theory & Computation, Harvard University, Cambridge MA.
http://arxiv.org/pdf/1109.6012.pdf and http://www.seti.org/seti-institute/project/details/seti-observations

SETI/Doug Vakoch message construction:
TED Talk: https://www.youtube.com/watch?v=hx9i-KRMCCc.

The Drake Equation:
1961, Green Bank, West Virginia: $= R_* f_p n_e f_l f_i f_c L$, where:
N is the number of civilizations in our galaxy able to communicate by radio
R_* = the average rate of star formation
f_p = the fraction of those stars that have planets
n_e = the average number of planets that can potentially support life
f_l = the fraction of planets that actually develop life
f_i = the fraction of planets that develop intelligent life
f_c = the fraction of civilizations that develop technology to release detectable signals
L = the length of time those civilizations release detectable signals into space

image:
Roden Crater, site of James Turrell's artwork, near Flagstaff, Arizona. Credit: United States Geological Survey, Department of Interior. https://commons.wikimedia.org/wiki/File:Roden.jpg

Turrell:
Occluded Front James Turrell, published in conjunction with the James Turrell exhibition at The Museum of Contemporary Art, Los Angeles, 13 November 1985 to 9 February 1986. The Lapis Press, Larkspur Landing California.
Interview with James Turrell by Julia Brown, p. 22.
Craig Adcock, "Light, Space, Time: The Visual Parameters of Roden Crater," *Occluded Front*, pages 101, 104.

image:
James Turrell, *Meeting*, Museum of Modern Art/PS1, New York, 1986 (photo: Jessica Sheridan/flickr).
Meeting is a site-specific installation consisting of a square room with a rectangular opening cut directly into the ceiling, allowing participants to view the changing sky. As Turrell described in an Art21 interview, "There's this four-square seating that's inside, seating toward each other, having a space that created some silence, allowing something to develop slowly over time, particularly at sunset. Also, this *Meeting* has to do with the meeting of space that you're in with the meeting of the space of the sky."
http://www.art21.org/texts/james-turrell/interview-james-turrell-live-oak-friends-meeting-house.
"Meeting" also refers to the Quaker gathering as a religious experience, featuring the stillness of worship that allows "illumination." https://www.nytimes.com/2001/04/08/arts/art-architecture-using-the-sky-to-discover-an-inner-light.html.

recurrence and the embedded image 8

Oh how should I not lust after Eternity and after the nuptial ring of all rings—the ring of recurrence?

— Friedrich Nietzsche, *Thus Spoke Zarathustra*

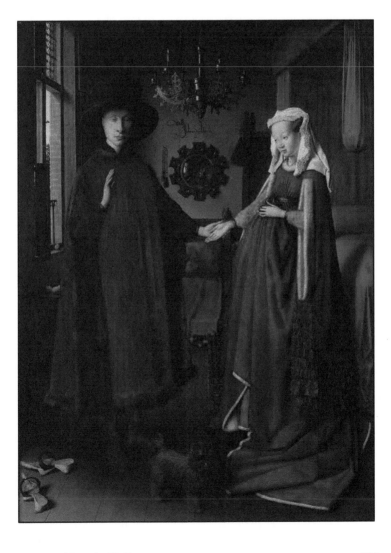

mise en abyme

Mise en abyme is a representation of embedded images or text within a work of art, which in turn reflects either literally or metaphorically the original structure: Hamlet's play within Shakespeare's *Hamlet*, Don Quixote's awareness of himself from an earlier part of *Don Quixote*, and André Gide's character Edouard in *Les Faux-Monnayeurs* writing a novel of the same title, are all well-known examples. We have already seen a mathematical example of self-similarity that is consistent with the *mise en abyme* concept—the reproduction of an infinite regression of forms, where

$$x = \sqrt{1 + x} \text{ generates } \sqrt{1 + \sqrt{1 + \sqrt{1 + \sqrt{1 + \sqrt{\ldots}}}}}$$

Brian McHale, in *Cognition en Abyme: Models, Manuals, Maps*, writes:

> Mise en abyme is exhilarating to think about, frankly, because it is such a prolific source of problems. Not least of all its problems is the question of what exactly counts as mise en abyme. By the strictest definition, the figure properly includes only those works that, paradoxically, contain themselves, such as Don Quixote or Les Faux-Monnayeurs. This purist criterion is straightforward, but it also yields the fewest instances. More relaxed definitions would admit all kinds of analogies or isomorphisms among more or less distinctly bounded parts of a text (e.g., "framed" descriptions, views from windows, etc.). Defined as broadly as this, the figure of mise en abyme ends up shading off into a general principle of analogy, whereby anything in the text can be construed as analogous to anything else.

Literally translated, abyme or "abîme" means "placed into the abyss," but in common use it is rendered as "the second story," or *effet de miroir*. A more general but useful definition might be that mise en abyme is a self-referential construct wherein the part is similar to the whole, like a spiraling nautilus shell that progressively generates copies as it evolves. It contains itself again as a subset, reflecting the original, but now with a new perspective, which is not unlike a geometric transformation, or "mirror" image.

In Jan van Eyck's *Portrait of Giovanni Arnolfini and his Wife*, painted in 1434, the artist has used a convex mirror in the room to show a reflection of the couple as a double image. As Susan Jones notes in the *Heilbrunn Timeline of Art History*, the mirror on the rear wall not only reflects their backs, but also

> reflects two tiny figures entering the room, one of them probably van Eyck himself, as suggested by his prominent signature above, which reads "Jan van Eyck has been here. 1434." By indicating that these figures occupy the

viewer's space, the optical device of the mirror creates an ingenious fiction that implies continuity between the pictorial and the real worlds, involves the viewer directly in the picture's construction and meaning, and, significantly, places the artist himself in a central, if relatively discrete, role.

In the mirror, Arnolfini and his wife are simultaneously reflected and diminished, but in doing so, the artist has given us more information than would have been possible without this device. Van Eyck's technique, a mise en abyme framed in a mirror, is isomorphic to the geometric composition of a reflection followed by a dilation—it gives the viewer a parallel structure, or dictionary, that translates those two systems of art and geometry. Together, the surrounding context (the story) and the embedded imagery (the story within the story) can be written as mapping an inseparable pre-image and image pair (the isomorphism). The lexicon used in mathematics, and more specifically geometric transformations, can be applied to show a similar structure among language, identity, and perception, all stemming from the initial position of a pre-image generator and its future self, the image. The embedding structure thus refers to a particular state, which in turn is reflected elsewhere.

But there is also a subtext, or underlying message within the portrait, because it is believed by some historians to portray an actual event, the signing of a marriage contract as witnessed by the artist. "Jan van Eyck has been here" may mean he was present in the room not only as a commissioned artist and recorder of the event, but also as the legal witness. The signature is the message, perhaps with a double meaning, in the same sense that a hand stamped in a prehistoric cave is evidence not only of a person's presence at a specific place and time but undoubtedly contains some symbolic message as well.

While Gide used the technique of mise en abyme to embed a second narrative, the term actually originates in the arcane terminology of heraldry as the central position, or *fess-point*, on an escutcheon within the division of the field. A second charge can be "placed into the center," as an inescutcheon.

```
                        middle chief
   dexter chief                                      sinister chief
                        honour point

                  fess point (mise en abyme)

                        nombril point
   dexter base                                       sinister base
                        middle base
```

Stuart Whatling of the Courtauld Institute of Art refers the heraldic discussion of mise en abyme to André Gide, who originated its modern usage. Gide was familiar with heraldic nomenclature and wrote in his journal:

> In a work of art I rather like to find transposed, on the scale of the characters, the very subject of that work. Thus in paintings by Memling or Quentin Metzys, a small dark convex mirror reflects the interior of the room in which the action of the painting takes place. Likewise in Velázquez's painting of the *Meninas*…None of these is altogether exact. What would better explain what I'd wanted to do in my [writing] would be a comparison with the device from heraldry that involves putting a second representation of the original shield 'en abyme' within it.

lensing and large numbers

Imagine at the fess-point, instead of an embedded image, we are actually seeing an older version of the same shield behind it, as it was 13 billion years ago. We can see both images simultaneously because light from the past would have bent around the larger shield in the foreground recreating the design from the multitude of individual photons. This effect might even create a halo of similar images surrounding the larger object.

Since light is actually bent by the gravitational field of massive bodies like black holes and galaxies, sometimes astronomers observe a large object that lies directly in the path of ancient beams that are coming from a more distant source located directly behind it. This is the same phenomenon that Wheeler used in his thought experiment, where a gravitational lens could potentially create a "delayed choice" for photons; its fortuitous placement in nature acts like van Eyck's convex mirror to tell a story that was begun long ago. The photons from these sources can be scattered into a ring of multiple images of the original quasar—a nascent galaxy emitting tremendous amounts of energy perhaps fueled by a massive black hole—this "lensing" through space and time of a distant object is like a slingshot that allows astronomers to look back to an early universe.

When NASA launched the Hubble Space Telescope in 1990, one of its missions was to conduct a survey that would estimate star population by taking a sample from one small area in the sky and extending that data for the entire universe. The project that began in 1995, named "Deep Field," was an attempt to look back in time to an era just after the Big Bang, when the universe had cooled long enough to allow light particles to emerge; this mission was followed by "Ultra Deep Field" that focused on the same region from September 24, 2003 until January 16, 2004. Astronomers found at least 10,000 galaxies residing in a narrow slice of sky that is 1/10th the diameter of the full moon (about one-thirteen millionth of the total area of our sky), located in the southern constellation Fornax. The telescope gathered this light for a period of 11.3 days. Since distance is proportionate to time, some of these red-shifted galaxies are 13 billion light years distant and therefore existed roughly 13 billion years ago, their light traveling across space at 299,792,458 meters per second and just reaching us now. Light carries this information through time, and embedded within each photon is a unit of data particular to that galaxy—those units could be called "bits" or "vertices" or "monads." Without actually counting all of them, accurate estimates can still be made of the number of stars in the sky. Astronomers estimate there are 100 billion to 200 billion stars in an average galaxy, and, based on Hubble Space Telescope data that suggest there are 100 billion galaxies, that would mean there are approximately 10^{22} (10,000,000,000,000,000,000,000) stars in the observable universe.

But this is only an estimate based upon the distribution of observable galaxies in space; it could be more, or less. Since light carries information through space, we are actually looking backwards through time to a former age—those objects may no longer presently exist, having changed into other forms through stellar evolution. Even our local star is 93,000,000 miles distant, and if it suddenly exploded the light would take about 8 minutes to reach our planet. Given the great distances across the universe, there is a disconnect between receipt of the message and when it was sent.

We can only view these unfolding messages at the speed that they actually occur, concurrent with our own time, even if those same objects and events already existed billions of years in the past. Yet there is often a compelling feeling of similarity among events, whether celestial or in daily life, that might directly lead to the philosophical question of "eternal recurrence": if time is infinite with a finite number of possibilities, then all configurations and combinations have already been played and the ones to be are only repetitions from eons ago. Belief in this doctrine is the uncompromising acceptance of one's life, including every detailed event, both good and bad, as a necessary fact. And recurrence allows for the possibility that it will be relived again and again exactly the same each time. This sense of fatalism, or *amor fati*, that Friedrich Nietzsche embraced might seem to be a plausible theory except for the fact that space and time continue to expand from the initial Big Bang, continuously pressed forward by an as yet unknown force of "dark energy," essen-

tially allowing more new events to occur as they fill the increasing void. On the other hand, as space increases along with time, more transformations of the same event can still occur, as if set into motion without instructions to stop.

An analogy would be a series of mirrors that continuously bounce a beam of light between them, each time reflecting the same original object along a continuous chain of events from pre-image to image. The beam of light never degrades but keeps going, and as it travels along, new mirrors are made that project the beam even further along its path. While the true source is in the distant past, its recurring message would be embedded within each new composition, and transposed across time to the present and future.

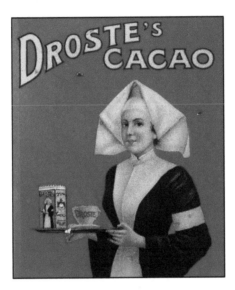

recursive sequences

While astronomers see the past by observing the light from distant objects in the universe, in mathematics an algorithm for looking backwards is a recursive process in which new elements are defined by previous ones, such as the Fibonacci sequence. One or two terms are defined, then all successive terms that follow are defined by prior terms—this action means looking behind to move ahead. Recall that the Fibonacci numbers begin with $F_1 = 1$ and $F_2 = 1$, and thereafter all of the rest are found by taking $F_n = F_{n-1} + F_{n-2}$ to get $F_3 = 2$, $F_4 = 3$, etc. Thus, taking two steps backwards and adding those terms will always find the next new term in the sequence—then the process repeats. Recursion is a special case of iteration, the repeated application of a transformation.

Benoit Mandelbrot, whose "theory of roughness" led to fractal geometry, discovered a recursive algorithm in 1979, which was later named the Mandelbrot set. As a research scientist, he used computers to create an iterative sequence that connected natural features such as shorelines, clouds, and mountains to a

mathematical process—at the same time, with the addition of computer graphics he replicated these objects abstractly, as an art form. We could say that the Mandelbrot set represents nature as an infinite texture of roughness.

To generate this set, Mandelbrot used complex numbers and graphed them in the Argand plane. Complex numbers are defined as $a + bi$, where a and b are real numbers and $i = \sqrt{-1}$. His equation is $Z_{n+1} = (Z_n)^2 + c$, where c is a complex number, such as $1 + i$. If the initial value, the "seed" of Z_0 is equal to zero, then adding that value to c, gives $Z_1 = c$. The next iteration results in $Z_2 = (Z_1)^2 + c = c^2 + c$, the next is $Z_3 = (Z_2)^2 + c = (c^2 + c)^2 + c$, followed by $Z_4 = [(c^2 + c)^2 + c]^2 + c$, ... etc. The recursive process is repeated over and over many times—in each case, the previous result becomes the new term which is squared and added to the original complex number, c.

He found that there are two possibilities that occur after the iterative process: either the number c is "bounded," that is, held within a region along with other tested values of c, or the chosen complex number quickly escapes to infinity, and is therefore "unbounded." As an unbounded example, after the first iteration the number $c = 1 + i$ becomes $1 + 3i$, and two iterations later is $-7 + 7i$, then it rapidly expands to $1 - 97i$, and then to $-9407 - 193i$, $88454401 + 3631103i$, eventually heading for a limit of infinity. However, $c = -1.38$, and $c = i$ are bounded and therefore within the "set." Using computers, Mandelbrot tested millions of different numbers, using the iterative process many times to find that there was a surprisingly small margin, about only two units in distance from the graph's origin, which determined if those numbers were either bounded or unbounded. In other words, each time some number (c) is sent through the equation, it lands in a new place on the graph, bouncing around the complex plane, because it has become a new number. If at any time during the iterative process its distance is greater than 2, the value will no longer stay nearby, but will rapidly become too large and leave the area, heading for infinity as it is repeatedly multiplied. However, this does not mean that *all* of those numbers within 2 units of the origin will stay bounded, as can be seen in the fractal hills and valleys in the representation, which some people describe as bat-like or bug-like.

He was further able to nuance the "speed" of how quickly the complex numbers left the bounded region and programmed a color-coding scheme to show that effect. The black region shows all of the numbers that are bounded and part of the Mandelbrot set; inside the blue region are unbounded numbers, and the borderline contains numbers that leave the bounded region either quickly or slowly. The set is "scale-invariant," meaning that on *any* level, near or far, it is self-similar; that is, each part is similar to the whole, and each transformed image is similar to the pre-image:

recurrence and the embedded image

Evidently, very small changes in the decimal expansion of c result in disproportionately large changes in the system as a whole. In this respect, mathematical models of the Mandelbrot set, the Julia set (discovered in the early twentieth century), and the Lorenz attractor (named after Edward Lorenz), are all evidence of chaos theory, which studies dynamic systems that are highly sensitive to initial conditions, often causing drastic results that could not have been predicted. Lorenz was known to have said that chaos is *when the present determines the future, but the approximate present does not approximately determine the future.*

self-similarity

If we consider some object that becomes larger or smaller as it moves through time, then its original identity is also carried along with that motion. This geometric transformation is a dilation, which is an increase or decrease in size of the pre-image, relative to the series of ensuing images.

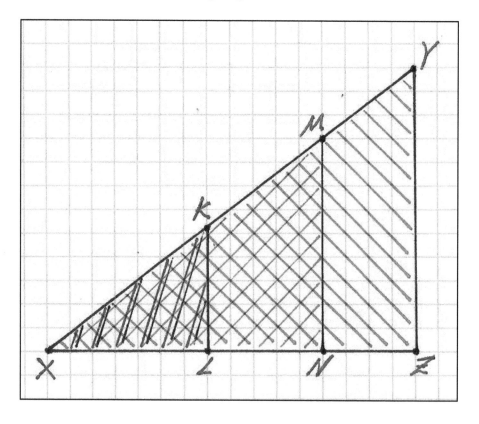

In this illustration, triangles **KXL**, **MXN**, and **YXZ** are all similar to each other in the strict mathematical sense. This requires them all to have corresponding angles of

equal measurement, and corresponding sides proportional to each other; although the three triangles could be regarded as separate forms, they are still related. Since they all contain the same angle X, and another angle which is 90 degress, their third angle must also be the same measurement. Furthermore, the lengths of *KL*, *MN*, and *YZ* all increase by a constant rate which is the same as *XL* increasing to *XN* and then to *XZ*. If triangle *KXL* is the pre-image then it is also nested within multiple later images, and remains there as the generator of this transformation. Or, conversely, if the original object is the pre-image triangle *XYZ*, then the transformations are shrinking the figures through time to *XKL* and further. This is also an embedding of similarity, like a series of mirror reflections that diminish to a vanishing point; in this case, converging to the vertex *X*. This vanishing point could be considered the origin of a recurring transformation that endlessly oscillates between increase and decrease.

Mathematically, it is a simple matter to just multiply each point in the triangle by some scale factor, k: if $k > 1$, the pre-image will increase, if $0 < k < 1$, it will decrease, if $k < 0$, the triangle will turn 180 degrees through a fixed point and reappear in another location. Since each triangle in this dilation contains the same identity as the original object, like a child growing to an adult, each new image along its evolution contains the identity of the original pre-image. By analogy, our transformation of triangles slide along from beginning to end, and might actually be considered a continuous transformation and not something achieved in discrete intervals, jumping from one location to the next.

Geometric similarity is an idealized version of the similarity and self-similarity seen in nature; in turn, art, literature, and music all use "similarity" as a suggestive device to emphasize a particular concept or thematic element. We often say that some characteristic is reflected in a work of art but this is not a literal "mirror image," rather it is a symbolic assertion that a second meaning is intended or revealed. In other words, there is an equivalence relationship between two or more elements that expands an idea. "Equivalent" in this sense conveys a subtle understanding that differentiates it from being equal—it implies that there is a strong correspondence to something else in terms of overall effect, thus connecting those elements to other associations in a network of affinities. Equivalence is a representative that carries a parallel message written by the original idea or form—it is like an amplification of the content, made more accessible by its changed position. This shifting of identity can also be thought of as a type of transformation in essence that is often embodied in a work of art, from nature to artist, to object and concept, to meaning. Thus, while recurring themes and poetic metaphors are sensory statements in literature, music, and art, mathematics avoids expressive messages for structural ones that are regarded as original and prevalent in nature.

Similarity can mean that there is a mimicked form within a form, or a theme within a theme; that is, a reflection or generational copy. It can also simply be a

repetition of shapes that by appearances alone may have some shared characteristics, but which also have differences. While similarity may be well-defined mathematically, in terms of making subjective comparisons it is a weaker statement than the mathematical congruence, which in turn might be considered weaker than equivalence. In common circumstances, the decision regarding the similarity of two objects is based upon factors other than if their corresponding angles are equal and corresponding parts are proportional.

As an artistic device, similarity is a purposeful thematic placement of text or objects, and that juxtaposition underscores the importance of the intended meaning. Thus, embedded within an artwork is a message that often references a universal characteristic or idea, which in turn is emphasized by the recurrence of the forms themselves as a motif:

Walter De Maria, 5 – 7 – 9 Series

Giuseppe Penone, Albero

As examples of the poetic use of similarity, consider two contemporary sculptures by Walter De Maria and Giuseppe Penone who both incorporate themes of recurrence into their work, either literally or metaphorically. Penone, an Italian artist from the *Arte Povera*, movement, maintained that he was working with different densities of materials through time. Wood, which is a hard material, becomes "fluid and soft with time," and he explored this relationship in the context of humans with nature. Growing up and working in the Piedmont forest of Garessio undoubtedly influenced his artwork, which has predominant themes of contact with nature and those sensations of earth, plants, trees, and breath, rendered in iron, bronze, wood, stone, and clay: "The tree is a memory, it traverses a space as it grows and records its form in its structure. The tree is fluid, clay is fluid, stone is fluid, water is fluid.... All materials preserve the memory of their experience, in their form." He believed that there was an original form of the tree itself locked within a finished beam of wood— that product still contained the tree which he sought to recover. Penone therefore worked to extricate the "treeness," or inherent character, that is literally found within the images of doors, tables, floors, and ships; he eventually produced many works of art based upon this idea.

In 1975, he obtained a large beam, 11 meters long, 22 cm wide, and 10 cm thick, and worked for a month in an abandoned warehouse near Garessio, which ironically used to be a sawmill, to bring forth an accurate representation of the tree at the moment it was cut down in the forest. Symbolically, we might consider the original tree to be a geometric pre-image and the concept of its treeness as the image which the artist, acting in the role of geometer, revealed through a transformation by using a mallet and chisel.

> To give it the appearance of the tree it was at a precise moment of its plant life, the first thing I had to do was to distinguish the top from the bottom. This I did on the basis of the growth rings, which correspond to the two layers—one harder, the other softer—present in all wood. The bottom is the part with the widest hard layer. Next I started digging, and now all I really have to do to recover the form of the tree is to continue to follow the harder layer. By doing this I not only obtain a shape, I also follow the growth of the tree to the moment at which a human hand or, who knows, a natural event, brought it to a halt.

Penone was most intrigued by the relationship of the real time of the tree's growth compared with the amount of time it took to release its image. Every tree contains a different history and a unique essence, which is then embedded within its "image," post-transformation, in the appearance of an altered form. It would seem that the artist is returning the tree to its natural state of identity.

Compared with Penone's sculptures, De Maria's machine-like art is the

antithesis of natural forms and common materials. Ostensibly, his work is closely aligned with mathematical precision and rigor, but on closer inspection, like mathematics, there can be seen within his stainless steel rods, bars, and grids, a structure that lends a sensory quality transcending those man-made materials to symbolize something more sublime. It is as if those multiple objects embody some aspect of universal architecture and design through that theme of recurrence; for then we can see the evolving pattern of things that are similar and therefore tending toward homogeneity, and things that are dissimilar and therefore tending toward heterogeneity. If we view patterns of similarity as an ouroboros, a snake eating its tail, then as time continues, that circle actually becomes an extended helix winding through space, for there is no real "return" to the origin, just references to it through time. The "ring of recurrence" is really like a helical compression of multiple trips around its edge, with all superimposed points corresponding to different generational states of similarity. Thus, within a framework of continuity there should also be a slight imbalance that allows for an evolving system, like the dynamics of a line divided unevenly.

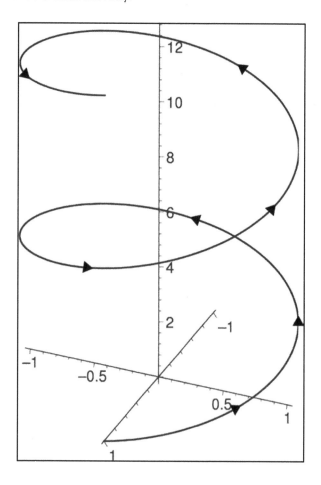

De Maria is well known for his large-scale installations of repeated forms, such as *The Lightning Field* and *The Broken Kilometer*. *Lightning Field* is an array of 400 solid poles with pointed tips, each 20 feet high, forming a grid measuring one mile by one kilometer in the western New Mexico desert. This is a sculpture that is meant to be walked through and around, and it should be experienced over an extended period of time, with the background of sky, clouds, sunrise, and sunset providing the changing palette.

By contrast, *The Broken Kilometer* does not incorporate nature as one of the ingredients in the sculptural experience. It is a sculpture located in a loft in New York City composed of 500 brass rods measuring exactly two meters in length, placed into five parallel rows of 100 rods each. It has been on display since 1979 and occupies a space of 45 feet by 125 feet and weighs 18.75 tons. There is a subtle change in De Maria's system of rods that can be felt by forcing a reversed perspective down the length of the room, which actually opens up rather than diminishes. He has placed each consecutive rod 5 mm further apart than the previous one, from front to back, with the first two rods 80 mm apart and the last two 570 mm apart. By doing this, he has introduced a mathematical device to heighten the viewer's awareness of an irregularity within the regularity of the pattern—an enclosed space, rather than an open field, allows for this close inspection and sensation.

This sculpture is a companion piece to De Maria's *The Vertical Earth Kilometer*, which was permanently installed at Friedrichsplatz Park, at Kassel, Germany in 1977. Viewers of the sculpture find it at the intersection of four footpaths in the park, which leads them to a red sandstone plate, two meters square. In the center of this is a circular disk flush to the surface of the earth that marks the top of an 18.75-ton solid brass rod five centimeters in diameter and one kilometer in length that had been lowered straight into the ground. The sculpture is unseen but pointed at the center of our planet, reminiscent of Eratosthenes' experiment to measure the Earth's circumference. A viewer standing here cannot directly witness the artwork, but rather will have an internal perception of it based upon mental concepts; she senses its intangible presence of weight, history, and location in relation to herself, ultimately connecting things that are only mental images.

Like *The Broken Kilometer*, De Maria's *5 – 7 – 9* is a work of art made from multiple parts and experienced as a whole composition. Made in 1992, there are 27 works in the series, with each unit consisting of three solid stainless steel polygonal rods that are attached to a rectangular granite base. The dimensions of each prism are 55 x 30.5 x 68 cm, and they have been grouped to show all the different arrangements of the three polygonal elements, either 5-sided, 7-sided, or 9-sided:

6 primary groups	12 asymmetrical groups		9 symmetrical groups	
5 – 7 – 9	5 – 5 – 7	7 – 7 – 9	5 – 5 – 5	7 – 9 – 7
5 – 9 – 7	5 – 5 – 9	7 – 9 – 9	5 – 7 – 5	9 – 5 – 9
7 – 5 – 9	5 – 7 – 7	9 – 5 – 5	5 – 9 – 5	9 – 7 – 9
7 – 9 – 5	5 – 9 – 9	9 – 7 – 7	7 – 5 – 7	9 – 9 – 9
9 – 5 – 7	7 – 5 – 5	9 – 9 – 5	7 – 7 – 7	
9 – 7 – 5	7 – 7 – 5	9 – 9 – 7		

Within the overall sameness of repeated forms there are implicit sensations derived from the explicit array of forms. Recurrence is clearly established, but once again, subtle changes in similarity, as opposed to overtly dissimilar or distinct elements, tend to make a more significant impact especially when experienced on a large scale. And when viewed close-up, those contrasts become reasonable because they are now aligned with a larger system, whatever that may be, universal or personal. From "The Sublime," in the exhibition catalog, Lars Nittve describes this experience:

> There is something tremendously attractive and hope-inspiring about a system where all possibilities have been explored. Through this alone, his work transports us in a dizzying wave—from its own microcosm to the macrocosm of possibilities. And our eyes confirm that we are no longer limited to the twentyseven [sic] possibilities of the realm of mathematics. The slightest movement before one of these works produces new and complex information. We glimpse a fleeting moment of visual order as we pass through the endless disorder of possibilities. A blank surface expanding, a razor sharp angle revealing itself…. The point at issue, then, is whether we approach De Maria's works as we approach the forces of nature—though obviously they are not of nature.

Like the comparison of passing between parallel mirrors, the polished surfaces of geometric polygons in 5 – 7 – 9 provide a reflected view of the observer, and even though distorted, it references the human experience relative to those objects as we pass through and among them. This can also be felt in *The Lightning Field*, where the grid of machined poles stand in stark contrast to the natural surroundings, but at the same time, it also represents a direct conjunction with something that was formerly unassociated. Thus, a connection was made that did not exist prior to that moment, by witnessing its distinction.

the fixed point attractor

In a sense, De Maria's regular arrays are like a matrix of possibilities. In mathematics, matrices (Latin, for "mother," and "womb") are rectangular representations of numbers, symbols, or expressions. We can create a matrix with a set of instructions

for the transformation of any pre-image, including a dilation, rotation, and translation that will rescale, turn, or shift it. If this process is done repeatedly, the matrix can generate multiple copies of the original object—the iteration producing a series of images that are similar, as seen in natural forms and fractal geometry.

We can start the transformation by representing multiple sets of two-dimensional coordinates of points, (x, y), in an array, like this:

$$[M] = \begin{bmatrix} x_1 & x_2 & \cdots \\ y_1 & y_2 & \cdots \\ 1 & 1 & 1 \end{bmatrix}$$

on which a general transformation matrix is then applied:

$$[T] = \begin{bmatrix} d\cos A & d\cos(A + 90°) & h \\ d\sin A & d\sin(A + 90°) & k \\ 0 & 0 & 1 \end{bmatrix}$$

where:

d = dilation or scale factor,

A = counterclockwise rotation by A degrees,

h = horizontal translation, and

k = vertical translation.

The pre-image [**M**] will be multiplied on the right side of the transformation [**T**] to get an image matrix, [**M'**], which is a new set of coordinates, after having undergone the prescribed series of changes: [**T**][**M**] = [**M'**]. This process can be repeated an infinite number of times with each former image becoming a new pre-image that is once again multiplied by the same transformation to produce another copy of itself that is rescaled, turned, and shifted both horizontally and vertically:

[**T**][**M''**] = [**M'''**].

As an example, we can take a trapezoidal pre-image object with (x,y) coordinates located at (2,1), (8,1), (7,6), and (3,6) and transform it by reducing its size by 0.8, turning it 30 degrees counterclockwise, and shifting it 7 units right and 2 units up:

$$[T] = \begin{bmatrix} 0.8\cos30° & 0.8\cos120°) & 7 \\ 0.8\sin30° & 0.8\sin120°) & 2 \\ 0 & 0 & 1 \end{bmatrix}$$

$$[M] = \begin{bmatrix} 2 & 8 & 7 & 3 \\ 1 & 1 & 6 & 6 \\ 1 & 1 & 1 & 1 \end{bmatrix}$$

Multiply the matrices together and their product is a new image located at the coordinates (8, 3.5), (12.1, 5.9), (9.4, 9.0), (6.7, 7.4):

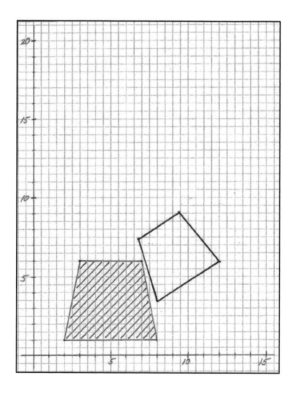

The iterative process continues, producing similar images which all carry the identity of the original trapezoid:

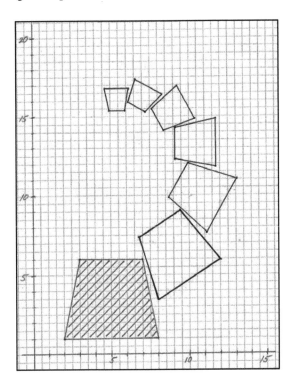

The trapezoidal shapes spiral inward and become smaller and smaller; they appear to be on a path to a central location, a "fixed point attractor," which draws them almost gravitationally, like a black hole, toward their final destination. The attractor is "invariant under the dynamics of the system, toward which the neighboring states asymptotically approach." That is, the sequence of images approaches a point of collapse; if a transformation is applied to this location, it does not move. Mathematically, at this location the fixed point is equal to the pre-image after n iterations, as n approaches infinity; philosophically, all of the successive images now have the same identity, carried along from the original figure. The fixed point can be approximately found by taking a sufficiently large number of transformations, such as $[T]^{100}$, because the four elements of the dilation and rotation in the last matrix effectively become zero, leaving coordinates in the h and k positions at the location (5.31, 13.42):

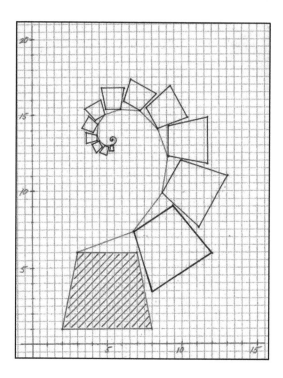

This pattern of self-reproducing shapes always refers back to the original pre-image structure, which is embedded within each of the similar images. The generator for this system was a set of instructions written in the form of a transformation matrix that sent the pre-image along the evolving pathway. As our geometric dilation took an original shape and reduced it, we could also imagine going back in time, with the attractor not as a destination, but a genesis state—the singularity from which the trapezoid sprang. In this case, by running our previous film backwards, that vertex is like a primordial seed that contains all of the information for creating later generations of similar forms, not unlike natural growth and expanding space.

Organic self-similarity can be seen in the spiral patterns of sunflowers, pineapples, and seashells. For example, the chambered nautilus contains similar copies of its structure that increase in size, growing at an exponential rate. The organism is replicating itself in larger and larger units, yet at any given scale it remains the same in terms of its overall composition—the proportional value is constant, which carries the same characteristics to each new level that is made. It is a series of recurring forms, each similar to the next, all of which are contained within the whole structure.

The Scottish naturalist D'Arcy Wentworth Thompson (1860–1948) made an extensive study of connecting biology and mathematics in his masterpiece, *On Growth and Form*, originally published in 1917. Thompson, like Pythagoras and Newton, believed that physical forces shape organisms directly, and their genetic

instructions are related to an idealized geometry. He writes in the epilogue to that work:

I know that in the study of material things, number, order and position are the threefold clue to exact knowledge; that these three, in the mathematician's hands, furnish the "first outlines for a sketch of the Universe"... For the harmony of the world is made manifest in Form and Number, and the heart and soul and all the poetry of Natural Philosophy are embodied in the concept of mathematical beauty.

In the chapter "On the Theory of Transformations, or the Comparison of Related Forms," he describes how forms are physically related to each other through transformations in two-dimensions. Although his investigation was limited without three-dimensional computer simulations, he compared certain bone structures by plotting them in rectangular coordinates, and then transformed them by stretching and shifting to include other groups. As an example, he found similarities among different mammal skulls, such as a tapir, horse, or rabbit, and showed through Cartesian geometry that one could be transformed into the other. An analogy would be tracing the outline of a human skull on a sheet of rubber and pulling it in different directions until it resembled a chimpanzee or baboon. There are limitations to similarities, however, which is why this must be a comparison of related forms, that is, those that are close in zoological classification. He found that, in agreement with Aristotle's idea of "excess and defect," the physical differences between one "species" and another are merely differences of proportion or relative magnitude.

In considering changing magnitudes, Thompson observed that the logarithmic spiral is a common trait not only in seashells, but also in tusks and horns of living creatures, as well as certain plant growth. "In the growth of a shell, we can conceive no simpler law than this, namely that it shall widen and lengthen in the same unvarying proportion: and this simplest of laws is that which Nature tends to follow. The shell, like the creature within it, grows in size *but does not change its shape*; and the existence of this constant relativity of growth, or constant similarity of form, is of the essence..." That recurrence of spiraling self-similar shapes is like a series of expanding rectangles based upon the Golden Ratio, ϕ, the same standard illustrated in Leonardo's *Vitruvian Man*, as the value of a person's height divided by the distance to ground from the navel. We have already seen how these and other natural forms are directly related to the Fibonacci sequence, which converges to the ratio of $\frac{1+\sqrt{5}}{2}$: 1, equal to the last Fibonacci number divided by the next to last one, as n approaches infinity: $\frac{F_n}{F_{n-1}}$.

Spiral shapes may grow at a constant rate like a coil of rope on a ship's deck, or exponentially like galactic arms as they wind through space, creating dust lanes and

new stars. Thompson called this type of logarithmic curve the equiangular spiral because, like the matrix demonstration with trapezoids, there is a constant rotation and therefore a constant angle from the fixed point to the object, which in our case was the trapezoid. This is similar to the path that many insects will follow towards a light in the dark, owing to the fact that their compound eye structure does not allow them to look straight ahead, but rather at an oblique angle. They constantly adjust their direction according to this angle, a sidelong view, as they home in on their target.

It can also be visualized that while the linear spiral progresses arithmetically, $r = a\theta$, the logarithmic curve increases geometrically, $r = a^\theta$, where r is the radius of the increasing spiral, a is a constant value, and θ is the whole angle through which it has revolved. Imagine there is an enormous clock with only a slowly turning second hand and you are standing on the pivoting end of the arm as it begins to arc. You slowly move away from the center as the radial arm swings around, all the while tracing the path below you with a marker. There are three simultaneous actions: the clock's arm is revolving, you are moving at a steady pace, and you are recording both motions. The shape drawn will be the spiral of Archimedes, an increasing coil, like playing a vinyl record in reverse as the arm moves outward. But if, instead of moving at a constant speed along the rotating arm, you walked faster and faster, eventually running, the spiral trace would revolve with an ever-increasing radius, moving outward exponentially. This shape resembles the snail's shell—the logarithmic spiral.

Even more astonishing is the connection between this particular curve and the prime number theorem. A prime number, such as 17, is a positive integer having exactly 2 divisors, 1 and itself—all other numbers are called composites. In this sense, primes are like atoms that create compound structures; for example, the number 51 is not prime but instead is the product of two primes, 3 and 17. To date, the largest prime number discovered is of a special variety called *Mersenne primes*, which are defined as $M_p = 2^p - 1$, where p is a prime number. For example, the first Mersenne prime is $M_2 = 2^2 - 1 = 3$, the second is $M_3 = 7$, the third is $M_5 = 31$, and the fourth is found using $p = 7$ for a value of 127. Thereafter, the pattern is broken with the next Mersenne prime being M_{13}; so within the set of prime numbers {2, 3, 5, 7, 11, ...}, the Mersenne primes make up a rare subset {3, 7, 31, 127, 8191, ...}. However, since their values grow exponentially by powers of 2, calculation and verification become possible only with machine programming; recently an Internet distributed computing project (GIMPS) has been successful in discovering new Mersenne primes such as the 50th one, $2^{77,232,917} - 1$, a number with 23,249,425 digits, and the search continues.

Around 300 BCE, Euclid proved that there are an infinite number of prime numbers. Here are the first few primes:
2, 3, 5, 7, 11, 13, 17, 19, 23, 29, 31, 37, 41, 43, 47, 53, 59, 61, 67, 71, 73, 79, 83, 89, 97...

Thus, there are 25 primes in the first 100 integers, or exactly 25% of the total. This ratio is the probability of choosing a prime number at random, given a list of the first 100 positive integers. It is also the same as asking, "How many primes are there less than 100?" That percentage does not remain constant, but decreases as we climb the mountain of numbers and the density of prime numbers, like the Earth's atmosphere, begins to thin out. There are 168 primes less than 1,000, 78,498 primes less than 1,000,000, and 5,761,455 primes less than 100,000,000. So the percentage decreases to 16.8%, 7.85%, and 5.76%—the prime number theorem formalizes this intuitive notion of decreasing density.

In 1792, when he was only 15 years old, Gauss proposed that we could approximate the number of primes for a search size of x, using the natural logarithm (ln) of that number: $\frac{x}{\ln(x)}$. For example, if the question is, "How many primes are there from 1,000 to 1,000,000?", then $\frac{1000000}{\ln(1000000)} - \frac{1000}{\ln(1000)} = 72{,}238$; ; about 7.2% of those numbers will be prime.

As the search size for primes increases, the prime density decreases in the same way that, as a logarithmic spiral's radius increases, the frequency of complete rotations decreases, because as one gets further away from the center it takes exponentially longer to complete the 360-degree journey. Visually, this relationship can also be shown with overlapping graphs. In other words, the rate at which prime numbers thin out is equivalent to the rate at which a snail's shell is coiled.

Not only is this logarithmic spiral directly connected to nature's biological "design of least resistance" and prime number theory, it also describes population growth and was found to have practical applications for calculating financial savings in banking. The Swiss mathematician Jacob Bernoulli (1654–1705) discovered that there is a natural limit to the possible amount of accrued interest in a given period, no matter how frequently the interest is compounded—even if it's compounded continuously. In other words, if $1 is invested at an interest rate of 100% per annum, then after one year the amount of money will have doubled, to $2. The amount will increase if interest is compounded more frequently—quarterly, monthly, daily, or every second. But no matter how frequently interest is compounded—even every nanosecond—it will approach a limit of $2.72, and never get any larger than that after one year has elapsed. A formula for calculating the amount of money A, after the principal P has been in the bank for t years with an interest rate of r, is $A = Pe^{rt}$. The number e, like π, is an irrational number and *transcendental*, which means that it is not a solution to any polynomial equation with rational coefficients. e is resolved only at infinity, but on a practical basis it can easily be calculated with a sufficiently large number, n. Named after Leonard Euler, e is the base of the natural logarithm and equal to $\lim_{n \to \infty} \left(1 + \frac{1}{n}\right)^n$

= 2.71828182845904523536028747135266249775724709369995...

Bernoulli's *spira mirabilis* is an example of asymmetrical growth in nature that is

at once intrinsic, mathematical, and aesthetic—conceivably, it is also timeless and universal. He found these implications so compelling that his gravestone was inscribed with a spiral and the words written around it: "Eadem mutata resurgo," meaning "although changed I arise the same...." This cyclical paradox is reminiscent of a flowing river, a powerful metaphor in Herman Hesse's *Siddhartha*, of something that is also simultaneously constant and changing:

> He once asked him, "Have you also learned that secret from the river; that there is no such thing as time?"
> A bright smile spread over Vasudeva's face.
> "Yes, Siddhartha," he said. "Is this what you mean? That the river is everywhere at the same time, at the source and at the mouth, at the waterfall, at the ferry, at the current, in the ocean and in the mountains, everywhere, and that the present only exists for it, not the shadow of the past, nor the shadow of the future?"
> "That is it," said Siddhartha, "and when I learned that, I reviewed my life and it was also a river, and Siddhartha the boy, Siddhartha the mature man and Siddhartha the old man, were only separated by shadows, not through reality. Siddhartha's previous lives were also not in the past, and his death and his return to Brahma are not in the future. Nothing was, nothing will be, everything has reality and presence."

This sudden understanding, or enlightenment, is like a transformation. Here, taken as a literary device, it alludes to an equilibrium that has abruptly collapsed, and the density from that implosion has the potential to create a new meaning when it rings true, as a singular tone of clarity. Hesse's river motif allows the possibility that somehow there could be a shift away from the normal geometry of space and time to a radical reinterpretation of it, merging before and after, here and there, to a single focal point.

Vasudeva's conversion could also be described as a "dynamic continuity" because, like "insight" and "stream of consciousness," there is a symbolic equivalence with the river: it is at once unbroken and whole, being in all places at once, and yet on a closer look it is obviously made of many different parts that are moving, mixing, and flowing. Again, this theme has already been touched upon in Magritte's "Le Blanc-Seing," where the rider has "carte blanche" to travel at will, a freedom of action perhaps without even physically moving. It was suggested that this event is like two parallel conditions that might overlap transdimensionally, and neither state, like Schrödinger's cat or the painted canvas, is determined until actually observed in a laboratory or captured by the artist, which immediately breaks the concurrence into one possibility or the other.

This portrayal, like Magritte's painting or Hesse's novel, of overlapping realities

and time distortion is especially prevalent in the speculative fiction genre, perhaps best represented by Chris Marker's evocative short film of static images, *La Jetée* (1962), which he called "un photo-roman" ("a photo-novel"). Other well-known examples include works by writers such as H.G. Wells (*The Door in the Wall,* 1911), Philip K. Dick (*Do Androids Dream of Electric Sheep?*, 1968), and Harlan Ellison (editor, *Dangerous Visions,* 1967). A similar idea is presented in *The Matrix* (1999), a film that interfaces two different realities from the near future: the familiar but simulated world devised by machines, and the other one, which is the apocalyptic view from outside the computer program. The story would not be possible without witnesses in a meta-location. As previously mentioned, induced conditions such as hallucinations and sensory deprivation create a time-loss and hearken back to shamanistic rituals in pre-historic Cro-Magnon cave sites where the world's first paintings and sculpture were created. Anthropological studies of aboriginal tribes have indicated that those people share a similarity with the past in terms of alter-native states of reality—this recurrence must indicate that these ideas are intrinsic to humanity and still currently important in some manner through artistic expressions like film, art, and literature.

That is the same viewpoint found in Alain Resnais' film *Last Year at Marienbad* (1962) in which there are alternating temporal perspectives, leading to an unre-solved but compelling quality in which the uncertainty of *now or then* is constant. The main characters, as depicted in the screenplay written by Robbe-Grillet, seem incapable of knowing if their reality is actual, controlled, feigned, or imagined, giv-ing a sense of unbalanced dynamism to the film because there is an untold history unfolding—a second embedded story. In fact, the characters have no names, but are represented, like mathematical variables, by letters: X, A, and M. Through layers of interpretation both for the viewer of the film and within the film itself—again, there is a crisis of identity from subject to object and back again—the possibility exists that they are actors in their own lucid dream, and if so, are there any consequences and effects resulting from their actions? The writer may be asking, "Can the residues of memory become sentient?"—a question that also parallels the darker implications of computers and artificial intelligence in science fiction.

Unlike the natural sciences, philosophy and the fine arts enjoy the freedom of speculation, presenting ideas to be built upon, appreciated, and either enhanced by time or forgotten in a moment. But growth in business is first assessed by risk analy-sis, mathematics requires proof, and science demands a method that can be verified and repeated. However, it could also be argued that breakthroughs in any field, at least to some degree, involve blending elements borrowed from Bergson's *élan vital* and Einstein's *rationality,* namely, intuition and reason. With these two aspects as a guideline, it seems that historically the most unexpected results in science and mathematics are often the ones that are most revolutionary. Innovation, insight, and theory become the driving forces for new inventions and ideas, and eventually

skepticism changes to acceptance through verification by others. But when tactile proof is missing, the task is much more challenging. Even with photographs of Earth from outer space it is sometimes still difficult to believe that the world is not flat, if only by appearances alone.

The same can be said when exploring the world of the very small. Consider the surprising results of an experiment carried out by Ernest Rutherford. Soon after J.J. Thomson discovered the electron in 1897, it was proposed that matter was composed of atoms that were positively charged spheres with electrons interspersed throughout; in other words, something like a "plum pudding." To test that theory, Rutherford, along with Hans Geiger and Ernest Marsden, directed a beam of positively charged particles at a thin sheet of gold foil, expecting them pass directly through the foil, as a bullet would through a sheet of paper. Most of the particles did just that, while some were deflected by a slight angle; but a small percentage ricocheted straight backward, as if they had struck a wall and abruptly reversed direction. Rutherford concluded that there was a solid but very small core within the atom that had a positive charge, and published that result in 1911.

Although he hoped to substantiate the plum-pudding theory, Rutherford unexpectedly discovered something entirely different than what he originally sought, adapting the new information to formulate a new conclusion—a combination of logic and instinct. He later said his discovery was as though one had fired "a 15-inch shell at a piece of tissue paper and it came back and hit you." The unseen world can still be measured, but it often requires a leap of faith in both the instruments and interpretation of theory that is tested. And as technology advances, scientific achievements may be understood by fewer and fewer people; it seems we are faced with the inverse relationship of needing more resolve to accept conclusions by fiat, such as the paradox of quantum entanglement—Einstein's "spooky action at a distance."

Likewise, there are mathematical "forms" such as the hypercube and the Klein bottle that have very real blueprints for their construction, but cannot actually be built in three dimensions because that needs a meta-state in some higher dimension. These objects, like geometry itself, exist only in our minds as idealizations, and as such are comparable to the non-physical essences that Plato believed to be a more accurate, or authentic version, of reality than their representations in this world. Parallel to this idea are the objects that lie between dimensions, namely fractals, that have their own unique properties—these can at least be partially depicted, but once again, their construction is limited as each iteration crowds the space around it until filled at infinity. Nevertheless, fractal geometry may still be considered a better description of nature than Euclidean, through the remarkable correspondence of patterns found among the rough edges in mountains, clouds, trees, and rippling ponds.

"What, however, is art itself that we call it rightly an origin?"

As presented in several examples throughout this work, the experience of reality can often be viewed as subjective, or even changing over time—this philosophy implies we might live in an evolving universe that responds to the questions we ask of it and the methods we use to analyze it. If this is an accurate description, then what, if anything, could be considered original, constant, or reliable? The twentieth century philosopher Martin Heidegger suggested that a response to this conflict, which appears to be common to many cultures, would be the role of art acting as a guiding force that "works inconspicuously to establish, maintain, and transform humanity's historically-variable sense of what is and what matters." That phrase, from the Stanford Encyclopedia, refers to a doctrine which Hegel originally developed called *ontological historicity* which considers this variability of experience. Building upon this notion, Heidegger believed that great works of art could help to explain dynamic cultural foundations, ethics, and meaning because they "ground history."

In *Poetry, Language, and Thought* (1971) Heidegger said: "Art, founding preserving, is the spring that leaps to the truth of what is, in the work. To originate something by a leap, to bring something into being from out of the source of its nature in a founding leap—this is what the word origin (German *Ursprung*, literally,

primal leap) means." In other words, he implies that art establishes a predominance in society and defines reality by its origination, value, and intention. "Thus art is: the creative preserving of truth in the work. *Art then is the becoming and happening of truth.*"

From onset to resolution, art, which Heidegger called the "setting-into-work of truth," travels a parallel course in mathematics, as they both evolve from an informed and enlightened introspection to a streamlined concept that is fresh, surrounded by already established structures. Perhaps more so than science, which is essentially founded on an empirical basis, mathematics uses symbols to represent its truth statements and so does art—they merely construct those verdicts differently. Then, from the wellspring of possibilities, a choice is made and theory, process, and synthesis later become the cultural products that we understand as proof, poetry, symphony, and other works. With this proposal in mind, mathematics is also art—constant and reliable.

It might be said that cultural progress, like evolutionary biology, is not gradual with one style or theory merging seamlessly into another, but rather is marked by explosive moments of branching and then an extended stasis or another quick replacement. This is known as "punctuated equilibrium," a phrase originated by paleontologists Stephen Jay Gould and Niles Eldredge in 1972. On a geologic scale this seems to be true, for fossil evidence can show the rapid decline or extinction of a species brought about by climatic change or some other catastrophe. But on a much smaller timeframe, both socially and culturally, the apparatus for change might be an ever-shifting and porous boundary where content is indirectly diffused and shared. At some point, there might be a flash of inspiration by an individual, or a critical mass of similar ideas becomes unavoidable, and the moment emerges as a bundle. Consensus is reached in terms of aesthetics, and proof is achieved in terms of logic.

This transformative moment is one by which both information and understanding are symbolically transferred from one state to another, or one person to another, and could be modeled by a pre-image and image. For example, the meaning of a sign or relation could be extended to include the interpretation of data, the message within a sentence, or the identity of a tree. These representations, like triangles, might be compared to an amalgam of two aspects: the impressions made by the physical shape itself and the recognition of its attached content. This is also like saying that a pre-image object presents properties to a subject which equates those properties as true because they are aligned with ideas, either correlated to prior experience or based upon theory. In return, the concept is verified and sent back to the shape and a connecting edge, or context, is established—together they overlap as a unity that is understood as one thing. Certainly this happens instantly every day as a common perception, but by extension it could also apply to the encryption/decryption process of creating works of art and mathematics, which

subsequently allows for "reading" a text, "sensing" a sculpture, or "correlating" a theory, all of which might have indirect or esoteric meanings that become poetic when revealed. In other words, the denotation has an embedded connotation that defines and supports the language.

In this regard, the image also defines the pre-image as a subject might define an object, but neither should be considered without the other, as shapes do not exist by themselves without a surrounding platform of associations. However, ideas without a physical reference, which Plato called Forms, might further be distinguished from the outward appearance of objects as pure essences, that is, *the Real of the real*, which alludes to some "quintessence," like mathematics itself. Because the transformation process carries the identity of an original form or entity with each iteration, it is a type of feedback loop, or recursion, always referencing that first pre-image. If, like Plato, we consider that to be a Form, then it is held in some idealized state with the inherent characteristics that give a triangle its "triangleness." For the transformation to be successful, evidence, intention, and evaluation take place in the symbolic transfer of information from things to ideas and back again, with the geometer, artist, or anyone, as the subject directing, mediating, and witnessing the action. This also suggests a model of cultural progress, which is always referring to some past icon, either associating with it or against it, by validating past achievements or presenting an alternative framework.

Although originally defined as a geometric movement, transformations can also be more generalized as a conversion of states, even transcendental ones. Theoretically, the aggregate of those vertices in *Siddhartha* (representing memories, rivers, people…) reveals the formerly linear order of past, present, and future to be a nonlinear exponentiation that somehow results in a compression of events. That is, every composite of concept and form suddenly becomes a singularity of impressions while still retaining the former identity of each "point," or monad. By analogy, just as the logarithmic spiral is emblematic of a perfect natural form—continuously increasing with self-similar shapes—the motif of "identity" is also constant, even through multiple transformations. It is carried along in that stream, within the composition of similar shapes that all share a common structure, and capable of endlessly recurring.

This type of connection exemplifies the broad approach of selectively mapping associations that were formerly unassociated. In other words, a network of elective affinities (things that are "kindred by choice") made by finding equivalent values: impressions, their representations, and the context that holds them together. Points are bound to other points and a fine structure is built. Symbolically surrounding each vertex is a cloud of potential relata that implodes to one unique meaning, and from that particular state and moment emerges a closer awareness. At once, the view from both inside and outside the system will be the same. The aim is to simplify a focused complexity, which paradoxically means that it is simultaneously

reduced as it expands in content. Like fractal geometry, the boundary becomes infinite, while still holding a finite area; at the same time, the system is more complete because edges that form the graph between vertices will increasingly diminish as more associations are made. That is, the network will contain more information by growing in density rather than spreading out, due to the proximity of similar and overlapping values in the surrounding matrix.

Of course, this distillation describes the objective of any academic pursuit, such as the ultimate prize in physics: a "grand unified theory" that would account for all matter and energy from the beginning of time to the present. It is believed that if such a cosmic rationale were discovered, it would be elegant, simplified, and undeniable in its extent. In mathematics there is also clearly an aesthetic to understand the beauty of relationships among eternal criteria and to correlate any new discoveries with established foundations, especially when they result from conclusions that were not foreseen—either replacing worn-out bricks with new ones to fortify an old construction, or tearing it down completely to rebuild it.

By most accounts, mathematics is an alloy of both invention and discovery—an abstraction that nevertheless precisely models basic properties of nature. In fact, it might be said that geometry is a synthetic science, being axiomatic and founded upon *a priori* deductions that exclude experience. Yet, those very conclusions still correlate, make sense, and can become limitless in their application. Likewise, this "origin" was also suggested as a defining characteristic for art, the "happening of truth," along with the modernist ideal that places the artist directly in the center of the creative process, acting as a vital conduit. The best work is then exemplified by the right mixture of inner vision and outward expression that remains true after critique— this interpretation captures the spirit of both art and mathematics. And it is from considering mathematics as a universal language that holistic connections among other disciplines can also be made because they too are based upon sensing distinctive patterns to discover why certain themes are prevalent, timeless, and thus essential:

watch the tallest branches in the wind
distant tree tops shifting
along the cloud line

sound air and light
moving changing
then refocus:

broadly wrapping
the sky behind thickens
and replaces our view

sense the pressing forward
weight filling space
now everything is new

endnotes: *recurrence and the embedded image*

Nietzsche:
Friedrich Nietzsche, *Thus Spoke Zarathustra: A Book for Everyone and Nobody*, translated by Graham Parkes, Oxford University Press, 2008, p. 202 and pp. 199–200 (below):

"One!
Oh man! Take care!
Two!
What does Deep Midnight now declare?
Three!
'I sleep, I sleep –
Four!
'From deepest dream I rise for air: –
Five!
'The world is deep,
Six!
'Deeper than day had been aware.
Seven!
'Deep is its woe –
Eight!
'Joy – deeper still than misery:
Nine!
'Woe says: Now go!
Ten!
'Yet all joy wants Eternity –
Eleven!
' – wants deepest, deep Eternity!'
Twelve!"

Commentary on The Roundelay: http://web.utk.edu/~sophia/readings/perry.pdf

Oh Mensch! Gieb Acht!	1
Was spricht die tiefe Mitternacht?	2
„Ich schlief, ich schlief —,	3
„Aus tiefem Traum bin ich erwacht: —	4
„Die Welt ist tief,	5
„Und tiefer als der Tag gedacht.	6
„Tief ist ihr Weh —,	7
„Lust —tiefer noch als Herzeleid:	8
„Weh spricht: Vergeh!	9
„Doch alle Lust will Ewigkeit —,	10
„—will tiefe, tiefe Ewigkeit!	11

image:
Jan van Eyck, *Portrait of Giovanni Arnolfini and his Wife*, 1434, oil on oak (82.2 cm x 60 cm).
http://www.nationalgallery.org.uk/paintings/jan-van-eyck-the-arnolfini-portrait/*/key-facts.

McHale:
Brian McHale, "Cognition *En Abyme*: Models, Manual, Maps," *Partial Answers: Journal of Literature and*

the History of Ideas, Volume 4, Number 2, June 2006, pp. 175-189.
http://muse.jhu.edu/login?auth=0&type=summary&url=/journals/partial_answers/v004/4.2.mchale.pdf.

Jones:
Susan Jones, *Jan van Eyck (ca. 1390–1441)*, Caldwell College, 2002. Description from Heilbrunn timeline of Art History, Metropolitan Museum of Art. http://www.metmuseum.org/toah/hd/eyck/hd_eyck.htm

Whatling:
Stuart Whatling, *Putting Mise-en-abyme in its (Medieval)Place,* Paper delivered at Courtauld Institute of Art, conference 16 February, 2009: "Medieval 'mise-en-abyme': the object depicted within itself." http://www.documentshare.org/culture-and-the-arts/medieval-mise-en-abyme-the-object-depicted-within-itself/

image:
Coat of Arms of the United Kingdom 1801–1837. Copyright-free courtesy of GNU Free Documentation License. Arms of England quartered with Scotland and Ireland with an escutcheon of the fourth quarter from the arms of the United Kingdom of 1714 surmounted by a crown. Blazon (verbal description) : "Quarterly, I and IV Gules three lions passant guardant in pale Or (for England); II Or a lion rampant within a double tressure flory-counter-flory Gules (for Scotland); III Azure a harp Or stringed Argent (for Ireland); overall an escutcheon tierced per pale and per chevron (for Hanover), I Gules two lions passant guardant Or (for Brunswick), II Or a semy of hearts Gules a lion rampant Azure (for Lunenburg), III Gules a horse courant Argent (for Westfalen), the whole inescutcheon surmounted by a royal crown." http://en.wikipedia.org/wiki/File:UK_Arms_1801.svg

image/text:
XDF, eXtreme Hubble Deep Field
 Called the eXtreme Deep Field, or XDF, the photo was assembled by combining 10 years of NASA Hubble Space Telescope photographs taken of a patch of sky at the center of the original Hubble Ultra Deep Field. The XDF is a small fraction of the angular diameter of the full moon.
 The Hubble Ultra Deep Field is an image of a small area of space in the constellation Fornax, created using Hubble Space Telescope data from 2003 to 2004. By collecting faint light over many hours of observation, it revealed thousands of galaxies, both nearby and very distant, making it the deepest image of the universe ever taken at that time.
 The new full-color XDF image is even more sensitive, and contains about 5,500 galaxies even within its smaller field of view. The faintest galaxies are one ten-billionth the brightness of what the human eye can see.
Credit: NASA; ESA; G. Illingworth, D. Magee, and P. Oesch, University of California, Santa Cruz; R. Bouwens, Leiden University; and the HUDF09 Team http://www.nasa.gov/mission_pages /hubble/science/xdf.html

stars in the universe:
ESA, European Space Agency.
http://www.esa.int/Our_Activities/Space_Science/Herschel/How_many_stars_are_there_in_the_Universe

image:
1904 Droste cacao tin, designed by Jan Misset. The Droste effect, or *mise en abyme,* is a technique of repeating self-similar images, placing one inside the other recursively (Wikimedia Commons).

image:
Mandelbrot set, showing successive close-up images of the fractal which continues indefinitely. https://commons.wikimedia.org/wiki/File:Mandel_zoom_00_to_01.png

Licensed under the GNU Free Documentation License and Creative Commons Attribution-Share alike 3.0 Unported license. Attributed to Wolfgang Beyer, October 2005.

matrices:
Roland Larson et al., *Precalculus with Limits: A Graphing Approach*, Houghton Mifflin Company, Boston, 1997.

Lorenz:
Christopher Danforth, University of Vermont.
http://mpe2013.org/2013/03/17/chaos-in-an-atmosphere-hanging-on-a-wall/

image:
similar triangles

image: Walter De Maria, *5 - 7 - 9 Series*. © Estate of Walter De Maria. Courtesy Gagosian. Photography by Matteo Piazza.

image: Giuseppe Penone, *Albero*, 348.5 x 19 x 19 cm, wood, 1970. ARTstor slide gallery.

Celant:
Germano Celant, *Giuseppe Penone*, Electa Srl, Milan, 1989. Quotes from pages 184, 49, 55.

image:
helix: https://en.wikipedia.org/wiki/Helix.

Nittve:
The 5 - 7 - 9 Series, Gagosian Gallery, 1992, New York. Lars Nittve, "The Sublime," originally published in *Walter De Maria: Two Very Large Presentations*, by Moderna Museet, Stockholm, 1989.

De Maria images:
For further De Maria images, visit these Dia Art Foundation websites:
http://www.diaart.org/sites/main/53
http://www.diaart.org/sites/main/57
http://www.diaart.org/sites/main/56

image:
Nautilus cutaway logarithmic spiral, Chris73, Wikimedia Commons.

fixed point attractor:
http://mathworld.wolfram.com/Attractor.html

Thompson:
D'Arcy Wentworth Thompson, *On Growth and Form*, Cambridge University Press, Cambridge, 2008.

Stephen Jay Gould: introduction, page ix, and pages 326–327, 273, 179.

Mersenne primes:
Although these particular prime numbers have been known since Euclid's time, Mersenne numbers are named after Marin Mersenne, a 17th century priest, philosopher, and mathematician. Both Euclid and Euler proved a connection between Mersenne primes and "perfect numbers," which are numbers whose proper divisors sum to the number itself. For 28, the proper divisors are 1, 2, 4, 7, 14, and $1 + 2 + 4 + 7 +$

14 = 28, making 28 a perfect number; moreover, 4 is a power of two, and 7 is a prime number that is one less than a power of two, making it a Mersenne prime. Remarkably, *every Mersenne prime corresponds to exactly one perfect number*, and *every even perfect number is the product of a power of two and a Mersenne prime*. In other words, if $2^k - 1$ is prime, then $(2^{k-1})(2^k - 1)$ is a perfect number. This means that for 28, the product of 4 and 7 can be rewritten as $(2^2)(2^3 - 1)$; using the 49th Mersenne prime, we can obtain a perfect number with 44,677,235 digits, the product of $(2^{74,207,280})$ and $(2^{74,207,281} - 1)$.
http://mathworld.wolfram.com/MersennePrime.html
https://primes.utm.edu/notes/proofs/EvenPerfect.html
http://www.mersenne.org/

prime number theorem:
http://mathworld.wolfram.com/PrimeNumberTheorem.html
https://www.khanacademy.org/computing/computer-science/cryptography/comp-number-theory/v/prime-number-theorem-the-density-of-primes

The Elementary Proof of the Prime Number Theorem: An Historical Perspective, Dorian Goldfield, Columbia University, New York
http://www.math.columbia.edu/~goldfeld/ErdosSelbergDispute.pdf
and graphically:
http://empslocal.ex.ac.uk/people/staff/mrwatkin/zeta/crudespiral.htm

Hesse:
Hermann Hesse, *Siddhartha*, translated by Hilda Rosner. Bantam Books, New York, 1951, originally published 1922, pages 106–107.

quintessence:
In ancient and medieval philosophy, quintessence was the fifth element in nature, also called "aether," which existed in a higher plane than the four others—earth, air, fire and water. It was said to be the essential substance of the cosmos, inherently pure, and the material from which the celestial bodies were made. Today it means the best example of something, or the most typical. Most recently, modern physics has reclaimed its original term as a mathematical field, specifically in connection with the hypothetical "dark energy" which is accelerating the expansion of the universe.

Rutherford and the Gold Foil Experiment:
http://chemed.chem.purdue.edu/genchem/history/gold.html

image:
Steve Deihl, *Winter Rock*, Narrowsburg, January 18, 2016.

Heidegger:
Martin Heidegger, *Poetry, Language, and Thought*, translated by Albert Hofstadter, HarperCollins Publishers, Inc., New York, 1971, pages 69 and 75.

Stanford Encyclopedia of Philosophy:
http://plato.stanford.edu/entries/heidegger-aesthetics/index.html#note-5

Elective Affinities:
Also translated "Kindred by Choice," was Johann Wolfgang von Goethe's third novel, published in 1809 under the title, *Die Wahlverwandtschaften.*

Langlands Program:
In mathematics, this is considered to be a grand unified theory, named after Canadian mathematician Robert Langlands (born 1936). In 1996, he won the Wolf Prize for producing a "web of conjectures" that generalizes number fields—this work relates equivalent mathematical structures to an infinite-dimensional representation theory. http://mathworld.wolfram.com/LanglandsProgram.html

poem:
Steve Deihl, *Then Refocus*, Yulan, 2004–2005.

image:
Steve Deihl, *Light Through the Trees*, Narrowsburg, 2016

Mario Merz: "Se la forma scompare la sua radice è eterna"
Photograph of a label for Mario Merz artwork located in the outdoor sculpture garden at Peggy Guggenheim's Venetian palazzo. The sculpture, not seen here, is blue neon tubing forming the words, "Se la forma scompare la sua radice è eterna" and is embedded within a surrounding hedge. Photograph by Ed Agosto.

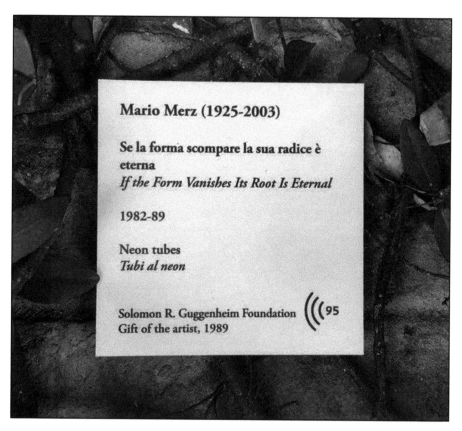

In *The Origin of Geometry,* **Husserl further states:**

It is a general conviction that geometry, with all its truths, is valid with unconditioned generality for all men, all times, all peoples, and not merely for all historically factual ones but for all conceivable ones. The presuppositions of principle for this conviction have never been explored because they have never been seriously made a problem. But it has also become clear to us that every establishment of a historical fact which lays claim to unconditioned objectivity likewise presupposes this invariant or absolute a priori.

Only [through the disclosure of this a priori] can there be an a priori science extending beyond all historical facticities, all historical surrounding worlds, peoples, times, civilizations; only in this way can a science as *aeterna veritas* appear. Only on this fundament is based the secured capacity of inquiring back from the temporarily depleted self-evidence of a science to the primal self-evidences.

Edmund Husserl, *The Origin of Geometry,*1936. Manuscript originally published by Eugen Fink in the *Revue internationale de philosophie,* 1:2 (1939), under the title, "Der Ursprung der Geometrie als intentional-historisches Problem." Jacques Derrida, *Edmund Husserl's Origin of Geometry: An Introduction.* Presses Universitaires de France, 1962. Translated by John P. Leavey, Jr., University of Nebraska Press, Lincoln, Nebraska, 1989, page 179.

acknowledgements

Although *Sensing Geometry* was years in the making, for most of this period I never planned to publish it—not until the very end, when it was assembled from extensive piles of notes, remembered conversations, experiences, and observations gathered over time. It was through my research and work, first as an exhibiting artist and later as a mathematics educator, that the various links became solid enough to set down in chapter form and send samples to several publishers. David Stover was among the first to respond positively, and I thank him for taking a risk on an unknown author of interdisciplinary theory. He was also open to unconventional approaches in the project's design—to me, that was a critical affirmation of a shared sensibility leading to our eventual collaboration.

Friends, old and new, who were influential in this project, contributing works of art, technical advice, and inspiration, include, among many others, gallerist, mentor, and visionary Bill Bartman, Dublin House brother Andy Fox, colleagues Chris Murphy and Regina Lee, mathematics crusader Mara Markinson, and photographers Sam Oppenheim and Katherine O'Brien, whose visual poetry echoes mine. I would also like to acknowledge Jim Simons whose foundation, Math for America, supports educators in mathematics and science through intellectual fellowship and development.

Finally, without the encouragement of my family, Nancy and Ford, who gave me the freedom to create and weave these ideas, this book would not have been possible. Time and space, both rare and precious, are the main ingredients for any artist, but the same opportunities should hold for everyone—elements not to be taken for granted, but used fully because they allow for cultural progress.

index

Eddington, Arthur Stanley, *relativity* and *Number*, 8–9, 69

Einstein, Albert, ix, xi, 61, 199; *relativity*, 8, 28, 59, 69, 90, 104; *Spukhafte Fernwirkung*, 101, 200

entelechy, 23

equality, 25–26, 152, 154–156, 160

equivalence, 121–122, 148, 154, 158, 163, 185–186; *equivalence (congruence modulo)*, 156; *equivalence relation*, 163, 173

Eratosthenes, 16–17, 189

Escher, M. C., 90

Euclid, *geometry*, 22–23, 31, 90, 133, 200; *prime numbers*, 196; *common notions*, 127, 148; *and Mandelbrot*, 51; *algorithm*, 149–151, 171

Euler, Leonhard, 9–10, 29–30, 208; *e, defined*, 197; *identity*, 9–10, 30

Europa (Jovian moon), 139, 170

fatalism, *amor fati*, 180

Feynman, Richard, and *Feynman point*, 6, 120

Fibonacci, *sequence*, 42–46, 48, 54, 128, 131,181, 195

field, *symbolic*, 75, 96–97; *algebraic*, 93–94, 160; *heraldic*, 91–92, 177–178

fixed point attractor, *defined,* 193

Ford, Ford Madox, 56

fractal space, 91, 129–131, 133, 147, 191, 200, 204

Frazer, James George, 31, 79, 81, 88

Fuller, Buckminster, 29, 57

Futurism, 67

Galois, Évariste, 93, 107

Gauss, Carl, 156, 197

geometry, *symbolically redefined*, 18, 69, 102

Gide, André, 176–178

golden ratio, 40–48, 128, 195

Gould, Stephen Jay, *punctuated equilibrium*, 202

gravitational wave, 104–105

gravitational lens, 101, 103, 107, 179

harmony, 41, 86, 121, 146, 196

Hausdorff dimension, 129, 137

Hawking, Stephen, *The Grand Design*, 102

Hegel, G. W. F., *ontological historicity*, 201

Heidegger, Martin, *Ursprung and truth*, 201–202, 204

Heisenberg, Werner, 119

heraldic terms, 91–92; *symbolism*, 91, 99; *division of the field*, 178

Hesse, Hermann, *Siddhartha*, 198, 203

Hilbert, David, 3, 49–50, 130, 132, 154

Hubble Space Telescope, *number of stars*, 166, 180

CPSIA information can be obtained
at www.ICGtesting.com
Printed in the USA
BVHW090945080419
544915BV00028B/2178/P

9 781772 441703